KAY WALKINGSTICK
an American Artist

General Editors

Kathleen Ash-Milby and David W. Penney

NATIONAL MUSEUM OF THE AMERICAN INDIAN
Smithsonian Institution
Washington, DC, and New York

Distributed by Smithsonian Books

This book may be purchased for educational, business, or sales promotional use. For information please write: Smithsonian Books, Special Markets, PO Box 37012, MRC 513, Washington, DC 20013.

The National Museum of the American Indian is committed to advancing knowledge and understanding of the Native cultures of the Western Hemisphere—past, present, and future—through partnership with Native people and others. The museum works to support the continuance of culture, traditional values, and transitions in contemporary Native life.

For more information about the Smithsonian's National Museum of the American Indian, visit the NMAI website at www.AmericanIndian.si.edu. To support the museum by becoming a member, call 1-800-242-NMAI (6624) or click on "Support" on our website.

Published in conjunction with the exhibition *Kay WalkingStick: An American Artist*, on view at the National Museum of the American Indian, Washington, DC, from November 7, 2015, to September 18, 2016. Traveling exhibition organized by the American Federation of Arts.

The American Federation of Arts is a nonprofit institution dedicated to enriching the public's experience and understanding of the visual arts, and which organizes art exhibitions for presentation in museums around the world, publishes exhibition catalogues, and develops educational programs.

Associate Director for Museum Programs
Tim Johnson

Publications Manager
Tanya Thrasher

Assistant Publications Manager
Ann Kawasaki

General Editors
Kathleen Ash-Milby, David W. Penney

Project Editor
Alexandra Harris

Senior Designer
Steve Bell

Editorial Support
Jane McAllister, Indexing Partners LLC

Permissions
Wendy Hurlock-Baker, Bradley Pecore

First Edition
10 9 8 7 6 5 4 3 2 1

Library of Congress Cataloging-in-Publication Data

Kay WalkingStick (National Museum of the American Indian)

 Kay WalkingStick : an American artist / general editors, Kathleen Ash-Milby and David W. Penney. – First Edition.

 pages cm

 Summary: "Kay WalkingStick: An American Artist is the companion catalogue to the exhibition, opening at the Smithsonian's National Museum of the American Indian in Washington, D.C., in November 2015. Kay WalkingStick (b. 1935) is an enrolled member of the Cherokee Nation and one of the world's most celebrated artists of Native American ancestry. This volume includes essays by leading scholars and historians, arranged chronologically to guide readers through WalkingStick's life journey and rich artistic career, tracing a path of constant invention, innovation, and evolving artistic and personal growth through visually brilliant and evocative works of art"— Provided by publisher.

 ISBN 978-1-58834-510-3 (hardback)

 1. WalkingStick, Kay—Exhibitions. I. Ash-Milby, Kathleen E., editor. II. Penney, David W., editor. III. WalkingStick, Kay. Paintings. Selections. IV. National Museum of the American Indian (U.S.) V. Title.

 ND237.W316A4 2015

 759.73—dc23

 2015010778

This paper meets the requirements of ANSI/NISO Z39.48-1992 (Permanence of Paper).

The essay entitled "Spring 1974" printed with permission, © Erica WalkingStick Echols Lowry, 2015.

Color separations by Robert J. Hennessey Photography.

Typeset in Sabon and Quadraat Sans

Printed in Italy by Graphicom S.r.l.

Cover: *New Mexico Desert*, 2011. Oil on wood panel, 40 x 80 x 2 in. Purchased through a special gift from the Louise Ann Williams Endowment, 2013. NMAI 26/9250

Title Page: *Farewell to the Smokies*, 2007. Oil on wood panel, 36 x 72 x 1 in. Denver Art Museum: William, Sr., and Dorothy Harmsen Collection. 2008.14

CONTENTS

1. *Sakajeweha, Leader of Men*, 1976. Acrylic, saponified wax, and ink on canvas, 72 x 96 in. New Jersey State Museum, Trenton; gift of the artist in memory of R. Michael Echols. FA1992.25

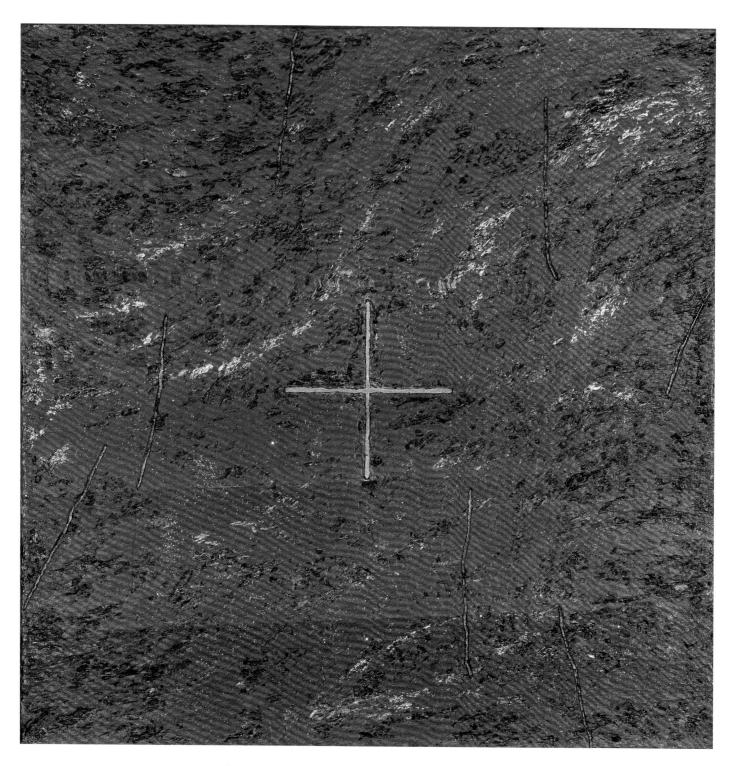

2. *Cardinal Points*, 1983–85. Acrylic
and saponified wax on canvas,
60 x 60 x 4.5 in. Collection of the
Heard Museum, Phoenix, Arizona.

The National Museum of the American Indian thanks the members of the museum's National Council for their leadership support of the *Kay WalkingStick: An American Artist* publication:

Allison Hicks (Prairie Band of Potawatomi Indians), Co-Chair
California

Gregory A. Smith, Co-Chair
Maryland

Elizabeth M. Alexander
Virginia

Stephanie A. Bryan (Poarch Band of Creek Indians)
Alabama

Uschi and William Butler
Virginia

David Cartwright
New Mexico

Vincent R. Castro
Delaware

Brian Cladoosby (Swinomish)
Washington

Charles M. Froelick
Oregon

Keller George (Oneida Indian Nation)
New York

Lile R. Gibbons
Connecticut

Marilyn S. Grossman
District of Columbia

LaDonna Harris (Comanche)
New Mexico

Dawson Her Many Horses (Sicangu Lakota)
Nevada

Summerly Horning
New York

Zackeree Sean Kelin (Caddo Nation) and Maria Bianca Garcia Kelin
New Mexico

Natasha Maidoff
California

Gina McCabe (Hualapai) and Sean McCabe (Navajo Nation)
New Mexico

Paul Moorehead
District of Columbia

Lori Nalley (Muscogee Creek Nation)
Oklahoma

Susan Napier
California

Brenda Toineeta Pipestem (Eastern Band of Cherokee)
Oklahoma

Clara Lee Pratte (Navajo Nation)
District of Columbia

Robert Redford
Utah

Robert W. Roessel (Diné)
Arizona

Alice N. Rogoff
Alaska

Angie Yan Schaaf and Gregory Schaaf
New Mexico

Shelby Settles Harper (Caddo Nation)
Maryland

V. Heather Sibbison
District of Columbia

John Snider
Pennsylvania

Joan and Marx Sterne
Virginia

Ernest L. Stevens, Jr. (Oneida Tribe of Wisconsin)
Wisconsin

Jerry C. Straus
District of Columbia

Tishmall Turner (Rincon Band of Luiseño Indians)
California

Jeff Weingarten
District of Columbia

Leslie A. Wheelock (Oneida Tribe of Wisconsin)
District of Columbia

3. Kay WalkingStick, 1995.

As children we learned from the Westerns that the bad guy wears the black hat, the good guy the white. These visual cues separated good and evil in the movies, but our human tendency to categorize and simplify doesn't translate well to the real world. We make real people flat and two-dimensional, stripping them of their complexity and diversity. Those same cowboy movies gave us the celluloid stereotype of Indians as well: bedecked with feathers, all seemingly of one tribe, one language. Flat, archaic, unreal.

Yet this script in many ways still stands as our national narrative: the dream of the West is the story of America; the Indian is the past. Countering this misrepresentation fuels our mission at the National Museum of the American Indian (NMAI) and drives our goal to add a third dimension to national and international ideas of Native peoples. By rewriting the script, we hope to break open the simple box to which Indian people have been relegated and showcase the diversity of Native peoples past and present through their histories, scientific knowledge, and artistic expression. Who are contemporary Native people? The true story has nuance and intricacy. We are multitribal, multiracial; we work in all disciplines, at all educational and socioeconomic levels; we wear both black *and* white hats . . . and sometimes even feathers.

For more than four decades, Kay WalkingStick has been rewriting the narrative about Native peoples through her artwork, which has defied categorization. Feminist, and not. Modern, postmodern, and not. Native, and not. Seeming contradictions encapsulate WalkingStick's complexity. Over her long career, WalkingStick has forged an artistic identity that reflects the times in which she has lived and the influence of encountered beauty, both in the United States and abroad. Her artworks are intrinsically linked to her life experiences; they are her autobiography. In them she is wife and mother, joyous and aggrieved, at peace and angered, in Italy, New York, New Mexico, wearing any color hat she wishes. To carry forward co-curator David W. Penney's metaphor of a "stereo view" in reference to her paired diptych paintings, WalkingStick's two-dimensional works adopt a multidimensional meaning in relation to her own life story. Her resistance to categorization is part of being a contemporary American Indian and is what makes her an American artist.

From the time we opened our doors on the National Mall, the NMAI has made a commitment to contemporary art in Washington, DC, and to recognizing influential and accomplished Native artists through major exhibitions. We inaugurated that journey with Allan Houser (Warm Springs Chiricahua Apache, 1914–1994) and George Morrison (Grand Portage Band of Chippewa, 1919–2000) in 2004, and have since shared the talents of other great American Indian artists, both recognized and established, such as Fritz Scholder (Luiseño, 1937–2005), and acclaimed and midcareer, as Brian Jungen (Dunne-za, b. 1970). Furthering this commitment, the museum is pleased to honor the legacy and life of Kay WalkingStick.

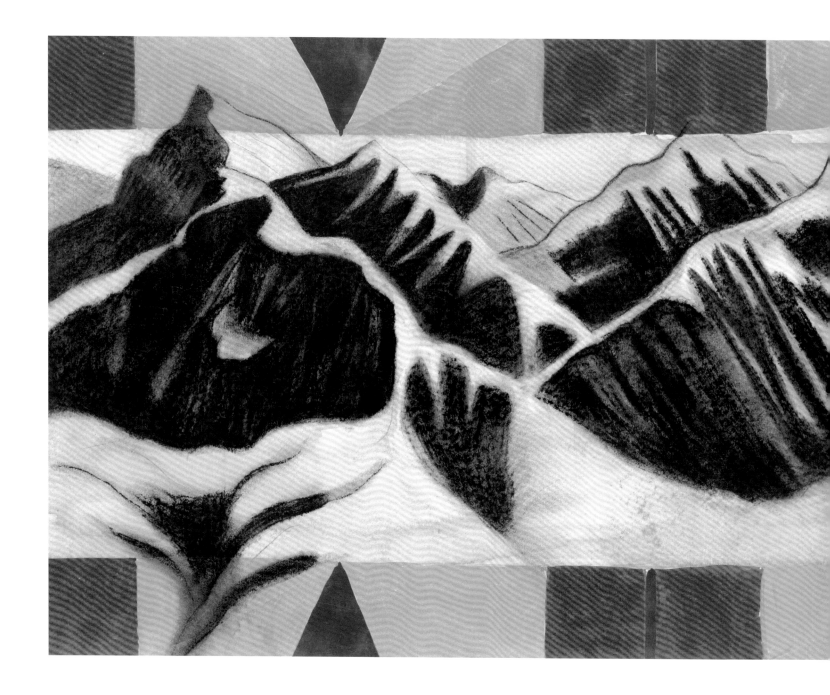

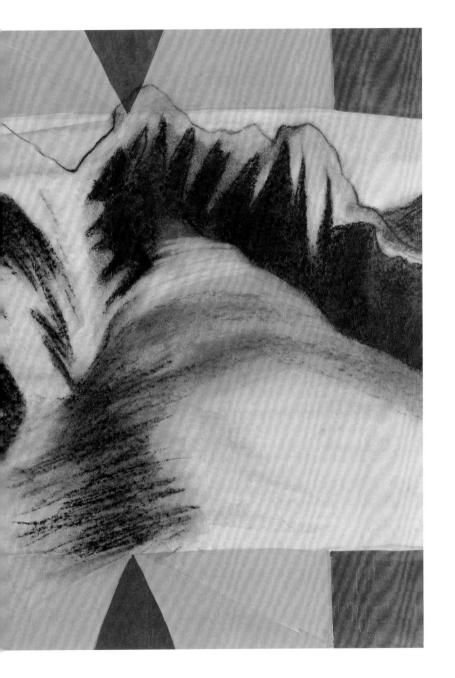

Our sincerest appreciation goes to the artist, who has been working closely with our curators on the exhibition and catalogue, and her gallerist, June Kelly of June Kelly Gallery, New York, without whom our exhibition would not be half what it is, both having contributed numerous works from their collections. Additionally, we extend gratitude to the National Council of the National Museum of the American Indian for their generous support of this extraordinary publication, the first major work on Kay WalkingStick. Finally, we are honored to have the support of the American Federation of Arts, New York, Suzanne Ramljak, its curator of exhibitions, and Shira Backer, curatorial assistant, who will coordinate the travel of this exhibition, thus sharing WalkingStick's legacy nationwide. These individuals and organizations, with the further support of the lenders, authors, and Walkingstick family, join us to ensure that this great artist's legacy will continue to impact American art for a long time to come.

Kevin Gover (Pawnee)
Director, National Museum of the American Indian

4. *Wallowa Mountains, View of Home,*
2003. Charcoal, gouache, and
encaustic on paper, 25 x 50 in.
Collection of the artist, courtesy of
June Kelly Gallery.

ESSENTIALLY AMERICAN

Kay WalkingStick is probably the best known and most celebrated artist of Native American ancestry working today. Unfortunately, those today who know and celebrate Native American artists add up to a modest few. She is known among her peers as a prolific "painter's painter"— more than forty years of work are represented in *Kay WalkingStick: An American Artist*. Her colleagues and students also recognize her as skilled mentor and teacher, who served on the faculty of the Cornell University fine arts program and others for two decades. At this moment, as WalkingStick has reached her eightieth birthday and the full scope and range of her life's accomplishments can be sensed and surveyed, the curators of this exhibition and authors of this publication wish to expand popular awareness and critical understanding of Walking-Stick's artistic accomplishments. Part of the challenge in doing so has been facing the rather narrow way that Native American artists have been understood and discussed by critics and art historians. The ghettoization of Native art, to express it baldly, when exhibited in exclusively Native artist shows or interpreted solely in terms of Native identity politics or with Native cultural referents, has long constrained the critical reception of Native artists, particularly those of WalkingStick's generation. As an antidote, this exhibition and companion catalogue seek to broaden that restrictive view by considering WalkingStick's work from multiple viewpoints. While Native themes visible in many of her works celebrate heroic Native leadership with stately, abstract compositions or recast American landscapes as Native places, WalkingStick's painting originates from her engagement with the advanced artistic considerations generated in New York City during the 1960s and early 1970s, which provided a foundation for all the work that came after.

Her standing as an important and influential Native artist emerged nationally and internationally during the mid-1980s to early 1990s. From the standpoint here, nearly thirty years later, it may be difficult to resurrect the excitement and controversies of that heady time when WalkingStick's accomplishments were thrown into such high relief. Coincidentally, both of the curators for this exhibition experienced their first meaningful encounters with her work in 1990. David W. Penney was in the audience at a groundbreaking panel organized by art historian W. Jackson Rushing for the 1990 College Art Association conference in New York City, titled "Institution/Revolution: Postmodern Native American Art."[1] WalkingStick's illustrated address, "Contemporary Native Art: A View from the Inside," included a slide of her crimson-dominated diptych of 1989, *The Abyss* (fig. 75), among other works.[2] Surely, few of the many who crowded into the Hilton's large ballroom for the occasion had heard of Kay WalkingStick, or Jimmie Durham (b. 1940), who was featured in a presentation by British art historian Jean Fisher, or many of the other artists who were discussed. The idea of sophisticated Native artists contributing to and leading the most advanced revisionist thinking in the art world of that day was something new and exciting for some, if provocative for others.

Kathleen Ash-Milby's first introduction to Kay WalkingStick's work was in another groundbreaking project held that same year, titled *The Decade Show: Frameworks of Identity in the 1980s*.

5. *Hudson Reflection, III*, 1973. Acrylic on canvas, 40 x 48 in. Collection of Joy Walkingstick Couch.

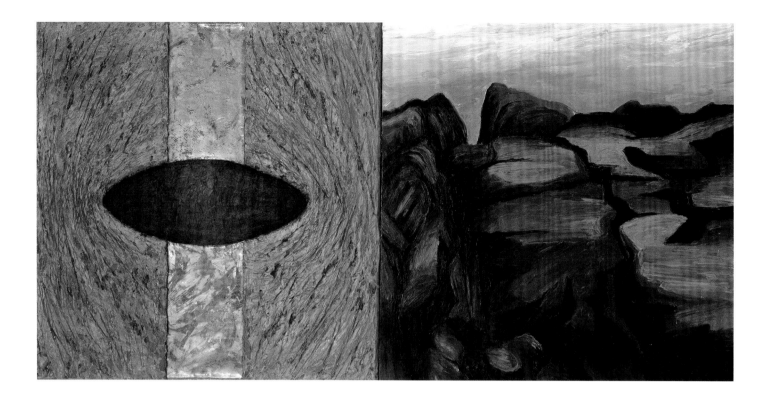

9. *Remnant of Cataclysm*, 1992.
Acrylic, saponified wax, oil, and
copper on canvas, 28 x 56 in.
Collection of the artist.

nique that traces a route through Duccio (ca. 1255–ca. 1318), Édouard Manet (1832–1883), and
Marsden Hartley (1877–1943) and created an impressive body of work that keeps coming. She
continues to focus on the emotional and cultural resonances of American places, particularly
in her long-term engagement with the epic land forms of the American West and its visual
traditions. Her passion for landscape reemerged during a residency and semester teaching at
Fort Lewis College in Durango, Colorado, in 1984, where experiencing the Colorado Rockies
compelled her to return to the subject of landscape in her work, after more than a decade of
abstraction. Her most recent paintings, from 2012 to the present, still hew to the horizontal
diptych format of two side-by-side panels, but she now unabashedly revels in the sheer beauty
of the land, allowing her representational imagery to spill across both panels entirely. Rather
than separate abstract designs that connect these places to the Native people who have inhab-
ited them, her patterns now float upon the surface.

We have asked a number of scholars and colleagues to tell the complex story of more than
four decades of Kay WalkingStick's career. The organization of both the exhibition and this
publication is primarily chronological; WalkingStick's development as an artist can be divided
into distinct periods, especially early in her career, where particular themes emerge. Also essen-
tial to understanding the nuances in her work is her underlying biography. While the artist
does not wish her art to be defined by the details of her life story, these experiences neverthe-
less offer insight into the evolution of her work over time. To this end, Kathleen Ash-Milby
introduces WalkingStick's legacy with a biographical essay that details the artist's family's his-
tory as well as her life story to the present. It is complemented by an essay from WalkingStick's
daughter, Erica WalkingStick Echols Lowry, who provides a passionate memory of a formative
time with her mother, and a chronological timeline for reference.

Carrying forward WalkingStick's life/art story, Kate Morris offers a detailed account of the
artist's early work, beginning with her sensuous renderings of nude bodies, which are soon
abandoned for a decade of near obsession with the geometry of abstraction. The arc, both a
symbol and simple shape, repeat fugally throughout this intense period of artistic growth,

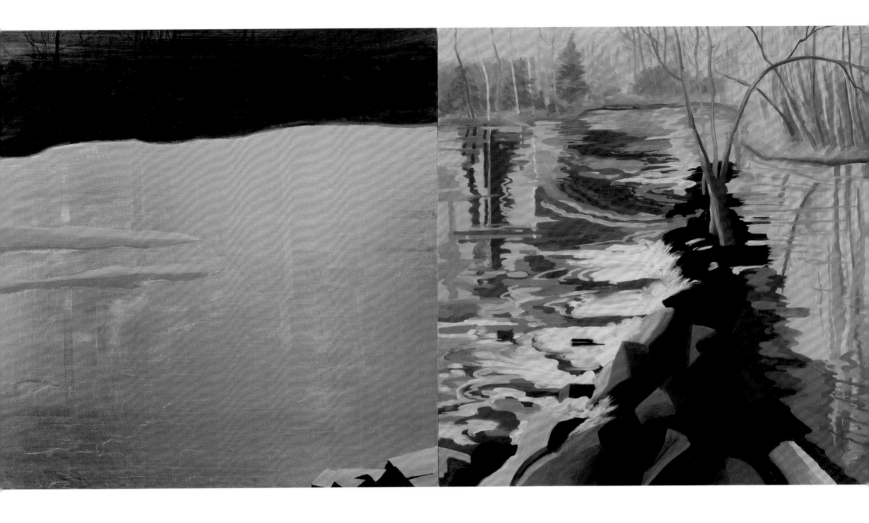

10. *Autumn's End*, 2009. Oil and aluminum leaf on wood panel, 32 x 64 in. Collection of the artist, courtesy of June Kelly Gallery.

which includes the creation of one of her most well-known and iconic works, the *Chief Joseph* series (1974–76). (It is worth noting that the significance of this work has resulted in its inclusion by several authors, offering different perspectives, throughout this publication.) David W. Penney addresses the development of the body of work that has come to define Kay Walking-Stick—the diptych. It was in the mid-1980s that the artist merged her passion for the landscape with her deep interest in abstraction within this format. Penney challenges previous readings of her use of diptychs as merely reflective of her biracial identity and mines the metaphysical subtleties at play throughout.

During the early 1990s, WalkingStick was invited to participate in several group exhibitions rooted in expressing Native identity and presence. Margaret Archuleta revisits the works that focus most explicitly on tragic Native historical events and her own Cherokee identity. Although WalkingStick is strongly associated with an influential group of artists whose work rose to prominence in the Native contemporary art scene during the 1980s and early 1990s, including the Native artists who participated in *The Decade Show*, in addition to Kay Miller (Métis/Comanche, b. 1946), Harry Fonseca (Nisenan/Maidu/Hawaiian/Portuguese, 1946–2006), Emmi Whitehorse (Navajo, b. 1956), G. Peter Jemison, and Jolene Rickard (Tuscarora, b. 1956), it is important to recognize that she entered this cohort as a mature artist. Cherokee and other American Indian social and material cultures and histories have never been WalkingStick's only cultural inspirations. For example, Judith Ostrowitz discusses the influence of Western art on Kay's artistic development through artists such as Manet, as well as historic painting tradi-

tions from Italy and India. Lisa Roberts Seppi's essay takes the examination of WalkingStick's Italian sojourns further, delving into the profound influence that living and working in Italy had on WalkingStick's art, beginning with her first trip to Rome in 1996. The work she made in Italy reveals her deep struggles reconciling the spiritual and corporeal through her art, themes found throughout paintings of the Italian Renaissance.

Several authors were invited to explore a particular artwork or theme. Miles R. Miller, a Yakama artist and museum professional, details his unexpected experience with a particular work and its connection to a place within his own family narrative, while art historian Jessica L. Horton offers detailed insights into the sensorial depiction of dance within the *ACEA* series. Lucy R. Lippard's reflections transcend any particular time period, instead providing an overview and exploration of WalkingStick's treatment of landscape over the course of her career. Specifically, Lippard delves into the symbolic and metaphorical meaning of land in her most recent paintings. We cannot understate the influence that WalkingStick has had on her artist colleagues and are grateful that Robert Houle, whose career as an artist, curator, and scholar has intersected with WalkingStick throughout, provides a passionate essay about WalkingStick and how she inspired him as a fellow painter.

While it is possible to look at WalkingStick's work through a variety of lenses, it is also important to include the invaluable perspective of the artist herself. Despite the interpretation of her work at times as expressionistic, the artist considers her work to be quite analytical in planning and process. To this end Kay WalkingStick provides a rare, in-depth account of her process that reveals her methodical approach and respect for the traditional craft of painting. Despite this painstaking attention to technique, her narrative also belies her underlying passion and fascination with the materials themselves, thus illuminating this seeming contradiction in interpretation.

Kay WalkingStick is a multidimensional artist who cannot be essentialized as a feminist or Native artist alone. Her work is far too complex in its origins and inspirations, as is the painter herself. The curators and authors herein have positioned WalkingStick's work where it really belongs, within a canon of American art. It is difficult to define it in any other way, with her roots in American modernist painting, her engagement in the postmodernist interrogations of the late 1980s and early 1990s, her passion for landscape painting, and her personal connections to Native American history and Cherokee ancestry on the one hand and her non-Native family of artists on the other, some of whom trace their ancestry to early settlers of New England in the 1600s.[25] WalkingStick's life's work reminds us of issues raised in 1990 by *The Decade Show*, but perhaps too neglected since. As the artist wrote at the time, "This is who we Americans really are. All different, all the same, all in it together, making art."[26]

11. Kay WalkingStick, 2014.

A LIFE

Kay WalkingStick's life story has been a source of fascination and speculation over the course of her entire career. Naturally her name draws attention; moving in sophisticated urban and academic circles in the Northeast, one doesn't usually come across someone with a name like WalkingStick. Though the name is prominent in Cherokee history, she didn't dress or play the part of Indian to prove who she was; it was a simple fact of her biography and her identity. As Jimmie Durham so aptly observed, "She herself has refused all of the easy comfort of colonial identity and has opted for the much harder, more rewarding, and more real and 'traditional' path of integrity through her discipline."[1]

An artist's biography can provide a window into their art but can also narrowly define or restrict how their work is interpreted. Furthermore, the amplification of small facts can obscure the depth and complexity of a real life. Kay WalkingStick is an artist with a complicated, rich, and intriguing past full of both joy and heartbreak. Like all artists, her life and art never existed entirely separately from each other; her life story is entwined with her work. Though it may risk eclipsing their artistic accomplishments, an artist's personal history can also deepen our understanding and appreciation of his or her body of work over time.

The beginning of Kay WalkingStick's story, of the person and her Cherokee identity that is so ingrained in her art, starts with her family history. The Walkingsticks are a storied family who can trace their Cherokee lineage to the 1830s. Her great-great-great-grandparents, James and Susie Walkingstick, with their son Ezekiel, were known as Old Settlers, indicating that they moved to Indian Territory, Goingsnake District (now part of Adair County, Oklahoma), before the forced relocation of the rest of the tribe in 1838 on what is known today as the Trail of Tears.[2] James Walkingstick was involved in the complex political affairs of his nation and opposed the signing of the Treaty of New Echota (1835), which ceded Cherokee land to the US government in exchange for the relocation of the tribe. In 1836, Walkingstick even accompanied Principal Chief John Ross to Washington, DC, to advocate for the repeal of the treaty. Another of Kay's ancestors, Archibald Scraper (ca. 1820–1904), did travel the Trail of Tears. Scraper was similarly active in Cherokee politics, having served as a Cherokee senator and traveled to Washington with several delegations.[3]

James Walkingstick's descendants, including his great-grandson (Kay's grandfather) Simon R. Walkingstick (1868–1938), continued to be active citizens. S.R. Walkingstick was involved in tribal leadership and served as a Cherokee senator and advocate for the creation of an "Indian state" in 1897.[4] He was actively involved with the implementation of the Dawes Act as a clerk, acting as an interpreter and encouraging Cherokee citizens to enroll.[5] He also became one of the first American Indian attorneys to practice law in both tribal and non-tribal courts in Oklahoma and Arkansas.[6]

12. Kay WalkingStick and Erica Echols, photographed for the newspaper *Suburbanite*. Englewood, New Jersey, 1966.

25

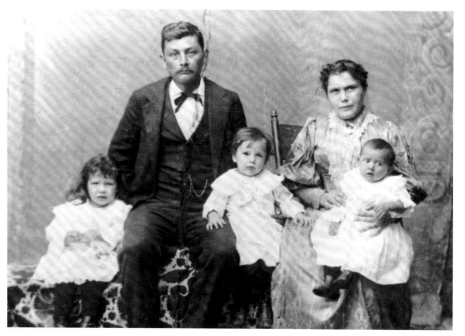

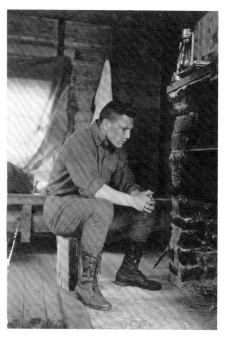

13. Simon Ralph Walkingstick, Sr., and Sallie Viola Orsborn (ca. 1874–ca. 1903) with their children Ada Sallie (1895–?), Simon Ralph, Jr. (1896–1970), and Celeter (1897–?), ca. 1898. Not pictured: Bruce (1899–1970).

14. Ralph Walkingstick, ca. 1917.

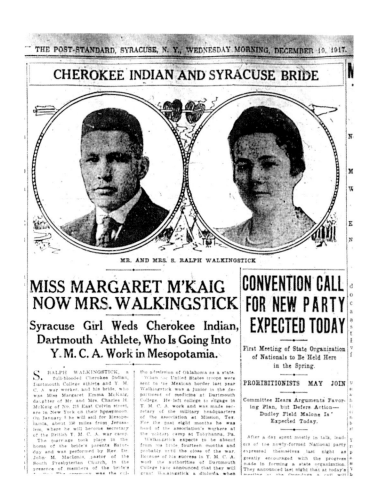

15. "Cherokee Indian and Syracuse Bride," *The Post Herald Syracuse,* Wednesday morning edition, December 19, 1917.

With this auspicious heritage, it was probably expected that Kay's father, Simon Ralph Walkingstick, Jr. (1896–1970), known by his middle name, would follow in his family's footsteps and attain an important leadership position in government or industry. Though his young life was promising, his legacy ultimately fell far short. The second of four children from his father's marriage to Sallie Viola Orsborn (1874–1903), a non-Native Midwesterner, Ralph was only six years old when his mother died (fig. 13).[7] He also grew up with several step-siblings from his father's second marriage.[8] After attending an Indian boarding school for several years in Tahlequah, Oklahoma, he began his undergraduate work at Dartmouth College in 1914 (fig. 14).[9] He became active with the Young Men's Christian Association (YMCA) in 1916 and met his future wife, Margaret Emma McKaig (1898–1967), also known by her middle name, on a train while she was returning from visiting her grandmother in Philadelphia. He withdrew from Dartmouth in the spring of 1917 after his appointment as a secretary of the YMCA International Committee, which worked to support troops during World War I and was attached to the British Army.[10] The local paper in Syracuse, New York, virtually crowed their marriage announcement in December 1917 with the headline, "Cherokee Indian and Syracuse Bride" (fig. 15).

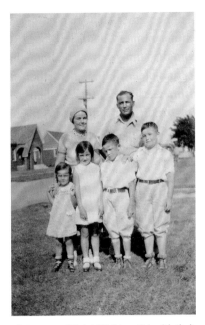

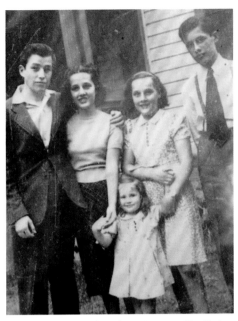

16. Emma and Ralph Walkingstick with their children (left to right) Joy, Betty, Charles, and Syverston. Muskogee, Oklahoma, ca. 1931.

17. Kay and Joy Walkingstick. Syracuse, New York, ca. 1937.

18. Sy, Betty, Joy, Mack, and Kay. Syracuse, New York, ca. 1938.

The McKaigs, of Scottish and Irish descent, had moved to Syracuse from Philadelphia where Emma's father, Charles Henderson McKaig, worked in the jewelry business.[11] Soon after their marriage, Ralph left for a series of international appointments in India, England, and Mesopotamia, not returning to the United States until 1919.[12]

Despite the local fanfare at their wedding, a fairytale marriage was not in the couple's future. After the initial two years apart due to Ralph's work with the YMCA, he transferred to a position in Muskogee, Oklahoma, where he and Emma began to raise a family. Their first four children were Syverston "Sy" (1920–1945), Charles "Mack" (b. 1922), Elizabeth "Betty" (1923–2015), and Joy (b. 1927) (fig. 16). Soon after returning to Oklahoma, he began working in the oil industry, including as a geologist for the Tide Water (Tydol) Oil Company, traveling frequently throughout the state. Joy recalls her mother as a "lovely, lovely woman" who sang every morning, despite raising her children virtually alone while suffering the privations of the Depression. The children do not have fond recollections of their father; Ralph's drinking and rages led them to hide from him whenever he returned home.[13]

In late 1934, while pregnant with her fifth child, Emma made the drastic decision to leave her husband. Her sister was able to send some money so that Betty could leave first, traveling by bus to live with family in Syracuse. At this time, Sy and Mack were young teenagers and Betty and Joy were still elementary age. Emma was able to leave soon thereafter, and Margaret Kay WalkingStick was born in Syracuse on March 2, 1935. After Kay's birth, Emma and her sister, Lillian McKaig, who was single and still living with their parents, decided to move in together. Despite the size of their combined family, they were happy to be living in relative comfort in a small two-bedroom flat in a two-family house.[14] To support the family during Kay's early childhood, Emma took in ironing and other housework and Lillian worked as a church secretary. The group was an intimate unit of perseverance, and Kay the adored and coddled child who had been spared the hardships of life in Oklahoma (figs. 17, 18).

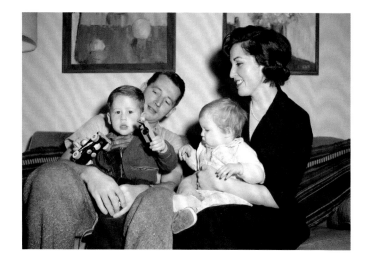

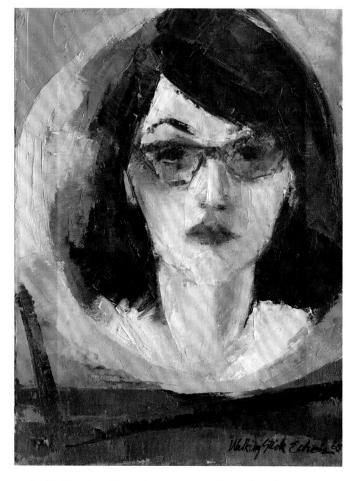

22. Kay WalkingStick with David, Michael, and Erica Echols. Englewood, New Jersey, 1963.

23. *Self-Portrait*, 1965. Oil on canvas, 12 x 16 in. Collection of the artist.

after decades of separation. The couple moved into an apartment in the summer home of Kay's sister, Betty Theobald, and Betty's family in Cape May Point, New Jersey. Sadly, within a few years Emma was diagnosed with cancer and moved, without Ralph (the couple had separated again), back to Syracuse, where her daughter Joy cared for her until her death in 1967. Kay's father passed away in Wildwood Crest, New Jersey, in 1970.

Maintaining her artistic practice during the 1960s and early 1970s while balancing the needs of her young children and expectations of her family was a challenge for Walking-Stick. At one point, after using the kitchen or spare bedroom as a studio in a series of apartments, she rented space in an office building in Teaneck, New Jersey, to get away and paint. She would occasionally leave her children with a sitter so that she could visit art galleries in Manhattan with an artist friend, Rachel Friedberg (b. 1929), a practice that confused and confounded people with more traditional expectations of young mothers. Yet her husband was warmly supportive of her identity as a practicing artist, and her children do not remember her as a distracted mother but as artistic, fun, and joyful. Her son, David, recalled of his childhood, "I remember being fascinated with her process and thinking that I had this special, secret knowledge about how she built her paintings." From the time he was a young child, he knew she was unlike other mothers, but was (secretly) proud of this difference. Art was always part of their lives: looking at art, visiting museums, and taking art lessons. While they learned to have fun with it—a painting by WalkingStick titled *David's Room* (1980) was inspired by his nasal explorations, smeared expressionistically on his wall—it was also treated as serious and thoughtful practice.[19] WalkingStick was not conventional; she continued to use her maiden name, an uncommon practice at the time. She was a mother but still an artist and, like many other women of her generation, sometimes struggled with reconciling the two roles.

While she would never claim to be a feminist per se, WalkingStick's art and life were infused with and invigorated by women's rights and interests, what she refers to as the women's liberation movement. At the time, the term "feminism" to her equated with an overtly political movement that she did not identify with. While she never considered herself an active feminist because she was just "too busy with her children and her career" to be political or deeply involved in the movement, she joined a few women artists' groups that met in Manhattan. She felt she was not taken seriously,

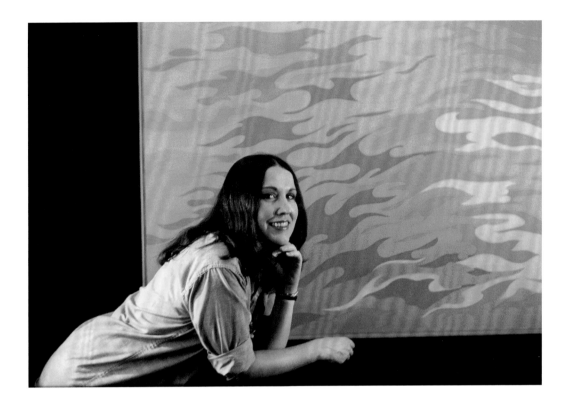

however, because she "bore the stigma of the suburban housewife" with children to raise and a happy marriage. Yet she still faced the same challenges as other women artists in a male-dominated profession: galleries routinely dismissed her because of her gender.[20]

WalkingStick chose to express herself more through the way she lived her life than overt activism. Paintings from this time, such as *Me and My Neon Box*, which her niece, Betsy Theobald Richards fondly recalls hanging among the many paintings in Kay and Michael's home (fig. 41), were unabashed explorations of sensuality and sexuality (see Morris, this volume). "Aunt Kay was that person who gives you permission to live and love to the fullest," said Richards. "She refused to be boxed in" and was artistic in everything she did, such as when she saw a beautiful red pepper, for instance, and attached it to the band of her hat. "My aunt taught me that it was possible to be a woman of power, do it with grace, as a lady, and with love."[21] WalkingStick's persistence and professional networking paid off: she held her first solo exhibition at Gallery 267 in Leona, New Jersey, and her first exhibition in New York City at the Cannabis Gallery in 1969, the latter receiving a positive review in *ARTnews*.[22]

WalkingStick continued to exhibit her work in the early 1970s while cultivating a teaching career (fig. 24). She periodically taught as a substitute in the public school system and in other temporary positions and eventually accepted a part-time art appointment at Edward Williams College in Teaneck. She also applied for and received a one-month artist residency at the McDowell Colony in Peterborough, New Hampshire, in 1970 and again in 1971, which was both an exciting opportunity and a challenge. Though David and Erica were getting older, managing the time away from home was a strain on her marriage. Despite the added stress, the residencies were clearly a personal turning point. She chose to give more serious attention to the development of her art and so applied to graduate school: "I had felt the need for years and was ready to act."[23] She received a Danforth Foundation Graduate Fellowship for Women to

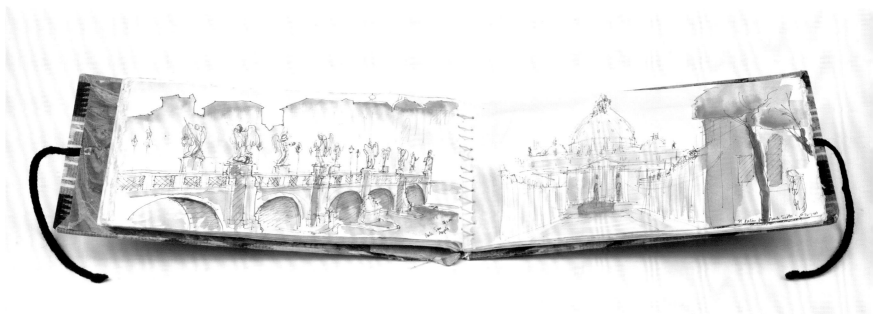

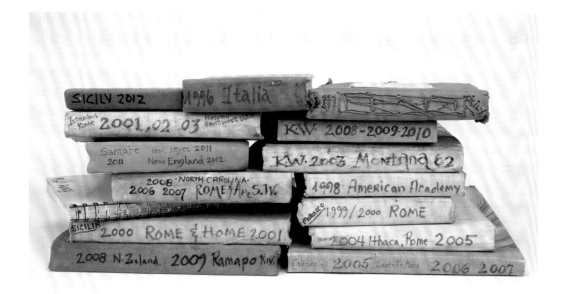

29. Detail of sketchbook
(Morocco/Rome), 1999–2000.
7.5 x 13.5 x 1.25 in. Collection
of the artist.

30. Sketchbooks, 1996–2012.
Collection of the artist.

31. *Over Lolo Pass*, 2003. Charcoal, gouache, and encaustic on paper, 25 x 50 in. Collection of the artist, courtesy of June Kelly Gallery.

32. *October 5, 1877*, 2003. Charcoal, gouache, and encaustic on paper, 25 x 50 in. Collection of the artist, courtesy of June Kelly Gallery.

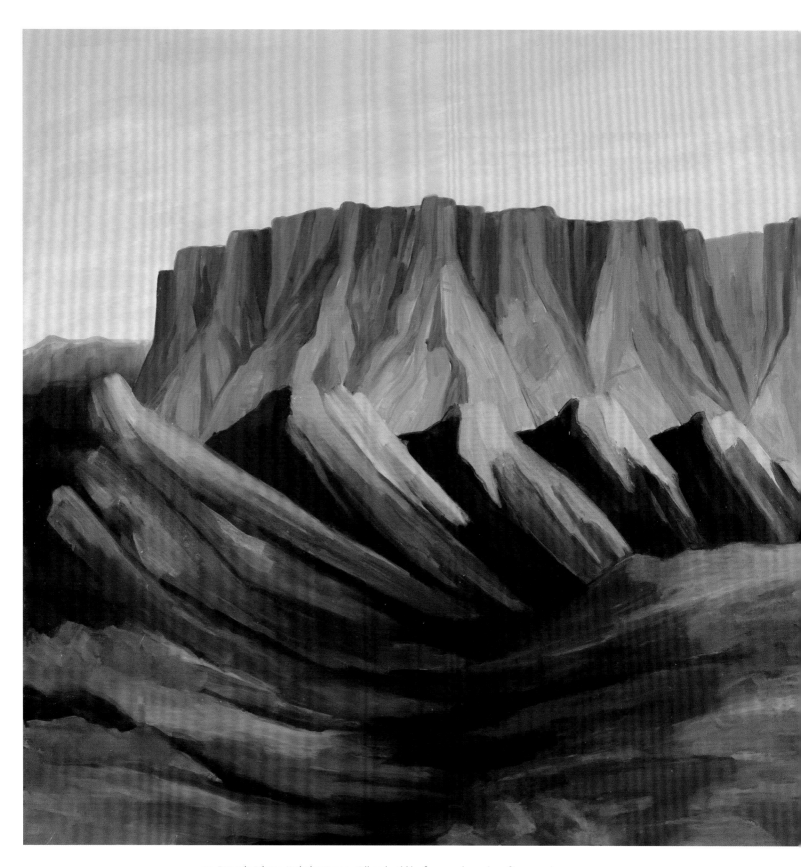

33. *Danae in Arizona, Variation II*, 2001. Oil and gold leaf on wood panel, 35.81 × 71.75 in.
Munson-Williams-Proctor Arts Institute Museum of Art, Utica, New York. 2002.20.a–b

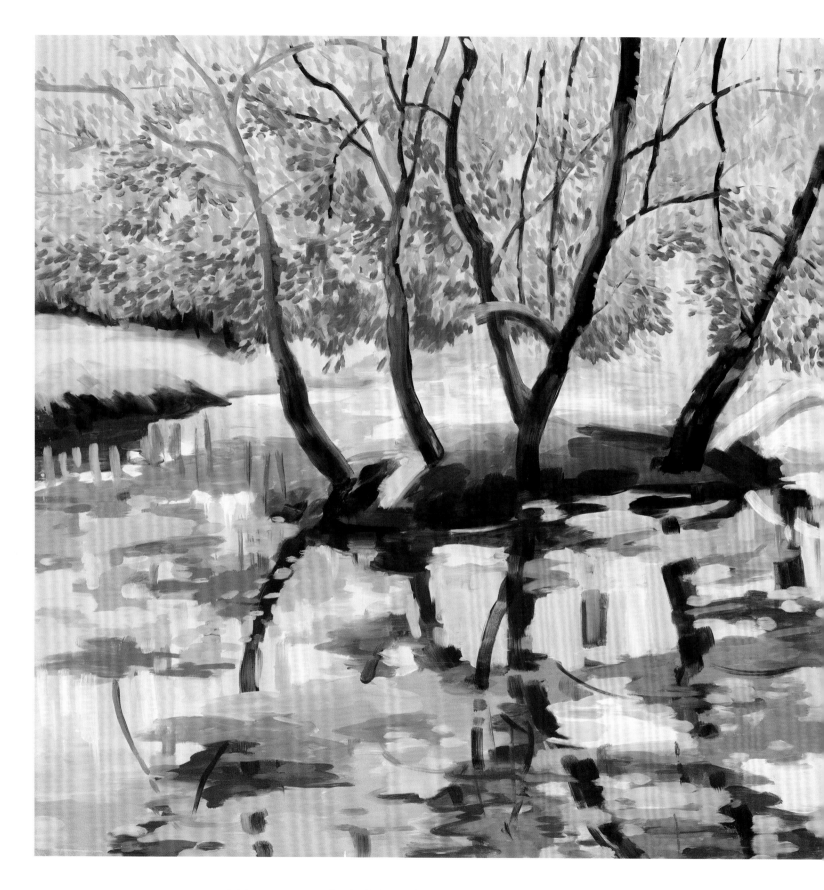

36. *July Low Water*, 2010. Oil and palladium leaf on wood panel. 24 x 48 x 1 in. Collection of the artist.

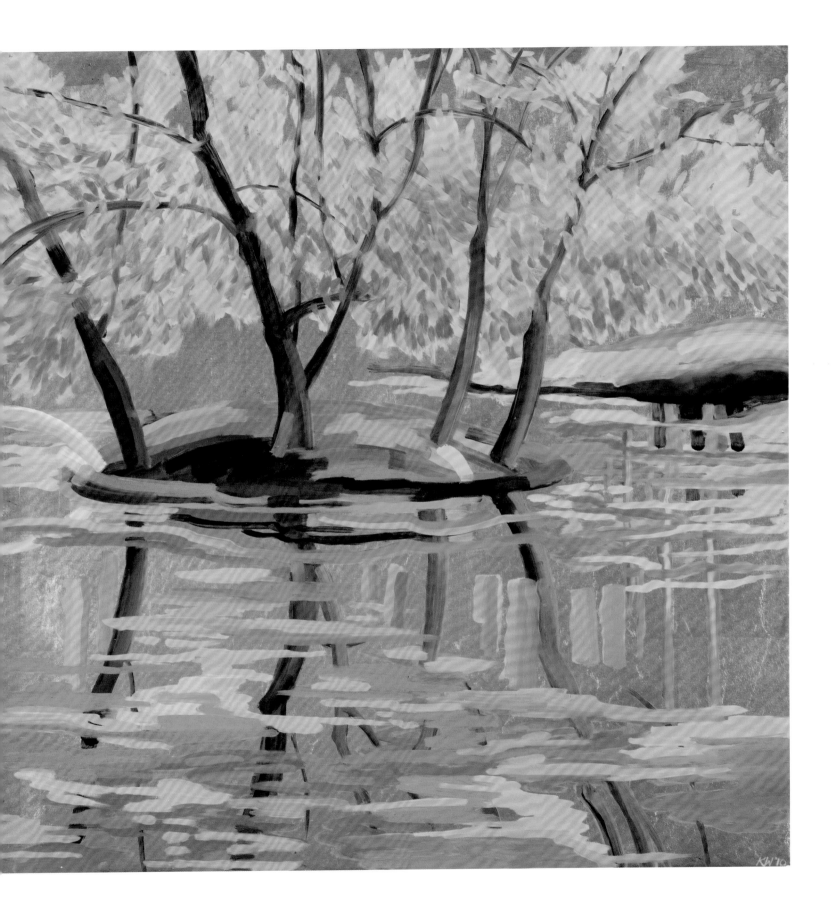

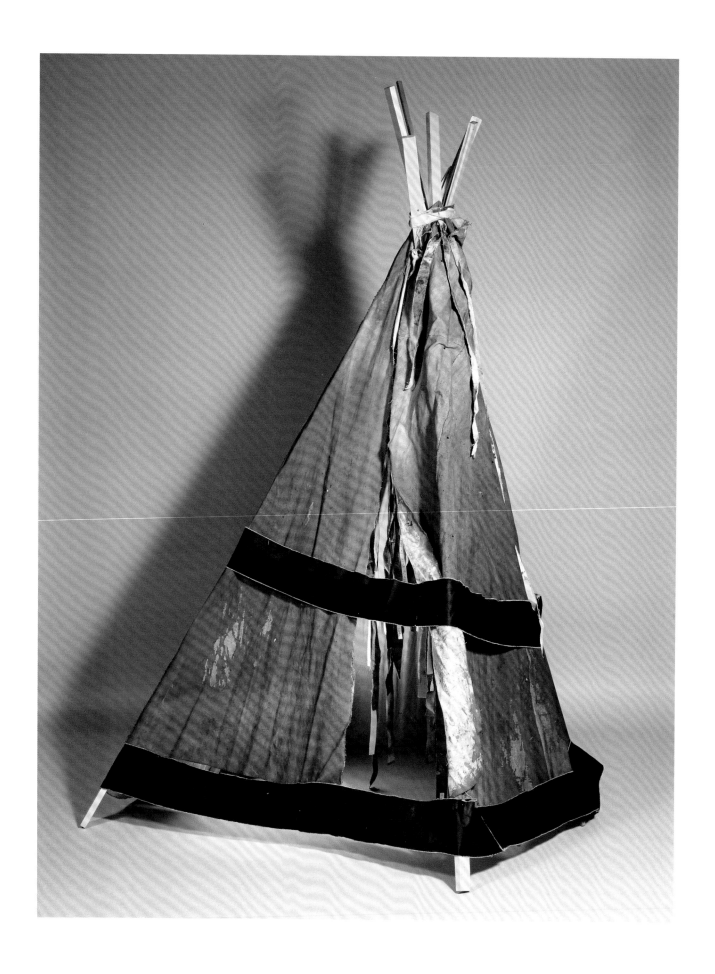

SPRING 1974

There was an exorcism going on. The way it happened, I felt like one of the quiet angels you see in paintings, with soft hands. I woke up one morning to find in our backyard a giant tipi made of raw canvas, painted by my mother (I wonder whatever happened to that tipi?)—and Mama didn't explain it (fig. 37). It was strange to see it there, in our prim backyard, next to Mama's hybrid tea rose bushes. Her father had died—the one who'd shot a bullet into a wall—the grandfather whom I'd never met, but had seen pictures of—so very handsome. The horrible drunk. The tipi—a memorial, I suppose—was enormous; I could have stood up inside it but didn't dare, because I knew it was something like a personal church and I didn't know the prayer. I peeked inside and saw dozens of strips of feathery canvas hanging from the ceiling, covered with words that I couldn't read. It was the Lord's Prayer, written in Cherokee.

In the 1970s, nothing was settled, anywhere. While Mama made a three-course dinner and fancy dessert every night, attended graduate school, worked part-time, sewed our clothing and curtains, and made many of my brother's and my toys, it was Vietnam everywhere, the Beatles were still the only viable answer, and always playing—"Here . . . come . . . the . . . Sun . . . King"—and Mama was painting like the world would soon end if she didn't paint. I swear I thought the world would indeed end if Mama didn't paint. The world was in fact coming loose and desperately trying to find some way to mend, with no mending in sight. But Mama herself was a solid-flying structure, with memorably wide feet, and determined to fly as well as she possibly could above whatever fray it was, or disarray, taking the fray right along with her, forming it into something that could truly mean something. Her life, and therefore mine, was absolutely going to mean something. She always insisted, "persistence will out," and she obviously meant it, while she also said to me, unaware of any high bar, "be the best, or don't bother." There really was no other actual solution to anything in one's life than the combination of the two—persistence and extremely ambitious dreams—and I suppose that was certainly so for the world just then, as it may still be.

That night of the tipi (I was twelve), I dreamed that my mother would paint arcs. A straight, taut line, with another line loping from one tip to the next. It was such a powerful dream, because the shape seemed to embody her. It was like a spiritual lozenge, entirely encompassing her, and entirely swallowed by me. It described the shape of my mother's being, which described me, as well: part hard, part soft; part no, part yes; part direct, part dilute. Part real and known, part not knowing what real is.

To my astonishment, she started to paint arcs. These arcs were the negative space formed by the outward shape of the tipi; the shape formed by canvas, draped over the slanted beams. When she pointed this out to me, it made logical sense, but I felt in my knees that the shape was something much more, that nothing could describe the shape, or mean what the shape

37. *Messages to Papa*, 1974. Acrylic, ink, canvas, wood, and paper, 8 x 6 ft.; no longer extant.

45

38. Detail, *Messages to Papa*, 1974.

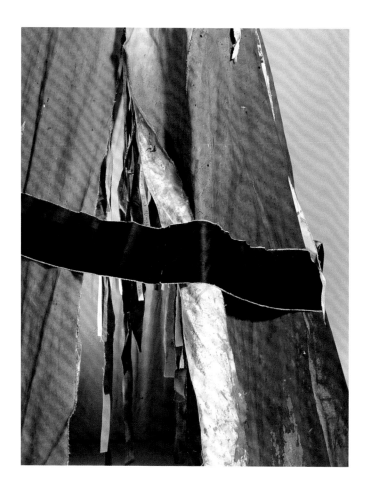

meant but the shape itself (I later likened it, in my own head, to Wallace Stevens's description of how a word is felt inside your tongue). If nothing means anything but the experience of it, this arc was a primal experience. So Mama spent years painting that shape out of her system. She painted painting after painting of that arc. Arc, arc, arc, arc. Arc, arc, arc. They were paintings that looked carved or clawed away, or pounded away, or rubbed away, that resulted in an improbably serene, solemn series she dedicated to Chief Joseph—who became to her like a good and honest father, for the time being.

Those paintings remind me of gravestones.

The exorcism of fate is what was happening. She was in the middle of doing a great undoing, on her part, for women of that era, for women artists, for Native Americans, for middle-class working mothers, and, mostly, for her own spirit. That arc was the thing. She forgave the unforgiveable and defied gravity, through a straight line and a curved one.

39. *Chief Joseph*, 1974–76 (panel 1 of
a 36-panel series), Acrylic, ink, and
saponified wax on canvas, 20 x 15 in.
National Museum of the American
Indian 26/5366.000

40. *Self-Portrait*, 1970. Acrylic
on canvas; no longer extant.

WHAT LIES BENEATH
SACRED GEOMETRIES, 1970–83

"It was always important to me to be recognized as a Native person. It was also important to be understood as a New York artist, one who was working in the mainstream."

—Kay WalkingStick, 2014

In 1970, Kay WalkingStick stood at her easel to paint a self-portrait for Michael Echols, then her husband of more than a decade (fig. 40). WalkingStick was thirty-five years old and wouldn't even begin her graduate career for another three years. Yet in the portrait she created we encounter an accomplished and assured artist, one whose command of the brush and of color, form, and composition are all reflected in the sitter's own air of confidence. After receiving her BFA in 1959, WalkingStick had painted steadily throughout the first decade of her marriage, exhibiting her work in galleries in New Jersey and New York City, and garnering positive reviews in the art press.[1]

In fact, WalkingStick had been painting and drawing since she was a child, and even though much of her earliest work is not extant, her meticulous records include volumes of slides of those pieces—portraits, still-lifes, and landscapes—which attest to her wide range of interests and "tremendous drive to make art all of the time." Keeping in mind WalkingStick's relentless commitment to challenging herself, to "always getting better," the period from just before her entrance into graduate school at Pratt in 1973 to her turn toward the diptych format that became such an important part of her work in the early 1980s is an immensely rich period in the development of her art, one in which she used her work to explore various aspects of her identity: as an artist; as a woman; as a wife, daughter, and mother; as a sexual being; and as a Native person. This was also a time during which WalkingStick was deeply engaged with the formal and intellectual developments of modernist painting and was conducting her own investigations into the physical properties of pigment and canvas, the depiction of figures in space, and the tensions between representational and abstract imagery. By the end of this period, WalkingStick had not only achieved her objective of imbuing minimalist forms with serious emotional content but had also developed an artistic vocabulary of archetypal imagery that has carried throughout her long career.

THE SHADOW SELF: FIGURAL WORKS, 1970–73
Self-Portrait (1970) is somewhat atypical of WalkingStick's work of the early 1970s in that the figure of the artist is so well defined; details of her outfit (a favorite hat replete with purple hatband, and a painter's apron which would later become ubiquitous in her work), her facial structure, and even individual strands of hair are delineated to convey the specifics of her identity and her seriousness of purpose.[2] As if to further underscore her identity as artist, Walk-

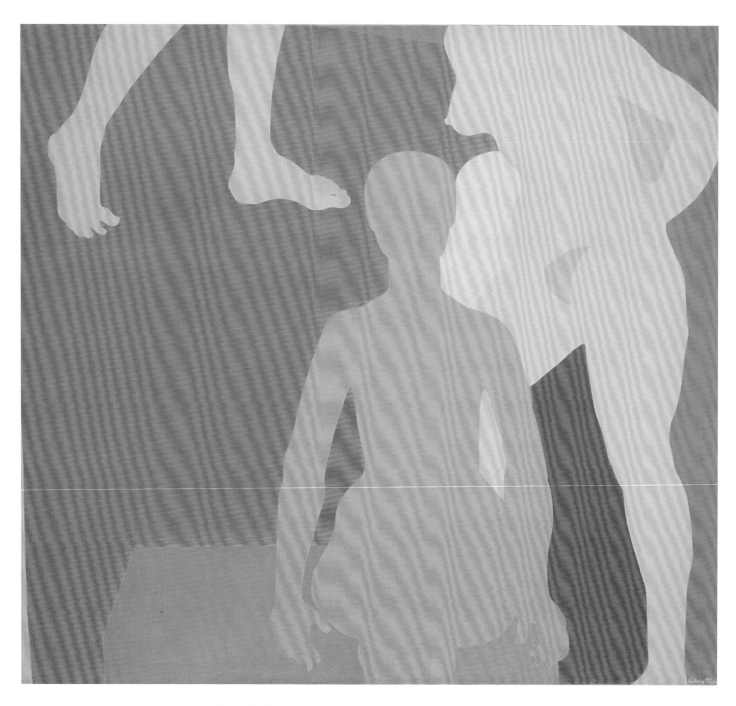

41. *Me and My Neon Box*, 1971.
Acrylic on canvas, 54 x 60 in. Col-
lection of the artist.

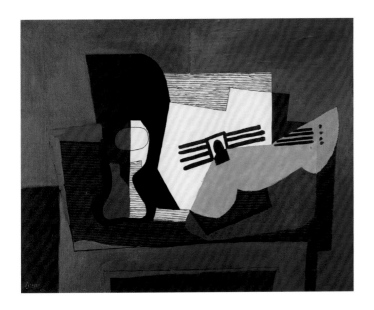

42. Pablo Picasso. *Nature Morte à La Guitare* (Still Life with Guitar), 1922. Oil on canvas, 32.67 x 40.36 in. Photo courtesy of the Rosengart Collection Museum Lucerne, Switzerland. © 2014 Estate of Pablo Picasso / Artists Rights Society (ARS), New York.

ingStick posed in front of one of her paintings, a reclining nude. The treatment of this nude differs slightly from the treatment of the subject and is more typical of her work in this period: the figure is a mere silhouette of a body, of equal mass or substance to the space that surrounds it.

If WalkingStick's intention in *Self-Portrait* was to convey a sense of her psychology as well as her identity as a painter, her rendering of the painting within the painting provides a near primer of her formal concerns in the medium. Looking back on this period forty years later, WalkingStick remarked, "It was the depiction of space and shape that interested me. I wanted something that was figurative.... I liked the idea of using figures in the painting, but I wanted to make a contemporary statement about figures in space."[3] In WalkingStick's view, contemporary space was compressed, flattened in a way that made only the slimmest use of Renaissance spatial devices such as shading and modeling, and linear perspective. The reclining nude of *Self-Portrait* is reduced to a silhouette to emphasize the flatness of the space it inhabits and thus underscore its modernity.[4]

The flattening of space is the hallmark of WalkingStick's representational style in the years immediately prior to her entrance into graduate school in 1973. *Me and My Neon Box* (1971), *Fantasy for a January Day* (1971), *April Contemplating May* (1972), and *Feet Series Arrangement* (1972) all feature silhouettes of figures or parts of figures, rendered in an array of candy colors against backgrounds that offer the barest hint of spatial context. *Me and My Neon Box* exhibits a few illusionistic devices, such as overlapping figures, angled lines that orient the box in space, and the division of the composition into three horizontal registers corresponding to the foreground, middle ground, and background (fig. 41). The size of the figures however, does not seem to diminish into this space (the feet of the uppermost figure crowd the picture plane), and the negative spaces formed between the two figures on the right become abstracted forms in their own right, confusing the relationship between figure and ground.

In sum, the space of WalkingStick's paintings between 1971 and 1973 is cubist, reminiscent of *Les Demoiselles d'Avignon* (1907) by Pablo Picasso (1881–1973), in which the spatial planes and bodies are so fractured and intertwined as to become nearly indistinguishable from one another. WalkingStick acknowledges the direct influence of Picasso and the cubists on her work from this period: "I was educated in Bauhaus and cubism, and I certainly love cubism. I think that was the most influential thing in the twentieth century.... It affected everybody, all of us, in greater or lesser degrees." While *Me and My Neon Box* depicts a group of nude female figures in an array of poses as *Les Demoiselles d'Avignon* does, it is more formally indebted to later cubist works. Following their experiments with collage, the cubists arrived at a treatment of forms in space that was less fragmented and angular than in their earlier compositions. In Picasso's *Still Life with Guitar* (1922), for example, objects are depicted as solid color fields with sinuous contours (fig. 42). Rather than dissolving into the space that surrounds them, Picasso's brightly colored forms interlock with one another like puzzle pieces on the flattened picture plane. WalkingStick used color to similar effect. In *Me and My Neon Box*, her decision to use a deep blue to describe the shape created by the bent arm of the figure on the far right was informed by both her appreciation of the "found shape between figures" and the effort to push

43. *April Contemplating May*, 1972. Acrylic on canvas, 50 x 50 in. Collection of the artist.

44. *Fantasy for a January Day*, 1971. Acrylic on canvas, 50 x 56 in. Collection of the artist.

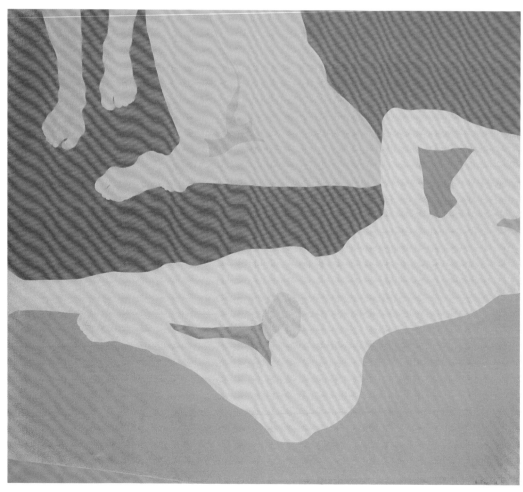

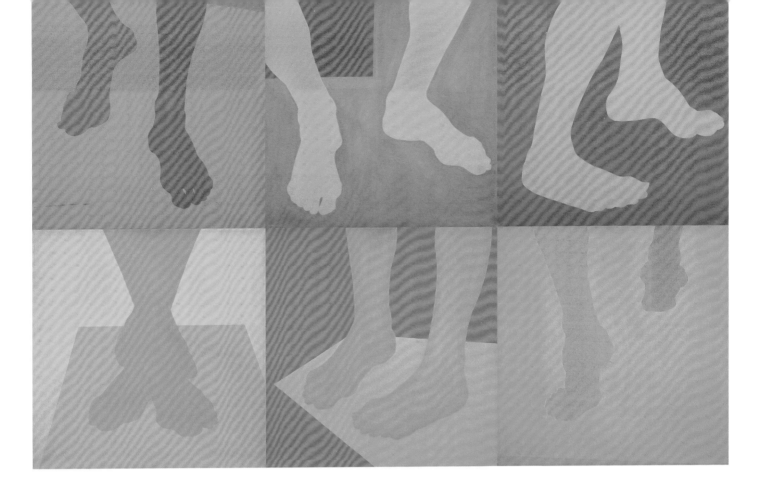

45. *Feet Series Arrangement*, 1972. Acrylic on canvas, 6 panels, 20 x 20 in. each. Collection of the artist.

that shape to the foreground. "We are such spatial animals," she notes. "Just the simplest things indicate space. I would have to have made that shape the same color as the background in order for it to recede."

As a treatment of the figure, a silhouette is the ultimate flattened form. In its physical manifestation, a silhouette requires a very strong light source, which smooths out surface detail, and a two-dimensional surface to project upon. In WalkingStick's case, the idea to use the silhouette came to her after seeing her own shadow on the beach, realizing that the form, though simplified, conveyed the essence of her person. There was nothing generic or impersonal about this projection of the body, despite the paucity of detail, which is crucial to understanding what WalkingStick sought to express in these early paintings. *Me and My Neon Box* is a composite self-portrait; each of the forms is based on the artist's own body. That the bodies in question are sensual bodies is made clear by the single anatomical detail that is rendered in each of WalkingStick's nudes: the contrasting color of the genitalia. Especially when paired with *Fantasy for a January Day*, the subject matter of *Me and My Neon Box* can be clearly identified as a celebration of the artist's own sexuality (fig. 44). As WalkingStick put it, "There is a joyousness in their nakedness, rather than nudity. They are enjoying their bodies. A lot of that early work was really about feminism and my own recognition of my own sexuality." For WalkingStick, even feet could be regarded as erotic subjects. In *Feet Series Arrangement*, six pairs of feet, still recognizable to the artist as her own and her husband's, gesture and cavort and effectively express a range of moods while also affording WalkingStick an opportunity to experiment with simplified figural compositions (fig. 45).

The grouping of separate square canvases into a unified rectangular composition became an important feature of WalkingStick's diptych paintings some years later, but at this early stage it was a relatively unique occurrence in her work. In the upper right corner of the painting titled

Hudson Reflection series (1973) differs substantially from the figural works of the same period, the paintings exhibit strong formal similarities (figs. 5, 24, 48). The color palette varies across the half-dozen works in the series, yet all are in the same range as the figural paintings. Further, the curvilinear forms of the river's surface are presaged by the abstract shape that drips off the front of the artist's hat in the *Self-Portrait* of 1970, and the repetition of shapes and colors is reminiscent of the compositional play seen in *Feet Series Arrangement*. Most important, the *Hudson Reflection* series continues WalkingStick's investigation of flatness; here she has captured all the rhythm and movement of an undulating surface without benefit of shading or modeling, and without suggesting recession into space.

As patterned and nearly abstracted as these works are, they are nonetheless based on direct observation, just as her figures were based on live models. WalkingStick produced plein air pastel drawings of the river while taking walks along the Englewood Boat Basin with her family. Back at home in her attic studio, the artist translated her sketches into large-format acrylic paintings, producing a series of five or six canvases over the course of a few months. WalkingStick's method, combined with the size of the finished works, attests to the diligence with which she approached her art in this period. "I was averaging about a dozen large paintings a year," recalls WalkingStick, "picking subjects that I knew would challenge me. I had a tremendous drive to make art all of the time. I had a tremendous commitment to always improving as an artist."

TOWARDS ABSTRACTION: PRATT, 1973–75

In 1973, with the financial assistance of a Danforth Foundation Graduate Fellowship for Women, WalkingStick enrolled in the MFA program at Pratt Institute in Brooklyn, New York. She was thirty-eight years old, and by her own admission ready to push her work in a new direction. Even before Pratt, she had been making regular trips to New York City art galleries with a friend, taking inspiration from color-field painters like Ad Reinhardt (1913–1967) and minimalists such as Brice Marden (b. 1938). At Pratt however, she was exposed to a range of new work through the school's visiting artist speaker series, and increased visits to artists' studios, museums, and galleries. She was particularly inspired, she recalls, by Helen Frankenthaler (1928–2011) and Sam Gilliam (b. 1933), the latter an African American painter best known for removing his canvases from the support and letting them hang loose like draped fabric. Intrigued by the shapes that Gilliam's draped canvases made, WalkingStick began a series of studies of an artist's apron—the same apron she depicted herself wearing in her 1970 *Self-Portrait*. In each of these paintings—*April Apron*, *Apron Agitato*, and *A Sensual Suggestion*, all created in 1974—the apron is shown hanging from a nail with the apron strings pinned to the apexes of an isosceles triangle inscribed on the studio wall. (figs. 49, 50, 51).[9] The images are basically representational, with the details of material, seams, paint smears, finger marks, folds, and gatherings of fabric all faithfully rendered. Nevertheless, the forms move toward abstraction, flattening against the wall as they begin to conform to the grid mapped on the color field behind them.

For WalkingStick, what she describes as the "simple iconic shapes" of the aprons opened her eyes to other similar forms. She recalls,

> I realized that what I liked about the aprons was the draped fabric, and I was thinking about that as I was driving every day to Brooklyn and looking at the bridges. The bridges were the best part of that drive—I think they are the best sculpture in the city. I'd look at these bridges and these huge nets that were stretched under them during repairs. I thought these wonderful draped things on the bridges were gorgeous.

48. *Hudson Reflection, VI*, 1973,
Acrylic on canvas, 48 x 50 in.
Collection of the artist.

49. *April Apron*, 1974. Acrylic on canvas, 42 x 48 in. Collection of the artist.

50. *Apron Agitato*, 1974. Acrylic on canvas, 48 x 42 in. Collection of the artist.

OPPOSITE: 51. *A Sensual Suggestion*, 1974. Acrylic on canvas, 42 x 48 in. Collection of the artist.

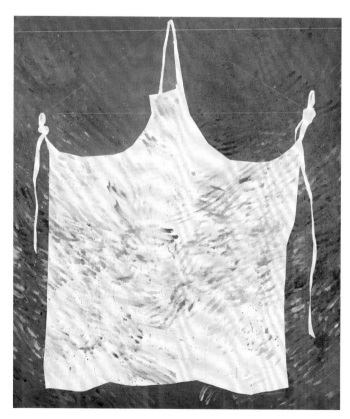

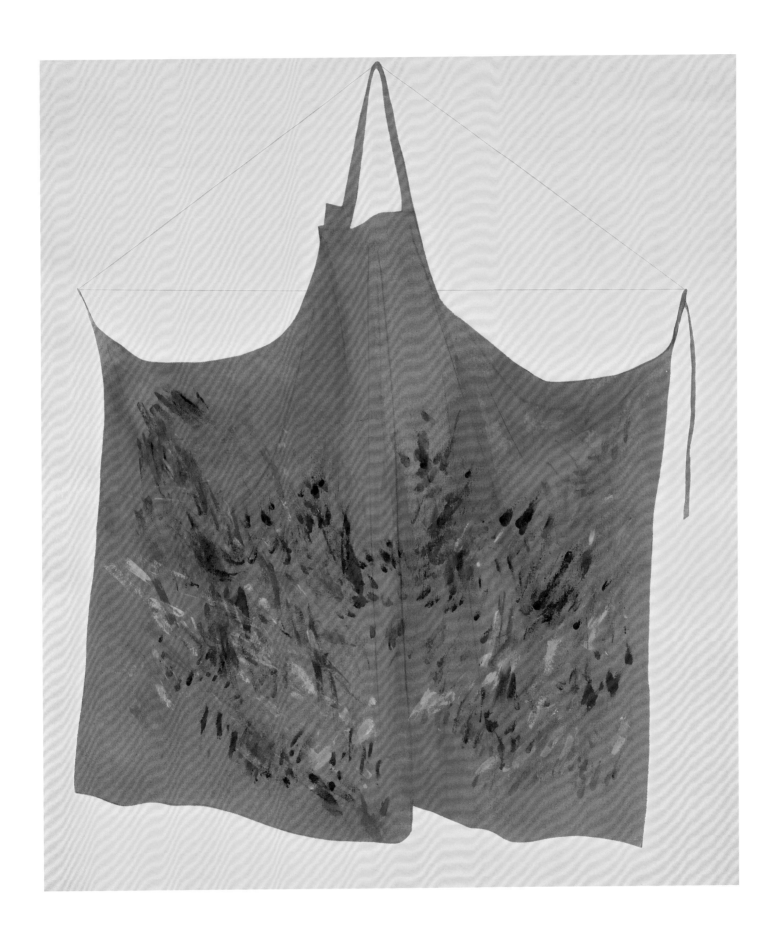

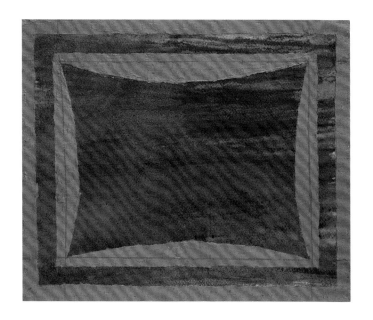

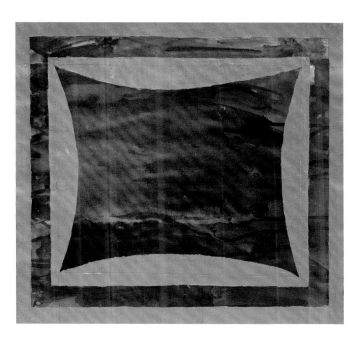

55. Untitled studies, 1974. Acrylic
and ink on paper. 14 x 17 in. each.
Collection of the artist.

on a spidery grid.[14] While the horizontal orientation of the
paper and the striated quality of the ink evoke landscapes,
cloudscapes, or even representational forms such as stretched
hides, WalkingStick's intention in this series of studies was to
address the increasingly abstract aspects of the apron paint-
ings and *Tepee Form*.[15] Here she isolates and enlarges the arc
that was formed in the apron paintings by the negative shape
between the top edge of the draped fabric and the bottom
edge of the inscribed triangle.

Once singled out, the arc became the critical, recurring
element of WalkingStick's compositions, including a paint-
ing from the same year, *Fear of Non-Being* (fig. 25). For the
artist, the arc was a negative shape, "like the shape between
bodies" and forms, as well as the trace of a positive gesture:
the movement of her hand or arm across the surface of a
canvas. By the time she embarked on the *Chief Joseph* series
in late 1974, WalkingStick had codified this gesture into
a purely geometric form, but it was never fully divorced
from its origin in the body. As her work in graduate school
became increasingly abstract, geometric, and minimalist, it is
important to acknowledge that every surface and gesture in
WalkingStick's paintings was imbued with sensuality.

In *For John Ridge* (1975), the sensuality is most evident
in the material surface (fig. 56). Returning once again to an
ink-stained canvas, WalkingStick elected to add wax to her
acrylic paint. This decision was inspired in part by her affec-
tion for the rich encaustic surfaces of the work of both Brice
Marden and Jasper Johns, but it was made possible by Walk-
ingStick's discovery of a wax that could be mixed with acrylic
rather than oil paint.[16] "It made this lovely surface," Walking-
Stick recalls, "I just fell in love with the surface. I had always
loved paint, this physical, joyous thing." With the addition
of wax, WalkingStick's paint became thicker, more viscous
and substantial, and ultimately, more visible. Though she
would come to use her hands to apply the paint in increas-

56. *For John Ridge*, 1975. Acrylic, ink, and saponified wax on canvas, 60 x 72 in. Gilcrease Museum, Tulsa, Oklahoma.

ingly thick, deeply textured layers in subsequent paintings, she applied the material of *For John Ridge* with a palette knife to create a relatively thin, smooth, and lustrous surface. In this case, the quiet of the surface and the dense black of the pigment combine to convey an air of solemnity appropriate to the painting's subject matter. *For John Ridge* is an elegy for the prominent Cherokee statesman who was killed in 1839.[17] In many respects, *For John Ridge* represents the synthesis of the various themes, techniques, and ideas that WalkingStick methodically explored in her graduate career: isolation of the arc; use of the grid; continued flattening of space; attention to surface; development of a unique saponified wax process; attunement to the expressive qualities of color, including black; and even the turn toward subject matters drawn from Native American experience, especially those of loss and tragedy. All of these would be brought to bear in WalkingStick's most ambitious project to date: the *Chief Joseph* series.

57. *Chief Joseph* series, 1974–76.
Acrylic, ink, and saponified wax
on canvas, 20 x 15 in. each. (32
panels of a 36-panel series).
National Museum of the American
Indian 26/5366.000–026, Tony
Abeyta, and private collection

CHIEF JOSEPH SERIES, 1974–76

"It was all about expressing emotion and thought through these very simple means. I really wanted to be as simple as possible, very, very reduced. I wanted to take it all as far as I could and still have a painting that somehow said something."

The *Chief Joseph* series is something of a paradox in that it is one of the most devoutly intellectual and minimalist works of WalkingStick's career, but it is also deeply affecting (fig. 57). The subject matter is profound and tragic, one that WalkingStick has returned to time and again: the 1,170 mile exodus of the Nez Perce Chief Joseph and his people in 1877.[18] Yet the work is purely abstract, even formulaic in its composition and conception. In the series of thirty-six separate twenty-by-fifteen-inch canvases, WalkingStick repeated four basic forms: two small segments of a sphere and two larger ones, which are all derived from the arcing form of earlier works—arranged vertically inside a rectangular field in one of two orientations (left-facing or right-facing).[19] She chose to create thirty-six canvases in the series, each with a unique combination of the four forms. To insure that she did not mistakenly repeat a single permutation, WalkingStick diagrammed the entire series on graph paper as the work progressed; her painstaking documentation of the series is preserved in her studio files (fig. 59).[20]

The proliferation of canvases in the *Chief Joseph* series belies the labor-intensive process by which they were made. WalkingStick prepared each canvas separately, working on the series over the course of more than three years. For each work, she first transferred her preliminary drawings onto the stretched canvas, drawing each precise form in pencil by hand, then stained

58. *Chief Joseph* series, 1974–76.
Acrylic, ink, and saponified wax
on canvas, 20 x 15 in. each. (panels
27 and 17 of a 36-panel series).
National Museum of the American
Indian 26/5366.016, 019

tional swatches of canvas affixed with modeling paste to create mounded surfaces. In concert with their formal qualities, the accumulated thickness of these paintings underscored their status as physical objects, a quality that was important to the artist and to critics. Writing for *ARTnews* in June 1981, Deborah Phillips remarked that WalkingStick's new approach to the canvas "rather rigorously define[d] the work as a physical object," and that this treatment lent "an immediacy and directness to the work."[30] Frederick Castle of *Art in America* agreed, noting that the paintings "look somewhat like paintings, which they are, but also somewhat like large, heavy square objects on the wall."[31]

The inherent paradox in WalkingStick's painting in the early 1980s is that just as the canvases were becoming increasingly visible as minimalist objects, they were also becoming more psychologically expressive. They were in fact increasingly gestural, in the sense that the artist's marks recorded her bodily actions as well as her emotions. WalkingStick recalls, "I had been scratching the surface for years to activate the surface. It gives it a lot of life to manipulate the surface physically, although that action also conveys a certain anger."[32] In the case of *Genesis/Violent Garden* and *Satyr's Garden*, the emotion was not anger per se, but an acknowledgement of the violence and veiled threats that permeate our myths and archetypes. "The *Gardens* are dark," WalkingStick says. "They're imagined gardens; they're night gardens that are spooky and juicy and full of critters."

Imaginary or not, it is important to recognize that the *Gardens* are in effect landscapes; they are interiors inspired by the darkened environment of WalkingStick's attic studio, brought into physical being through the manipulation of pigment and material surfaces. It is impossible to know whether WalkingStick's naming of these works was a subliminal recognition of her growing interest in landscapes, or whether these titles called out the latent tendencies of the multilayered canvases to evoke the strata of the geophysical earth. Either way, the transition had begun in WalkingStick's imagery, from resolutely geometric forms to the landscapes that would occupy her for the next three decades.

CONCLUSION: THE EMERGING LANDSCAPE

In 1983, WalkingStick received support from the Edward F. Albee Foundation to spend a month as an artist in residence in Montauk, Long Island. It would prove a transformational experience—almost immediately, paintings such as *Montauk, I* (1983) reflected the change from working indoors in New Jersey and New York City to working outdoors where she could see the sea (fig. 65). WalkingStick recalls that she was struck "by the colors that were there, they were so different from the dark colors of the attic and the studio." She continued to build monumental canvases, laying down as many as thirty layers of paint and wax with her hands, and adding in pebbles taken directly from the beach. As she scratched through the "twilight tones of muted pink" into the pale green layers below, she was aware that her wavy, vertical lines suggested trees, scattered throughout the composition.[33] Enticingly, in both *Montauk, I* and *Montauk, II (Dusk)* (1983), WalkingStick inscribed a short, thick, straight horizontal line segment in the middle of the composition (figs. 66, 67). Though the placement of each line segment is determined by a mathematical ratio (they are equidistant from the top and bottom edges of the canvas), it is tempting to interpret them as fragmented horizon lines. WalkingStick allows that the paintings had "a little bit more to do with the landscape at Montauk than with just the inside of my head."

65. *Montauk, I*, 1983. Acrylic,
saponified wax, ink, and pebbles
on canvas, 56 x 56 x 4.25 in.
Collection of the artist.

66. *Montauk, II (Dusk)*, 1983. Acrylic, saponified wax, and ink on canvas, 56 x 56 x 4.25 in. Collection of the artist.

67. *Detail, Montauk, II (Dusk), 1983.*

If, on the one hand, the *Montauk* paintings herald the arrival of the landscape-based imagery for which WalkingStick is best known in her forthcoming diptychs, they also represent the culmination of more than a decade of concerted investigation into the formal language of modernist painting. In these works, and every subsequent landscape that she would paint in the coming years, WalkingStick translated her encounter with the physical world into her own highly developed vocabulary of abstraction, grounding it in geometry, the objecthood of the canvas, and the sensuousness of "this wonderful stuff we call paint."

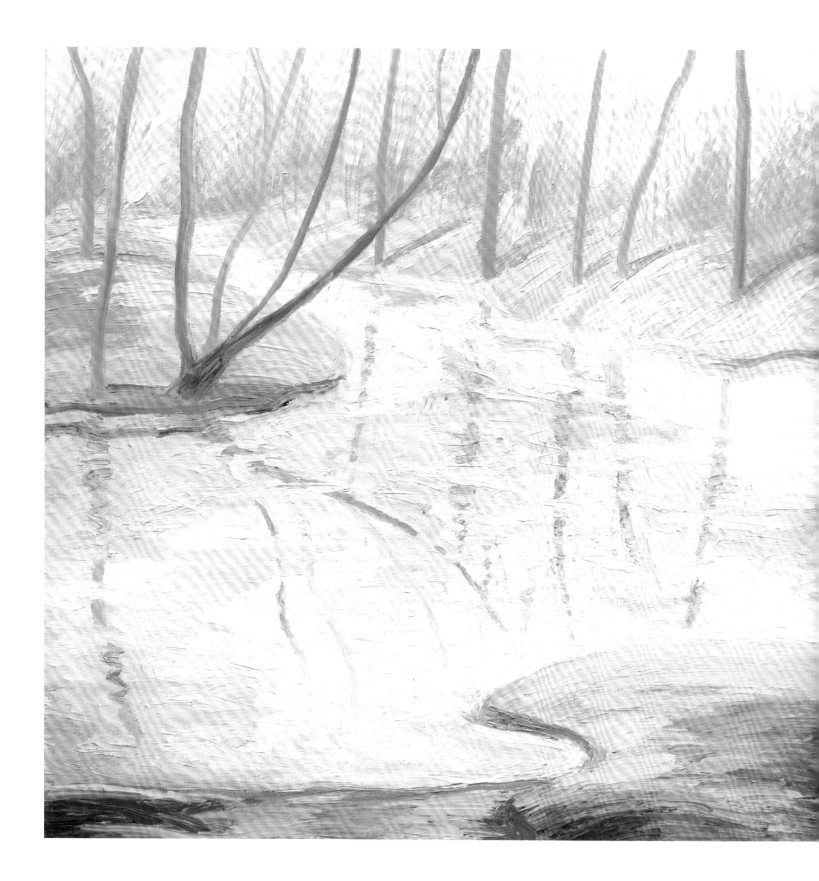

70. *Eden, Perceptual Dilemma*, 1985–87. Oil on canvas (left), saponified wax and acrylic on canvas (right), 36 x 72 x 3.5 in. The Museum of Contemporary Art San Diego; gift of the S. W. Family Trust in memory of Muriel Wenger.

71. *Four Directions / Spirit Center*,
1994. Acrylic, saponified wax,
and oil on canvas, 28 x 56 in.
Collection of Erica WalkingStick
Echols Lowry.

STEREO VIEW
KAY WALKINGSTICK'S DIPTYCHS

Kay WalkingStick's painted diptychs, two contrasting squares set side by side, became her most durable and recognizable way of working and represents the paintings most firmly identified with her career and success. She pursued this format unwaveringly up through the mid-1990s, producing several complex, ambitious paintings, each composed of two separately created square panels, one ornately textured and featuring a geometric shape or shapes, the other painted broadly with the image of a landscape. By the late 1990s some works blurred the boundaries between the two contrasting squares with images ranging across both panels. And yet, for the purposes of other particular projects, WalkingStick again returns to the discipline of the two inviolate squares, separate yet united by their physical juxtaposition.

Critics, writers, and WalkingStick herself interpret the diptych format as a key to her artistic program. "This duality has several layers of meaning," Anthony Janson wrote portentously in his father's revised *History of Art* in 1997.[1] Holland Cotter, writing early in WalkingStick's career, enjoyed their open-ended qualities: "The images in her diptychs reveal themselves slowly and derive their power from their ambiguities."[2] "Dialectic seems to be WalkingStick's fated artistic mode," wrote reviewer Richard Vine for *Art in America*.[3] Vine, like others, saw the diptych as an allegory of WalkingStick's mixed-race identity, the lineages of the well-known Oklahoma Cherokee Walkingsticks and her Irish/Scots mother having merged together to create her unique artistic persona. Robert Houle, writing about WalkingStick for the catalogue of the landmark National Gallery of Canada exhibition *Land, Spirit, Power*, drew an explicit connection between the diptychs and contrasts between Cherokee and Anglo-American kinds of perception.[4] In a recent artistic statement, WalkingStick mused, "The diptych is an especially powerful metaphor to express the beauty and power of uniting the disparate and this makes it particularly attractive to those of us who are biracial."[5] It is a mistake, however, to interpret this comment and others like it too narrowly. The diptychs do not divide into an Indian side on the one hand and white side on the other. WalkingStick sees her biracial situation as itself an allegory for a larger concern with the juxtaposition of differences that "unity of the totally dissimilar," as she put it in 1991.[6] Consistently over the years, she has described her work as drawing distinctions between "the physical and the spiritual," between the material realities of our collective human condition and our less tangible yet no less real feelings, thoughts, and memories.[7] Art—life, really—lies between these coordinates. WalkingStick's juxtapositions of difference locate the ephemeral position of humanity between experience and memory, our bodies and our emotions, our physical needs and our spiritual yearnings.

Critical to this thematic program, although rarely acknowledged, is the fact that the diptychs resulted from two very different ways of working, two distinct processes for making paintings. The nonrepresentational panels derive from an artistic practice developed while

74. *Late Summer on the Ramapo*,
1987–91. Acrylic and saponified
wax on canvas, 48 x 96 x 3.5 in.
Collection of the artist.

WalkingStick's quest for unity through the juxtaposition of difference would necessarily develop intuitively rather than rationally. She sought a kind of transcendence through feelings sparked by deep spiritual reflection on the one hand and sensual perceptions when experiencing the earth's places on the other. The transcendent ambition of late modernist/minimalist practice, broadened by her distinctive, almost ritualistic use of her hands to paint, accessed for her "deep," "mythic" memory.[19] Her early diptychs sought means to convey a comparable strength of feeling and transcendence in her illusionistic landscapes as well.

The most powerful diptychs in this regard, those paintings that stand as masterpieces of her midcareer, were prompted in part by intense feelings of personal tragedy. In 1989, just after her appointment to the faculty of Cornell University in Ithaca, New York, WalkingStick's husband, R. Michael Echols, fell ill and died suddenly. Contending with nearly overwhelming grief, WalkingStick sought out some of Ithaca's most distinctive and evocative places in the deep gorges of Fall Creek, which borders the Cornell campus, and along Enfield Creek in nearby Robert H. Treman State Park. A number of WalkingStick's most important and memorable works stem from those locations.

The Abyss (1989) is perhaps the most fiercely heartfelt painting of this series (fig. 75). The color schemes in both panels are reduced to black and an intense crimson red with white for the foam of rushing water. WalkingStick built the massive abstract panel of her then customary acrylic and wax. A red, glowing section of a circle, or "sector" (the geometric term), hovers in the center of the heavy panel. Echoes of its shape frame it in black, like shadows above and below. The shape and its shadows float amidst a deeply textured background of scumbled black and red, creating an indeterminate field of space or solidity behind it. In contrast, WalkingStick painted the landscape on canvas with oil paint, also using her hands. We see a series of cascades of rapidly flowing water, observed from a vantage point almost amidst them yet slightly above. The water surges from the right only to disappear over an edge into a black void in the upper left corner, the abyss referenced in the title of the work.

The red waterfalls panel was inspired by an isolated location in the depths of Fall Creek Gorge. Fall Creek drains into the south end of Cayuga Lake, the forty-mile long glacial lake that can be seen in panoramic views below the Cornell campus. The precipitous, often vertical, shale and sandstone walls of Fall Creek Gorge were cut when the glaciers that formed Cayuga Lake retreated, lowering the lake to its present level and leaving this portion of Fall Creek as a hanging valley. Fall Creek descends to lake level in a series of dramatic waterfalls located along a roughly two-mile stretch that runs along the side of the Cornell campus from Beebe Lake, an artificial lake formed by a dam, to Ithaca Falls, the last and largest of the waterfalls, towering 175 feet above the lake. The gorge is crossed by a series of bridges, including a pedestrian suspension bridge spanning 270 feet and hovering 140 feet above the gorge's midsection. A path close to the footbridge provides the only access to the interior of the gorge, descending by switchbacks and stone steps to the bottom. There, in summer months, young people sometimes swim illegally directly beneath the bridge in Foaming Falls, where fifteen vertical feet of stepped table rock funnels the cascading water into a powerful spume. Turning downstream, one can walk without a path along rocky and increasingly precarious terraces until the roiling water meets a near vertical wall of shale before it tumbles down Forest Falls. WalkingStick based the angular cascades of *The Abyss* on a series of rapids between the two waterfalls, visible from the bottom of the footpath. *On the Edge*, a companion painting of that same year, shows the same series of angular rapids, the view raised slightly to reveal the shale walls of the opposite bank (fig. 76).

75. *The Abyss*, 1989. Oil on canvas (left), acrylic and saponified wax on canvas (right), 36 x 72 x 2 in. Collection of the artist.

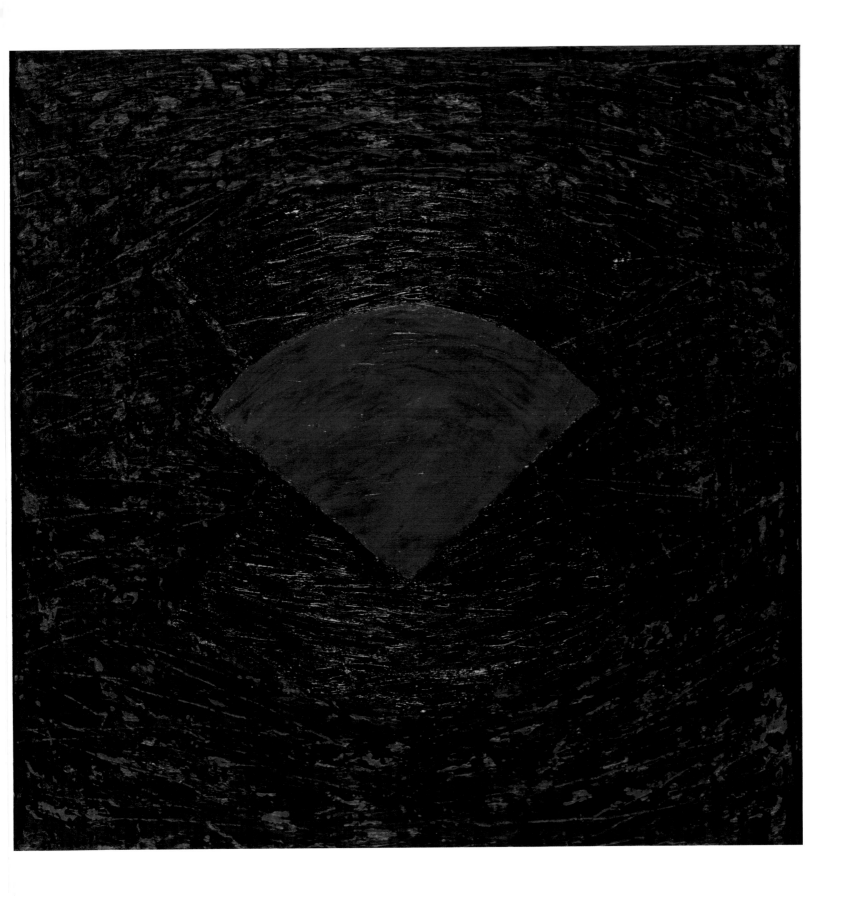

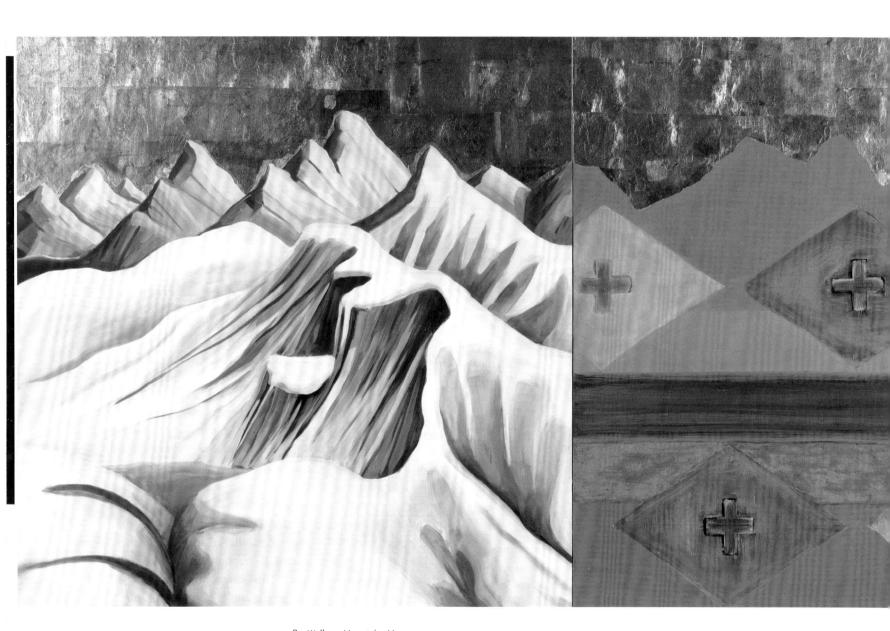

83. *Wallowa Mountains Memory, Variation*, 2004. Oil and gold leaf on wood panel, 36 x 72 in. The Metropolitan Museum of Art, New York; gift of Mr. and Mrs. Douglas A. Dial. 2008.175a, b

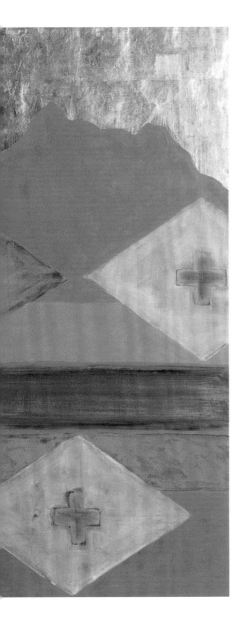

LANDSCAPE
THE LIVING SYNTHESIS OF HUMAN PRESENCE AND PLACE

The way in which artists introduce themselves in public forums and symposia is often cryptically nuanced to indicate what they do aesthetically or culturally, or both. In Indianapolis in 2003, at such a panel on the occasion of her recognition as a Distinguished Artist of the Eiteljorg Museum of American Indians and Western Art, Kay WalkingStick introduced herself in the following manner: "Hello, my name is Kay WalkingStick. I see myself as a New York artist and a Cherokee woman."[1] The museum was celebrating its third round of the Eiteljorg Fellowship for Native American Fine Art, and WalkingStick was the first female artist to receive the honor. As one of the five other fellowship recipients that year, I was part of that panel and admired her confidence and candor on the polemical issue of identity, personal and collective. The clarity with which she defined herself is something that I remember foremost to this day.

As a painter, she firmly establishes her romance with the land. Her uncompromising stance on who she is and what art means to her has always given me solace. She centers her practice beyond the rhetoric of the indigenization of the American Indian with tribal postcolonial representation. Her landscapes are a living synthesis of human presence and place, transformative in much the same way as meditation regimens designed to enhance attentiveness in order to cope with technology and its formidable power to distract. Her conceptual conceits and multiplicity of materials are a fresh enterprise of originality and talent.

We first met in 1983 in Stillwater, Oklahoma, where we had been part of a group exhibition at the Gardiner Art Gallery of Oklahoma titled *Contemporary Native American Art* and have remained friends and compatriot artists. We share the language of painting and the perennial question of who we are and how that situates us in the larger scheme of things. This was confirmed twenty years later when she introduced herself in Indianapolis. I was so impressed by her dignified yet circumspect deportment; her voice had a sovereign air of matriarchal defiance and warrior confidence.[2] I knew at that moment that Kay was a cultural sentinel, an artist icon with the dual heritage of North American Antiquity and New York Modernity. In a recent essay, "Harold Rosenberg Versus the Aesthetes," Debra Bricker Balken writes about the aesthetic interests that surfaced in midcentury New York that made me realize how important the cultural influences of that period would have been for a very young WalkingStick.[3]

The action paintings of Jackson Pollock (1912–1956) and the abstractions of Barnett Newman exemplified modernist art as a declaration of the artist's subjectivity, influences that are manifested in her landscapes defining this anxiety and creativity, and at times residual figuration, lyrical and expressive. They embody the concept, the spontaneous interplay of patches of color as gestures expressing the emotional condition; it is the application of spots of color irrespective of subject. Distinct from the geometric abstractions of Barnett Newman, her affinity probably lies closer to the Automatistes, a heterogeneous group of artists from Montreal

who published *Refus Global* in 1948. In it, Paul-Émile Borduas wrote, "We are forced to accept the past along with our birth, but there is nothing sacred about it. We don't owe the past a thing."[4] This social document and aesthetic statement is a manifesto outlining three distinguishable modes of automatism championed in Kay's landscapes: mechanical, psychic, and surrational.[5]

Painting, often deemed a dying craft, remains a major cultural critical signpost. As historical materialism, it inspires a long visual history of art making on Turtle Island, North America. The painting process, body and content, matter and trauma, is fossilized on the land. Walking-Stick's painting language of visual tropes of land and landscape has presence and memory of the Wallowa Mountains of northeastern Oregon, the Ramapo River of Bergen County, New Jersey, and the waterfalls in Ithaca, New York. Her paintings of personal loss in the abyss of a mystic landscape of tumultuous waterfalls defying gravity and of shape shifting fanlike leitmotifs in her midcareer work signify a mnemonic symbol.

The co-presence of indigenous and modern is culturally contested space, manifested through colonization, requiring the artist warrior to develop a sovereign strategy to negotiate further. WalkingStick took it to a new level in her story of Chief Joseph through a major abstract work. It was not just about removal, but the implied oppositional colonial meaning of "settler." In 1877 the chief and his people were forced to leave their ancestral land, which they had settled first, an unsettling perspective of intercultural space.

This contested heritage, evident in one of her first major works, a suite of thirty-six abstract paintings titled *Chief Joseph*, is a pictographic vocabulary of geometric and linear markings of time and space, a mapping of the land walked by the Nez Perce along the Wallowa River (fig. 57). This extraordinary work, influenced by the psychic improvisation of the surrealists who had taken refuge in New York after the war, is monumental. The elementary doctrine of historical materialism described by Walter Benjamin, "history decays into images, not into stories," can be used to examine this trauma of dislocation.[6] These narratives of displacement in search of hope, emphasized by the existence of the individual as a free and responsible agent determining development through acts of will and existentially stressing the reality and significance of human freedom and experience, provide a contemporary metaphor for Kay's *Chief Joseph*.

Despite the malaise left by war, New York became the cultural laboratory of a new art movement, abstract expressionism. Its prestige, besides being the vanguard of an indigenous art form much like jazz in the beginning of the twentieth century, was enormous and pivotal in making American art a leading force in world culture. Today, these transformative creative forces are the inspirational source for WalkingStick's expressive abstract landscapes, celebrated through a perspective of land sovereign to identity: Cherokee. She reveals an automatism of unpremeditated spontaneity, a universal creativity of the unconscious mind long championed by her city.

WalkingStick's recent diptychs of desert vistas and arid-climate landscapes are manifestos coded with Navajo, Nez Perce, and Northern Cheyenne patterns. Her cultural duality is without hybridization and speaks to her determination to find a place in the practice of abstract painting despite its domination by a white male middle-class bastion of Platonic sensibility. What makes her a major figure in painting is her ability to find a spiritual and temporal place in a patriarchal profession and flourish by endowing abstraction with human drama and refuting its tendency of static absolutism.

Her self-revelatory application of paint, whether by hand or brush, is the human drama in early diptychs like *The Abyss* (1989), *Wallowa Mountain Memory, Variation* (2004), and *Highwater April* (2009) (figs. 75, 83, 84). Her standoff with postmodern parlance and her dismissal of its

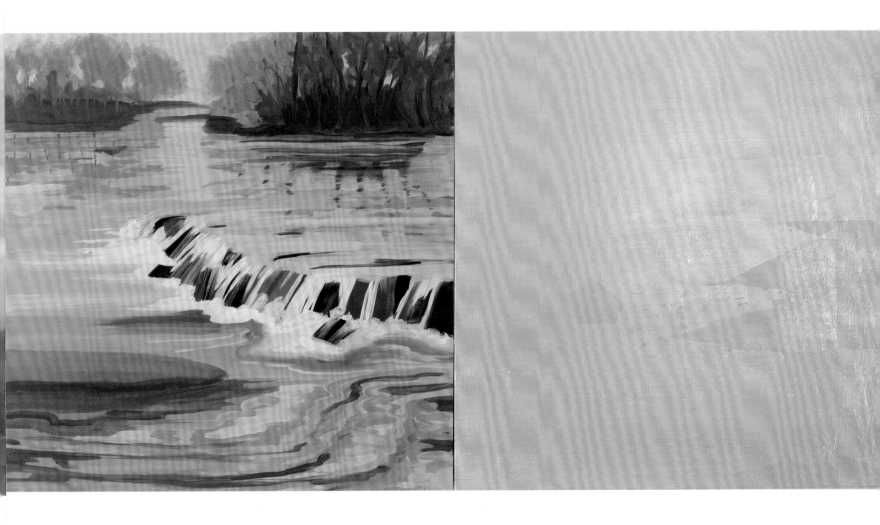

84. *Highwater April*, 2009. Oil and gold leaf on wood panel, 24 x 48 x 1 in. No longer extant.

new postcolonial indigenization of Native American art reveals a true aesthetic warrior. She stands proudly before the Eurocentric exclusionary classification that accepts the work of the surrealists and abstract expressionists who were inspired and influenced by Native American art, but she does not accept Native American art inspired and influenced by Western culture. It is deemed a hybrid, a rhetoric that exposes the duplicity in not recognizing this cultural exchange. Remember also the colonial idea of its contamination by technology, classifying it as "foreign," leaving it fossilized in history. Defying marginality, WalkingStick is inspired by Native American art and committed to painting techniques developed through Western aesthetics. An artist decides what and how to paint something without cultural exclusivity to aesthetics.

The Abyss exhibits a discordant note made mysterious through autobiography. With its red coloration and symbols of memory and loss, a holistic composition of natural and metaphysical landscape, Kay has created an expressive abstraction of human absence. Her crafting of this work engages the viewer to see the waterfall on the right canvas as a visual manifestation of drama caused by trauma through the body. In an artist statement she writes about the lack of figures in early paintings: "In fact, their absence had seemed crucial to the significance of the work."[7] The painting is not devoid of content; the act of the painting process itself is the content. Through her attention to the physical qualities of the paint and its expressive manipulation, WalkingStick is triumphant in creating an unstructured picture space. Its emotional

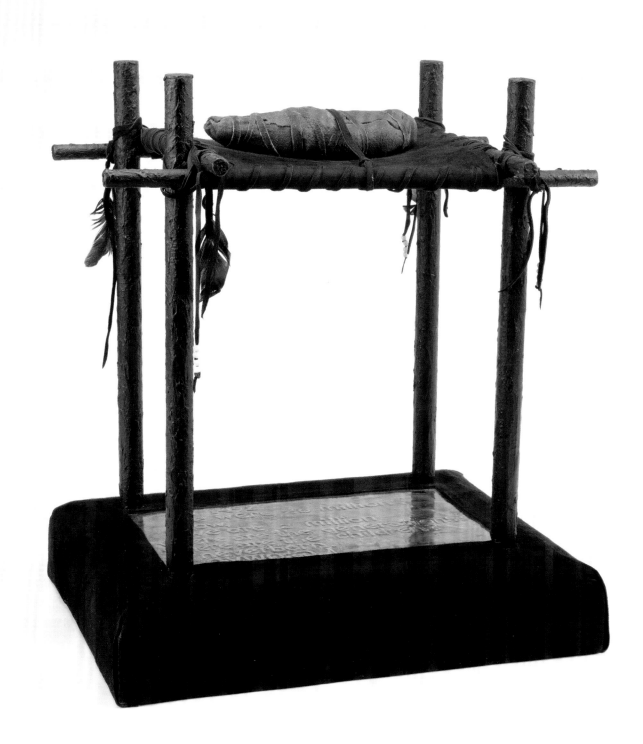

ON BEING CHEROKEE

"What does my heritage have to do with my art? It is who I am. Art is a portrait of the artist, at least of the artist's thought processes, sense of self, sense of place in the world. If you see art as that, then my identity as an Indian is crucial."

—Kay WalkingStick[1]

Kay WalkingStick's cultural identity is critical to the discussion of her art. An enrolled member of the Cherokee Nation of Oklahoma, she grew up in Syracuse, New York, with pride in her heritage—a pride that was instilled in her by her non-Indian mother. She recalls with fondness the dignity her mother imbued in her and her siblings in being a Walkingstick. She has continued to use her Cherokee family name even after her marriage, as a statement of her identity. While considered "funny" by many, her name is a source of honor and has become an impetus for her art as well.

When considering "identity," it is necessary to understand the conditions of identity. Similar to "race," identity is a contested term. The fluidity of its meaning, evolution, and dependence on outsider constructs creates a multitude of definitions, particularly over long histories of cultural intersection and conflict. Identity does not exist before it is constructed; it exists in relation to others and can be defined by others: family, community, nation, and/or self. In other words, the changing definition of identity has been dependent on how it is used within legal, social, cultural, and/or personal contexts and purposes.[2] For Indian people, the dynamic distinction of identity is often oppositional: our struggles and continued need to distinguish and maintain the boundaries between ourselves and others, particularly within the context of colonial experience and repression. WalkingStick has not relied on an Indian identity to construct or promote her work but has instead preferred to identify as a contemporary artist. Her art reflects her creativity, experiences, and training, and who she is as a woman, an Indian, and most important, a creative being. As an artist, Kay WalkingStick's Cherokee identity has manifested most notably within four major projects during the early 1990s: *Tears/ᏣᎳᎩ*; *Where Are the Generations?*; *The Wizard Speaks, the Cavalry Listens*; and her artist book, *Talking Leaves*.

The five-hundredth anniversary of Christopher Columbus's voyages—the Quincentennial, as it came to be known—constructed a space for WalkingStick and other indigenous artists to draw global attention to the holocaust of the Americas. In 1992 she was invited to participate in several group exhibitions of Native artists with the Quincentennial as a theme. In response, she created artworks that depart in significant ways from her working method of the time and delved deep into thoughts and reflections about American Indian history, experience, and identity, which allowed her to experiment with new art forms. WalkingStick had explored histories of encounter between Indian peoples and Euro-Americans before, but the Quincentennial provided for a new artistic impetus to express concern over the suffering and loss endured by American Indians, the Cherokee in particular.[3]

86. *Tears/ᏣᎳᎩ*, 1990.
Mixed media, 18.25 x 16.5 x 12 in.
Collection of the artist.

Tears/ᏗᏍᎤᏫᏓ was produced for *The Submuloc Show/Columbus Wohs: A Visual Commentary on the Columbus Quincentennial from the Perspective of America's First People*, organized by her Native artist colleague Jaune Quick-to-See Smith (fig. 86). WalkingStick intended the work to be a remembrance of all Native people who died at the hands of Columbus and those who followed him. *Tears/ᏗᏍᎤᏫᏓ* contextualizes the genocide metaphorically through her construction of a representational Plains Indian funerary scaffold. With this work, WalkingStick publicly grieves for the loss of all Indian people. Though monumental in appearance, its small size is suggestive of a maquette for a war monument; a memorial to the lost, the never born. The three-dimensional work is constructed with natural, mostly indigenous materials, including deer and cow hide, copper, feathers, bone beads, corn, stones, turquoise, and Anasazi pot sherds. The wooden posts are painted with an acrylic black paint, the only modern material used in the artwork. The last four items—corn, stone, turquoise, and pot sherds—are wrapped in the deer hide to resemble the shape of a human body. The body rests atop the scaffolding in repose. Underneath the scaffold, WalkingStick has placed an embossed copper plaque with her words of remembrance for those generations never born:

> In 1492
> We were 20 million
> Now
> We are 2 million
> Where are the generations
> Where are the Children?
> Never born
> ᏆᏴᎳᏆ¹ᏪᏗᏬᏓ[4]

By using the Cherokee language to sign her name, WalkingStick is claiming it as her own, explicitly confronting the issues of her cultural identity. "My anger is profound."[5] The protracted nature of historic trauma, its complexities and manifestations, provided WalkingStick with the grist to ask about the generations of absent Native people.

In her painting *Where Are the Generations?*, she uses her iconic diptych format to further navigate the terrain of overwhelming absence (fig. 88). She uses the darkness of the desert sky

88. *Where Are the Generations?*, 1991.
Copper, acrylic, and saponified
wax on canvas (left), oil on canvas
(right), 28 x 56 x 0.5 in. Collection
of Jim and Keith Straw.

to visualize the vastness of grief and a feeling of emptiness. The landscape side of the diptych is a representation of Sabino Canyon, located outside Tucson, Arizona, in the eastern foothills of the Santa Catalina mountain range. WalkingStick has rendered the canyon walls and mountains in a limited palette of pinks and blues. Above and behind the mountains, the background is painted a dark blue-black that suggests the depth of the night sky. The moonlight raking across the canyon walls and floor is created through the use of a cool palette, applied using broad, flat strokes. WalkingStick captures the appearance of extremes in a desert landscape inhabited only by short scrub. The canyon shows no evidence of humans. It is empty. Where are the generations?

The layering of rich impasto colors—blues, blacks, greens, and reds—creates the abstract portion of the diptych. WalkingStick attached a copper circular plate, imprinted with the same words WalkingStick used in *Tears/ᎠᏣᎵᏍᏗ*, to the center of the abstract panel. She then applied thick paint to create radiating waves that seem to move outwardly from this central disk. The words on the disk summon up the lost voices of the absent generations who echo her Quincentennial manifesto.

The Wizard Speaks, the Cavalry Listens continues to address the history of mass extermination policies by implicating the US government within the trajectory set by Columbus (fig. 89). The work references Wounded Knee, the Ghost Dance, and by association the history of murder and mutilation of innocent women and children by the US Cavalry in the nineteenth century. On December 29, 1890, in a ravine near Wounded Knee Creek, South Dakota, more than three hundred Lakota men, women, and children were slaughtered at the hands of the Seventh Cavalry. Two-thirds of the massacred Lakotas were women and children.[6] Walking-Stick's wizard is L. Frank Baum, owner and editor of the *Aberdeen Saturday Pioneer* in Aberdeen,

92. Detail, *Talking Leaves* (pages 2–3), 1993.

93. Detail, *Talking Leaves* (pages 5–6), 1993.

94. Detail, *Talking Leaves* (pages 8–9), 1993.

95. Detail, *Talking Leaves* (pages 11–12), 1993.

96. Detail, *Talking Leaves* (pages 14–15), 1993.

99. *Howitzer Hill Fusillade*, 2008.
Oil stick on paper, 25 x 50 in.
Collection of the artist.

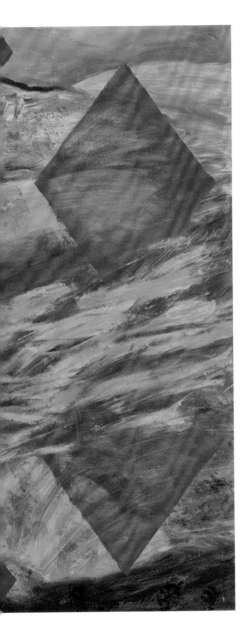

HOWITZER HILL FUSILLADE
A PERSONAL PERSPECTIVE

When I walked into Kay WalkingStick's studio one summer day in 2013, I never imagined that I would encounter a piece of home in her work. I had traveled across the country from the Yakama Nation in eastern Washington to work as a curatorial resident for the National Museum of the American Indian in New York. On that day, I met curator Kathleen Ash-Milby in Jackson Heights, Queens, New York, for a studio visit to look through the artist's storage, searching for particular pieces of artwork. Until then, I had seen only small images of WalkingStick's work in books and on the web. Now standing in her studio, I set my eyes upon a familiar landscape filled with personal stories and cultural memory. My companions were unaware that a tale of sorrow and survival waited to be shared when the artist pulled the work *Howitzer Hill Fusillade* from a drawer (fig. 99). It was my first encounter with this drawing; I did not recognize the scenery at first—until I heard the artist's story. As WalkingStick spoke about the history of the Nez Perce War and her admiration for Chief Joseph, I thought, of course—it's Big Hole, a site of an important Nez Perce battle! While Ash-Milby listened intently, I stood silent, only half listening as my mind flooded with memories and associations with this place and history.

As a child, WalkingStick heard her mother and siblings talk about her Cherokee cultural heritage. Later, as a young, inquisitive adult, she researched the history of other North American Indian nations to understand the United States' wanton need for westward expansion and was angered by repeated acts of genocide. The story of Chief Joseph's strategic outmaneuvering of the US Army for more than four months, crossing rugged terrain from what is known as the Wallowa Valley, Oregon, to Bear Paw, Montana, especially intrigued the artist and eventually lead to the creation of the *Chief Joseph* series.[1] Years passed, but WalkingStick still felt the urge to set her own eyes on, as described by mid-twentieth-century historian Helen Addison Howard, "a beautiful prairie basin of rolling hills and meadowland, intersected by numerous streams and woods, and encircled by precipitous, forest-clad mountains."[2] In 2002, in preparation for creating a new suite of work for an upcoming exhibition, WalkingStick embarked on a quest to see the landscape through which Chief Joseph led his people during the war.[3]

The war began in June 1877. Refusing to sign an agreement that would hand over his Walaawa band's homeland to the United States and relegate them to a reservation, Chief Joseph led his people on a 1,170 mile journey from the Wallowa Valley in northeastern Oregon toward Canada, over rough terrain.[4] Two months later, after the White Bird and Clearwater battles, the band negotiated buffalo hunt trails over the Lolo Pass into the Big Hole Basin in present-day southwestern Montana (fig. 100). Once there, they erected a village of some ninety lodges in a grassy meadow on the banks of the Big Hole River, where Ruby Creek joins with Trail Creek. The Nez Perce believed they were days ahead of the army led by General Oliver O. Howard, and so were surprised by the dawn attack from a different force, 163 army regulars and thirty-

five volunteers under Colonel John Gibbon. The tide of battle turned quickly, however, and the soldiers were soon on the defensive from Nez Perce warriors. Joseph returned to the village to rally the women and elderly to break camp and escape while his warriors captured two thousand rounds of ammunition and rolled Gibbon's howitzer over a steep cliff.[5] The band escaped from Big Hole, but with heavy casualties.

Once WalkingStick had visited Montana, including the Big Hole battlefield, she was ready to create a new suite of works on paper to commemorate the Nez Perce War, the band's tragic loss of land, and the pain associated with the loss of home. Unlike her well-established diptych format of stylized landscapes shown in abstract and realistic forms, the depiction of the Big Hole battle is an oil stick drawing on a single sheet that creatively layers both techniques to represent fear, rifle fire and howitzer canon bombardment, and survival. WalkingStick's interpretation of the August 9 and 10, 1877, attack appears to be looking from the camp to the direction of the hillside where Col. Gibbon was situated with his forces. In one layer, WalkingStick shows us a terrain that has changed little over the years: dense willow thickets still grow alongside the riverbank; grass, sage, and rabbit brush cover the valley floor; and a small number of pine trees still cover the hillside. An added dominant layer in the drawing, a fiery orange field with red, cloudlike spots entangles with floating red diamond patterns. These bright, gestural flashes of color symbolize the early morning attack and the frightening melee of people attempting to escape. WalkingStick's use of diamond patterns, borrowed from 'isáp-takay (parfleche) designs, floating over the land represent the surviving Nez Perce people.[6]

After the artist finished her story of *Howitzer Hill Fusillade*'s inspiration, I shared an account by my late Aunt Rosalie Pinkham-Bassett (Yakama/Nez Perce) her *ála* (paternal grandmother),[7] Lydia Pinkham, a survivor of this very battle. I knew the area well and could immediately recognize where WalkingStick stood when she first sketched this landscape, looking back up at the hill where the army had set up their canon and aimed down onto the encampment of sleeping Nez Perce—she was depicting this place from the perspective of the people as they were attacked. When I was young I used to hear my aunt's anecdote of her *ála*, who is my great-grandmother. She would cry each time, remembering her *ála*'s tale of surviving the war, two years of imprisonment in Fort Leavenworth, Kansas, with more than four hundred other Nez Perce, and the long journey home after she escaped.[8] Looking at this landscape in an artist's studio in Queens, I was immediately transported home and moved by the memories it stirred. I shared the story with WalkingStick and Ash-Milby that day so that they would know the struggle did not end when Chief Joseph surrendered at Bear Paw.

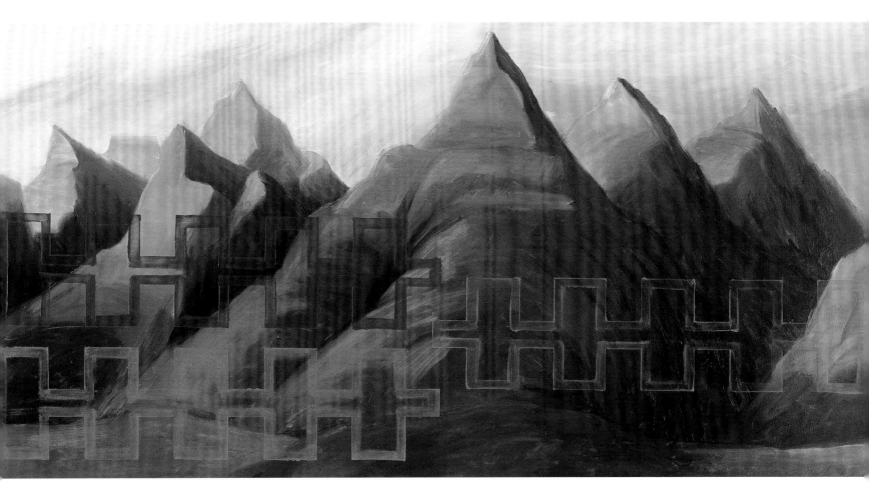

100. *Nez Perce Crossing, Variation,*
2008. Oil stick on paper, 25 x 50 in.
Collection of the artist.

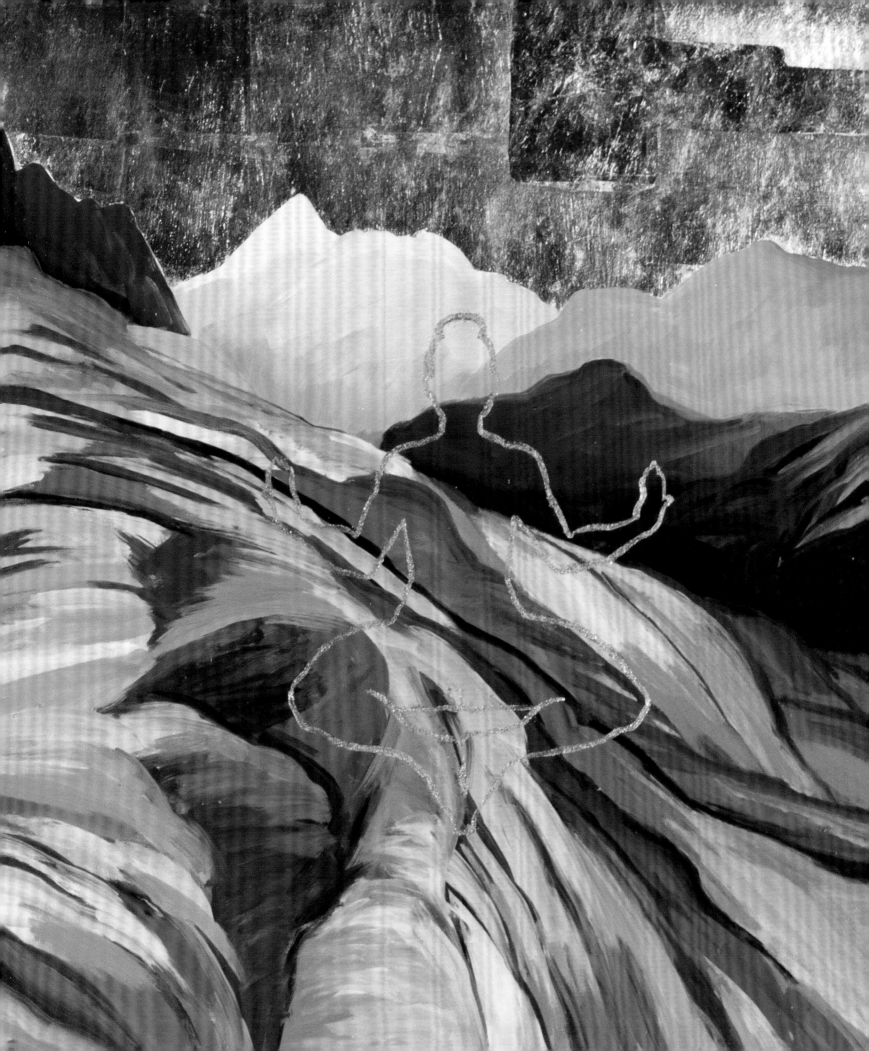

LISA ROBERTS SEPPI

THE ARTIST IN ITALY
DESIRE, THE BODY, AND THE DIVINE

After presenting about Kay WalkingStick's work at the "Essentially Indigenous?" symposium at the National Museum of the American Indian in New York City in 2012, I was approached by well-known Native artist who confessed his surprise at the importance of Christianity in the artist's work and her conversion to Catholicism in 2000. Later that evening, as I relayed this conversation to WalkingStick, she smiled knowingly and said, "That's because nobody ever asks, but it's right there [in the work]."[1] Throughout WalkingStick's forty-year career, the majority of discussions of spirituality in her work have focused on its relationship to her Cherokee heritage or Native American cosmologies. In light of the artist's own statements about the strong spiritual bond she feels toward the earth—a bond shared by many artists of Native American descent—this is an appropriate, but also an incomplete, response, one that ignores the influence of her early religious upbringing in a tight-knit Protestant family and the extent to which the Christian values and concepts ingrained in her mind as a child have informed her work from the beginning, and the added effects of years spent in Rome.

During the mid-to-late 1990s Kay WalkingStick began making regular sojourns to Italy, where she often spent months at a time living in Rome. Influenced by the art, geography, and cultural climate there, WalkingStick's work underwent numerous conceptual and aesthetic transformations in content, format, style, color, medium, and process. Throughout this work, WalkingStick continued to employ a diptych format. Instead of combining naturalistic landscape imagery with nonobjective form, however, she replaced her well-established abstract vocabulary of arcs, ovals, and circles with figurative imagery ranging from Roman fauns to large-scale female nudes. Although this new imagery demarcates a stark break with the abstract iconography and the uninhabited landscapes contained in WalkingStick's earlier diptychs such as *Hermosa Ridge, Variation* (1988) and *Spirit Center, II* (1992), the return to more conventional figurative art testifies to the ongoing importance of bodily imagery throughout her career (fig. 81).[2] WalkingStick's work remains tangibly involved with her intimate bodily experience, sensuously celebrating the materiality of the body and the human relation to land and place. At the same time, she also explores the meaning of and possibility for different kinds of mystical or spiritual encounters—ambiguous and elusive occurrences often associated with sensations of disembodiment or physical transcendence—with which religion and sexuality are familiar. While many of WalkingStick's conceptual interests from earlier in her career remain the same, including her preoccupation with the mind-body dualism embedded in Western metaphysics, the sacredness of the earth, transcendentalism, and the primacy of the body and touch, these subjects are now filtered through the experiences of a mature artist involved with addressing the physical, psychological, and spiritual changes and issues that generally arise later in life. Through WalkingStick's interest in mythology, art history, and contemporary art and religion,

101. Detail, *Il Sogno, II*, 1998.

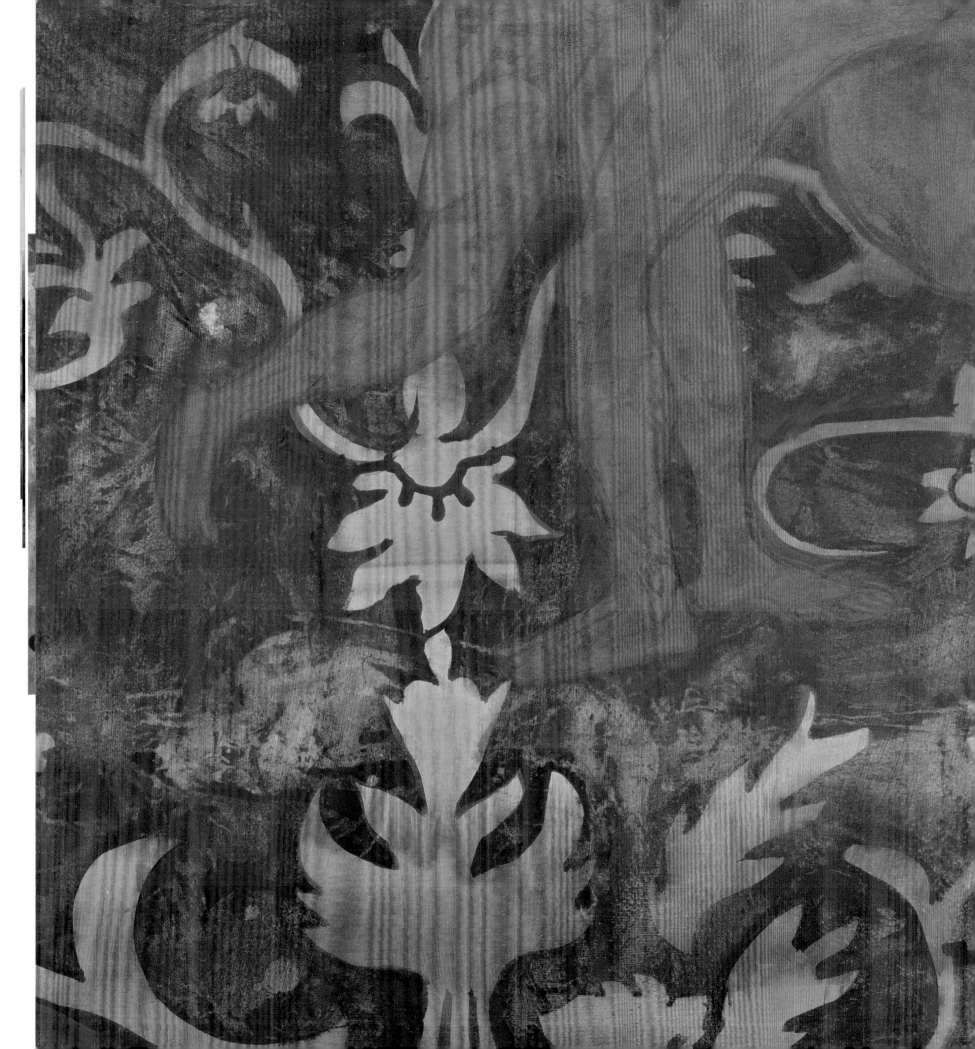

102. *Kokopelli Energy*, 1996.
Gouache on gessoed paper, 19.25 x
38.5 in. Collection of the artist.

In drawings such as *Kokopelli Energy* or *Mountain Men* (both 1996), WalkingStick juxta-posed mountains with representations of Kokopelli, Roman fauns, and Eve, separating them between left and right halves of the paper. The Humpback or Hunched-back Flute Player, also known as Kokopelli (a name from Hopi, where he is also a katsina dancer), is seen in numer-ous prehistoric pictographs and petroglyphs in Arizona, Colorado, New Mexico, and Utah, occurring most often near the ancient Anasazi sites of Mesa Verde, Chaco Canyon, and Canyon de Chelly. Although rock art portrayals vary, he is easily identified by his curved or bent-over posture denoting a humped back, a visually pronounced or erect phallus when present, and often, but not always, carrying or playing a flute. Although scholars debate his exact function in ancient rock art, ranging from associations with hunters and trade to animals and fecundity, the well-known modern figure of Kokopelli is considered a mischievous fertility figure fabled for his sexual prowess and playful, prankish antics.[8] WalkingStick's faun figure, based upon the small bronze statue from the House of Faun in Pompeii, is another inviting figure that entices us to put away our intellectual constraints and enjoy ourselves. In Roman mythology, fauns are identified with the Roman god Faunus and equated with Greek satyrs, the male attendants of the wine god, Dionysus (who is also depicted in the Villa of the Mysteries frescos in Pompeii).[9] Like Kokopelli, whom WalkingStick describes as a "tempter" that "beguiles us with his erect flute," fauns and satyrs seduce nymphs with their music. The wanton, uninhibited sexuality and mischievous personalities associated with these wild, mythic male characters influenced the direction of WalkingStick's work as she became interested in engaging what she describes as "mythic corporeality."[10] Kokopelli and fauns are rustic deities personifying lust and carnal desire.[11] They symbolize the classic dialectic struggle between disciplined reason and unre-strained desire.

103. *Eve Energy*, 1996. Gouache on gessoed paper, 19.5 x 38 in. Collection of the artist, courtesy of June Kelly Gallery.

This struggle is also embodied by the figure of Eve, who features prominently in drawings like *Eve Energy* (1996), which includes six silhouetted bodies of Eve, rendered as headless, truncated figures, alongside stenciled legs. Some of the legs comprise parts of what appears elsewhere as a stylized image of a copulating couple. On their own the free-floating legs are a metaphor for disembodied experiences—sexual or otherwise—that cause us to feel as if we physically come apart or temporarily transcend the physical boundaries of our bodies.[12] The biblical temptress, Eve, also alludes to a physical state ruled by nature and the primal forces of desire.[13] Like Kokopelli and fauns, Eve is another figure signifying what happens when reason and intellect do not restrain one's emotions and passion. Within the Judeo-Christian tradition, Eve was the source of humankind's original sin, which resulted in the Fall and expulsion from the Garden of Eden. As punishment for Eve's transgression, God reduced humankind to a "state of death," a loss of the "supernatural gifts" of innocence, wisdom, and bodily immortality; more pointedly, humans would now experience old age, suffering, and ultimately death.[14] In Christian thought, Eve comes to embody the fallen condition of humankind and the debased materiality of the body and physical world, both of which must be controlled and transcended.[15]

WalkingStick does not share these dogmatic views of Eve or the need to suppress one's passion and desire. In fact, similar themes in her work from the 1980s, such as *Garden of Earthly Delights* (1981), *Genesis/Violent Garden*, (1981) and *Satyr's Garden* (1982), were informed by knowledge of Mitochondrial Eve (figs. 64, 72).[16] The Mitochondrial Eve thesis, based upon human genetics research begun in the late 1970s and early 1980s, refers to the most recent common female ancestor of all modern living humans, who lived in Africa approximately one-hundred-forty-thousand to two-hundred-thousand years ago. Despite the name Eve, Mitochondrial Eve doesn't reference the first woman or biblical Eve but instead speaks of a woman (one of several) believed to be the genetic ancestor of modern humans, linked through mitochon-

drial DNA, or mtDNA.[17] Despite being taken as support by some for Christian ideas about biblical Eve as the original woman of humankind, others have argued that Mitochondrial Eve actually undermines that notion. Mitchondrial Eve is only the "most recent" common woman, not the first woman, from whom modern humans received their mtDNA; Mitchondrial Eve also had a mother. Therefore in using the scientific rather than the biblical Eve, WalkingStick represents and honors all women as mothers. Perhaps more significant for WalkingStick's work and thought process at the time was the need to challenge the Christian ideas of Eve not only as *the* first woman but as the symbol of carnal lust and the sins or guilt associated with succumbing to temptations of the flesh. It is after Eve's actions (eating fruit from the forbidden tree) that she and Adam fall from God's grace, paradise on earth is lost to them, and they become aware of and ashamed of their nudity. Eve's disobedience is the cause of humanity's original sin, the blame for which is laid upon all women through Eve, recast as a temptress. According to WalkingStick, Eve's "error is highly overrated in our patriarchal society." She is a "maligned girl" who was simply following her "curious nature."[18] In work like *Satyr's Garden* the tactile quality of the dense surface, made of saponified wax and acrylic paint, along with the bright red shapes, one of which appears swollen, intentionally makes reference to the physical body. As WalkingStick stated, "They're about sexuality . . . so to really avoid that is avoiding a lot of the importance of what's going on in the work. There is this sensual, physical being that is making these things" about the sexual as well as the spiritual or transcendent.[19]

In the drawings from the 1990s discussed earlier, WalkingStick's rich color palette, along with the painterly appearance of the materials and the lush surface sheen (the latter of which is created by applying spray varnish to painted and gessoed paper), adds to the overall celebratory and sensual pleasures intuited by the figures. As part of a larger whole, this work testifies to the impact of Italian culture and art on WalkingStick's life and artwork. "It was the right moment for everything to come together," she stated in 2004. "I had finally finished grieving over my husband's [Michael's] death. I was living in this beautiful area surrounded by these glorious churches and palazzos . . . and I had an Italian boyfriend there who was half my age. . . . There was this whole world that was so different. In Ithaca it was like living in a monastery."[20] WalkingStick's figures are clearly influenced by the preponderance of erotic imagery seen in the art of classic Greece and ancient Rome. In her travels throughout Italy, WalkingStick was affected by the sexually explicit public frescoes at Pompeii in the Suburban Baths and the Houses of the Mysteries, the Vetti, the Centenary, and the Caecilius and also at the Villa under Farnesina in Rome, as well as the red-and-black-figure painted pottery or the mass-produced Arretine ceramics, the latter two of which place lovemaking couples in symposium or banquet settings.[21]

In addition to classical art, the plethora of Renaissance paintings with Christian themes struck a chord with WalkingStick, whose own religious upbringing in a close Protestant family involved routine talk about God and spirituality. As WalkingStick stated in a 1997 interview, "a lot of that interest [in transcendent imagery] was stimulated by my early religious education, which forced one to deal with primal things—beginnings, life, and death—and the meaning of existence. . . . These questions have been part of my thought bank and therefore my paintings all of my life."[22] In fact, Édouard Manet's 1864 painting, *The Dead Christ with Angels*, one of WalkingStick's favorite artworks at the Metropolitan Museum in New York, had already provided her with inspiration for dealing with the difficult subject of transcendent imagery (fig. 129). In Manet's work the corpselike body of Christ is depicted leaning upright against white linens while two angels with outstretched wings flank him on either side. Although Christ's face is obscured by shadow, his dark eyes appear to engage the viewer and call attention to

104. Duccio di Buoninsegna
(ca. 1255–ca. 1319). *The Tempta-*
tion of Christ on the Mountain,
1308–11. Tempera on poplar panel
(cradled), 17 x 18.125 in. The Frick
Collection, 1927, 1927.1.35.

the mysterious events unfolding before them. WalkingStick spent hours looking at and analyzing this painting, which she maintains "is often misinterpreted."

> The dead Christ is the corporeal becoming incorporeal. I didn't believe it was possible to paint such an esoteric subject until I stood in front of that painting and analyzed it—I'd seen it a hundred times. I finally realized that Christ is becoming spirit; you can see it.... Part of the body is evaporating.... And I realized it was possible to suggest the spirit in painting.[23]

Therefore, whether looking at Duccio di Buoninsegna's mountains with their ethereal gold skies denoting sacred space or the humanist portrayal of saints by Michelangelo Merisi da Caravaggio (1571–1610), Italian art seemed to share some of her interest in merging sensual and spiritual content (fig. 104). Most visitors to Rome, regardless of their religious position, cannot help but be moved by the legacy of the Catholic Church through its majestic, awe-inspiring churches and art. For an artist like WalkingStick, however, who for most of her career was engaged in an ongoing dialogue with the spiritual, the appeal of religious culture in Italy was profound, but not only in the way one might expect.

The modern city of Rome has undoubtedly been shaped by the presence of the Pope and Vatican City, the center of the Holy Roman Catholic Church. As Percy Allum, professor of political science at the Instituto Universitario Orientale in Naples, has pointed out, however, by the 1960s Italy was no longer a Catholic country. With practicing Catholics in the minority and membership in organizations like Catholic Action having declined by two-thirds between 1966 and 1971, the 1970s was marked by Catholic dissent, which he argues reached its peak in 1974 with the referendum in favor of divorce. According to Allum, of the 80 percent of Italians who believe in a Christian God, less than 30 percent believe in Catholic precepts that apply to matters of sexual morals and family. Thus, after being in power for more than fifty years, the Catholic Democratic Party has disappeared.[24] Consequently, while the art and churches of Italy speak to the traditions of Christianity or religious pursuits in general, Italian culture no longer rigidly adheres to Catholic dogma.

Another significant feature of contemporary Italian culture involves attitudes toward sexuality, which stem from what David Brown sees as the "ancient Greek understanding of beautiful bodies as graced by the divine," which was renewed in the Renaissance; the frequency with which "sexually explicit imagery was part of the public sphere and not the private" in the ancient world; and the "potentiality of sexuality as a religious metaphor" in the Baroque art of Rome, as can be seen in *Blessed Ludovica Albertoni* (1671–74) and *The Ecstasy of St. Teresa* (1651) by Gian Lorenzo Bernini (1598–1680).[25] As a result, the mixture of ancient mythology and Christian faith has produced a cultural climate that, according to WalkingStick, openly accepts and celebrates the human body and sexuality. "In Rome," explains WalkingStick, "there is a heightened sensuality, a body consciousness, a constant awareness of the duality of sexuality that the United States simply no longer has, probably never did."[26] Living in this atmosphere was a liberating experience for WalkingStick, particularly as an artist whose work has consistently demonstrated a concern with exploring the sensuality of the body alongside spiritual matters.

SELF-REFERENTIALITY AND ROME: THE ITALIAN SUITE

WalkingStick returned to Italy during the summer of 1997 and again for two months in 1998 when she was an artist in residence at the American Academy in Rome. She made numerous sketches of the Italian Alps. Commonly referred to as the Dolomites, this mountain range extending across northeast Italy contains some of the country's most dramatic landscapes, with spectacular limestone spires and lush green alpine meadows. WalkingStick used these sketches to produce a set of charcoal drawings known as the *Italian Suite* series and several diptych paintings. WalkingStick's autobiographical approach toward landscape, particularly her identification with the mountains of Italy, is a distinguishing feature of this work, which contains large-scale images of the nude body, some of which are based upon WalkingStick's own, superimposed above or physically embedded within expansive alpine settings. Despite their imposing scale, the figures are intimate and human. The naturalistically detailed, often graphically explicit figures convey a broad range of psychological conditions. In these extremely self-referential works, WalkingStick continues to explore the raw, physical materiality of corporeal existence by detailing her relationships, as well as her newfound love of Italy.

In several drawings, dark haunting figures express sexual potency and emotional turmoil. In *Alpine Mäenad* (1997), a large female figure crouches down on all fours (fig. 105). Her body is turned away from the viewer, fully exposing her naked buttocks. She faces what appears to be a treacherous and foreboding mountain setting where white jagged ridges rise up alongside her like flames. The position and dark tonality of the figure's body prevent a clear reading of her demeanor. She appears to have her head cupped in her hands, suggesting she is agitated, confused, or distraught. Maenads (which feature prominently in the Villa of the Mysteries frescoes in Pompeii), also known in Roman lore as bacchantes, were the priestesses of the Greek god of wine, Dionysus (Roman god Bacchus). According to mythology, during orgiastic rituals maenads became possessed by the spirit of Dionysus and, in a drunken, naked frenzy, tore apart and consumed the bodies of animals or their sacrificial male victims. In less salacious accounts, the Dionysian cult's rituals used trance-inducing practices (like consuming wine and dancing) to reach a state of liberation or freedom from social constraints and self-imposed inhibitions. Clearly WalkingStick's maenad does not appear to be in an ecstatic state of sexual frenzy; nonetheless, she is meant to suggest the unrestrained sensual character associated with maenads and

113. *ACEA I*, 2003. Gouache and
gold acrylic on paper, 19 x 38 in.
Collection of the artist.

114. Marble pilaster with acanthus scrolls. Roman, early Imperial, Julio-Claudian, 1st half 1st c. AD. Marble, 138 x 28 in. The Metropolitan Museum of Art, New York; Rogers Fund, 1910. 10.210.28a–c. Image © The Metropolitan Museum of Art. Image source: Art Resource, NY.

joy are intrinsically linked to spirituality. There is "joy in the heavenly spirit," she explains, "joy in the human spirit."[43] In addition to expressing physical and spiritual joy, the paintings generate greater awareness of the unity between mind and body, which WalkingStick sees as intrinsic to the unity of the body/matter and mind/spirit. "It is through the body and the mind that we experience the spiritual," explains Walking-Stick. "We need an awareness of the body/mind relationship in order to seek the spiritual; we need both a body and a mind to transcend."[44]

Through the combination of figure, landscape, and gold sky, WalkingStick expresses the unification of inner and outer being. Her work demonstrates that material reality can provide access to a profound spiritual reality. In an essay from 1999 titled "Seeking the Spiritual," WalkingStick expressed her frustration with how to discuss and represent that which cannot be represented (life, death, eternity, the mystical), posing the question, "How does one address the spiritual in art without sounding like an airhead? . . . It certainly is not a 1990s concern."[45] As Richard Francis, then chief curator at the Museum of Contemporary Art, Chicago, similarly pointed out, the problem with using terms such as "mystic" or "mystical" is that they "often suggest a weak or intellectually inadequate response, the softened edges of a populist attempt to be 'in touch' with the 'beyond.'"[46] Despite the challenges in dealing with these concepts, WalkingStick maintains that the spiritual is still relevant to contemporary art. "I think there is a segment of the population who still believe in a kind of importance to profound, deep content," explains Walking-Stick. "It's not qualitative but something that I respond to as a truth about how to live life. . . . I want to look at art that touches my soul as well as entertains the eye."[47] Whether we are looking at carefree figures dancing in a state of dreamlike euphoria amidst gold-leaf skies, or fauns frolicking alongside Eve with imposing mountain summits behind, these Italian-inspired works of art speak of a life that, despite its fair share of tragedy and struggle, has reached an enviable state of spiritual and physical bliss.

ART HISTORY'S TANGLED LEGS

I recall dance classes and strange intimacies. Clammy hands, smooth skin, sure steps, sharp smells. The imminent possibility that I might trip over a toe twice the size of mine and end up entangled.

In Kay WalkingStick's *ACEA* series (2003), dance is a recurring subject. Even when the limbs of coupled bodies are nowhere visible, a dance sensibility lingers across the seven works on paper (figs. 113, 117, 118).[1] The same physical proximity—pleasurable, precarious—is apparent in the scuffed surfaces of gouache, acrylic, and crayon; the pirouettes of vegetal tendrils; and the swaying towers of flora in shades of terra cotta, cream, or gold that look—no, *feel*—a bit sticky. Replacing the landscapes more common to WalkingStick's practice, a repeating plant motif forms an organic grid that divides each paper into asymmetrical halves. To gaze at the wayward structure of vines is to experience a slight loss of equilibrium, to be made acutely aware of the human capacity, as described by Immanuel Kant, "to feel a difference . . . between my right and left hands."[2] WalkingStick's long-standing concern with conveying embodied (rather than purely optical) experience through painting crystalizes in the *ACEA* series, as she arrives at dance as an analogy for a sensuous, communal art history. She notes that dance "is the one activity that I know of that virtual strangers can embrace. . . . It has this intimacy that is usually socialized and controlled."[3] We are compelled to join WalkingStick's embrace of materials, patterns, and figures drawn from classical and modern precedents, collapsing the distance and decorum we normally maintain before great works of art.

Travel abroad prompted WalkingStick to recognize the painterly potential of dance. The series parallels her growing familiarity with the artistic culture of Italy, where she arrived, a stranger, in 1996. She recalls, "I fell in love; I was absolutely, madly in love with it."[4] She returned year after year thereafter to study classical and Renaissance arts in Italy's innumerable museums, villas, and temples.[5] The recurring plant pattern appears in the artist's detailed sketchbooks in 2001, drawn from observation of a first-century-BC mosaic displayed at Azienda Comunale Energia e Ambiente (ACEA), a museum of antiquities housed in the former Montemartini power station on the outskirts of Rome (fig. 116).[6] The fleshy and well-muscled nudes of two-thousand-year-old marble statuary fill the same book. WalkingStick later translated the sketches into vivid color on the pages of the *ACEA* series, where they meet and mingle, inviting us to lovingly transform all that is cool, distant, and strange into intimate, sensorial knowledge.

115. Detail, *ACEA V*, 2003.

116. Detail from sketchbook (Istanbul, Rome, Pompeii, US Southwest), 2001–3. 11 x 13.5 in. Collection of the artist.

117. *ACEA V*, 2003. Gouache and gold acrylic on paper, 19 x 38 in. Collection of the artist.

118. *ACEA VI, Bacchantes*, 2003. Gouache, conté crayon on paper, 19 x 38 in. Collection of the artist, courtesy of June Kelly Gallery.

WalkingStick's heterogeneous process is integral to the relationships unfolding on paper. To create an exemplary work from the series, *ACEA V* (fig. 117), she began with a mottled wash of acrylic. Overlaid with blue gouache, the contours of flora were left bare, gleaming like the forms on Athenian red-figure vases. The artist repeatedly laid towels on the wet overcoat, scraping and removing blue pigment to create an encrusted surface. Lastly, she drew the dancers' legs in a crayon the color of burnt sienna, never fully covering the layers of paint. Lacking a perspectival ground, feet in *ACEA V* appear to have churned up the whole page with their movements. Nor does the plant motif lie passive beneath their implied activity. Vines shimmy up the dancers' semitransparent legs, caressing them, tugging gently. Fused together by WalkingStick's hybrid method, figure, pattern, and paint pull one another into an indeterminate space, neither classical past nor familiar present.

We are made vulnerable to the dancers' limbo in a number of unique ways. *ACEA V* is the first work in the series (followed by *ACEA VIII* and *ACEA IX*) in which the figures are coupled in dance and cropped at their thighs by the top edge of the paper. No longer observable in their ideal totality, the dancers are rendered androgynous, active, and touchable, the contemporary equivalent of Pygmalion's kiss.[7] As WalkingStick has pointed out, we receive a similarly truncated view of our own bodies when looking down.[8] Bare limbs of indeterminate sex invite us to project our own bodies into the image, a sensation that is enhanced by the tactility of the abraded surface. A brief comparison of *ACEA V* with *Gioioso, Variation II* (2001), a diptych inspired by WalkingStick's visit to Fietta, Italy, clarifies the new effect (fig. 112). In the latter, the

cropped, opaque gold legs of dancers are anchored by a silhouette of brown mountains behind them, which is then articulated in the panel to their left. By trading a tangled surface of vines and limbs for traditional landscape elements, WalkingStick releases her figures from the seal of specific places, creating a sense of greater proximity to our bodies.

The floral motif involves an additional hook, described by anthropologist Alfred Gell as the "cognitive stickiness" of pattern. Gell explains that when we look at repeating designs in wallpaper, textiles, and other decorative arts, we only ever grasp a fragment of an implied whole that extends far beyond the limits of the human eye.[9] Pattern generates a material web that entraps and decenters us within its vast and seemingly inexhaustible world. It also has a social function, as its filaments wrap us into relationships with distant humans who have likewise become attached to the work. By repeatedly excerpting the Roman mosaic, WalkingStick enthralls us in a mesh that is material, social, and even transhistorical, encompassing the works in the *ACEA* series, the past art forms cited within, and the people (ancient Romans, WalkingStick) who made them.

WalkingStick makes the communal element of her vision explicit in *ACEA VI, Bacchantes*. Instead of coupled legs, four nearly complete figures fill the frame (fig. 118). Delineated in a deep orange crayon matched to their surroundings, they are named for the followers of the god Bacchus, driven to ecstasy through dance and drink.[10] Creamy white vines thread through their arms and caress their breasts, like the streams of milk that the Bacchantes scratched from the earth at will in Euripides's famed version of the myth.[11] WalkingStick's rendering also acknowledges that classical mythology has a long afterlife in art history, especially in European and American painting of the early twentieth century. The interlaced duality of reason and revelry, found throughout the Greek and Roman pantheon and reinterpreted in the work of nineteenth-century German philosopher Friedrich Nietzsche (1844–1900), appealed to members of a transatlantic avant-garde seeking the unconscious or mythic underpinnings of a world riven by industrialization and warfare.[12] The famed *Dance II* (1909–10) by French modernist Henri Matisse (1869–1954) shares with WalkingStick's *ACEA VI, Bacchantes* a basic composition of dancing female nudes in red. In his canvas, five figures clasp hands to form a circle against color-blocked fields of green and blue, suggesting elemental earth and sky. Although the modernist cropping and flattening of perspective draws them near, the backsides of dancers close the circle to us. They exist apart from us, performing a primitive spectacle for our gaze.[13] In *ACEA VI, Bacchantes*, the dancers face us in a semicircle amidst a horizonless maze of paint and flora. Their raised fingertips brush the edge of the page; one arm reaches past it, recalling the cropped legs of *ACEA V*. More than a metaphysical vision, their appeal is tactile and corporeal. They embrace us in a jubilant choreography that crosses art historical periods, locations, and cultures.

The *ACEA* series sensuously bridges the distance that art history often engenders. Scholars typically locate objects in their specific cultural contexts, uncovering the myths and practices that define makers and communities at a particular juncture in time and place. This project is literally bolstered by glass, ropes, and alarms that protect artworks from inquisitive visitors to museums, which invite us to look but not touch. On WalkingStick's paper, citations of classical and modern art meet, mix, and move. They sway us, tip us off balance, and pull us into the web of their worlds, even as we tug them into ours. They invite us to approach art history anew, as a dance lesson. Like many in the United States in the twenty-first century, I greet bacchantes and Matisse as strangers. WalkingStick's work is a medium for my entanglement.

LAND THROUGH TIME

Between 1974 and 1976, Kay WalkingStick painted a series of thirty-six small, heavily textured abstract paintings dedicated to Chief Joseph, the great Nez Perce leader who almost succeeded in leading his people to safety in Canada while pursued by the US Army (fig. 57). In 2003, 2004, 2007, and 2008 she reenvisioned the series by representing the places and arts associated with Chief Joseph's life (figs. 4, 31, 32, 83, 99, 100, 120). In the interim, a period of more than thirty years, there was a shift in her approach to landscape as it became an increasingly powerful presence in her work. In the earlier (mid-career) production, her characteristic diptychs paired western and Plateau landscapes with geometric/organic forms on or in a monochromatic impastoed ground, the surfaces reminiscent of "tilled earth, dense and agitated" (see Penney, this volume). For a while, the pictorial side was flatter, more clearly an illusion, or representation, while the single form, on a thicker stretcher, protruded as much as three-and-a-half inches, to make it "more real." Different as they are, the two do not so much contrast as interact. "One is not the abstraction of the other," she explained. "One is the extension of the other."[1]

WalkingStick associated uninhabited landscapes, their often brilliant colors and golden skies, with "the eternal."[2] Time is a recurring theme in her work. In fact it is almost impossible to separate time and space when thinking about landscape. She has said of these diptychs, "I do not see my paintings as landscapes, per se, but rather as paintings that describe two kinds of perception of the earth. One view is visual and fleeting and the other is abstract and everlasting."[3] She avoided specificity, wanting the landscapes "to stand for more than just one place and thereby take on a mythic character." But more recently she reflected, "Why not let the place be what and where it is? It still carries its own mythic quality."[4] On the back of the paintings shown in 2013 in her *American Landscape* exhibition, she identifies the tribal source of the superimposed symbols and the location of the image (figs. 85, 124, 133, 136).[5] For example, traditional Northern Cheyenne beadwork designs traverse an image of St. Mary's Mountain in Montana. They are no longer separated from the land, on the other side of the diptych's divide, but seem to dance above it or even emerge from its horizontal span. More ephemeral than the layered paint of the earlier single forms, their delicate presence transforms the landscapes into actively spiritual sites that remain meaningful even as they have become "property" in the dominant culture. Hills and mountains are perceived as forces rather than objects.

WalkingStick's most recent landscapes brilliantly achieve the unity that is her aesthetic goal. Earlier works indicate different attempts to integrate the two sides of the paintings, such as in *Our Land* (2007) (fig. 120), in which a brightly colored and patterned vertical band asymmetrically slices the landscape, or *The Sandias* (2008) (fig. 121), where an abstract textile or pottery pattern fills the left side. These works have precedents in the early 1990s; for instance, *Eternal Chaos/Eternal Calm* (1993) (fig. 122) and *Seeking the Silence, I* (1994) (fig. 123) feature panoramic

119. Detail, St. Mary's Mountain, 2011.

vistas overlaid by two equilateral crosses that move across the divide, foreshadowing the paint-
ings she would make more than twenty years later.

In the late 1990s, after many years of absence, figures, often dancers, reappeared in Walking-
Stick's work, invoking a kinesthetic or haptic memory of the relationship between humans and
nature. The landscapes are from the American West or the mountains near Fietta in Italy, where this
series began. In *Il Regalo* and *Il Sogno, II* (both 1998), the figures are insubstantial, superimposed in
outline over the vistas like ghosts, or visions (figs. 108, 109). The introduction of gold leaf, evoking
early Italian religious images, persisted in recent works, such as the glowing *Going to the Sun Road*
(2011) (fig. 125). In the *ACEA* series (2003), Dionysian figures dance in decorative floral fields, which
might be seen as landscape, close up and schematized (see Horton, this volume).

The emotions embedded in WalkingStick's landscapes may be enigmatic to viewers, but
they can be almost tangible. This is especially true in the works painted at the time of her hus-
band's death in 1989, in which images of waterfalls in Ithaca, New York, paired with her signa-
ture geometric forms, became expressions of pain and loss (see Penney, this volume). Billowing
waves of thick red, white, and black paint represent the "unstoppable onrush of time."[6] Most of

124. *St. Mary's Mountain*, 2011. Oil on wood panel, 36 x 72 in. Collection of the artist, courtesy of June Kelly Gallery.

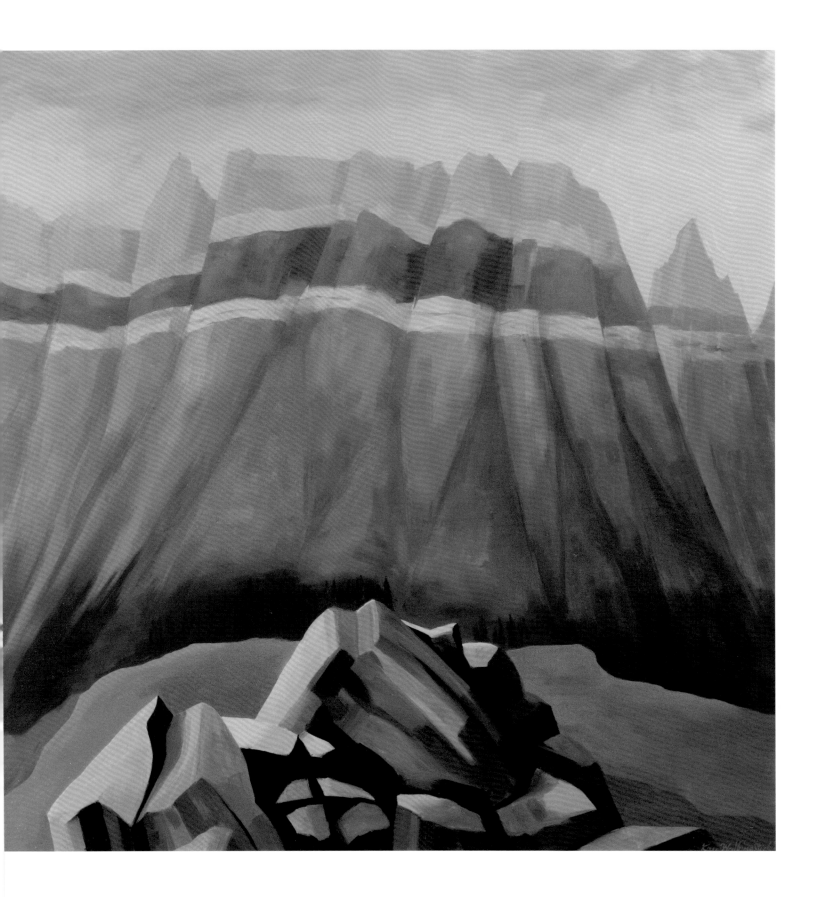

In 1991, Quick-to-See Smith noted that it is rare to find realism or even a horizon line in contemporary Native landscapes. At the same time, specificity lies in cultural detail: "Traditional foods, ceremonies, and art come from the indigenous plants and animals as well as the land itself."[18] Anthropologist and curator Bruce Bernstein has remarked that the lack of background and horizon was not the invention of the Dorothy Dunn Studio at the Santa Fe Indian School; they were simply unnecessary in Native traditions focusing on the "creation and continuance of life." He continued, "Native people do not need markers to remind them of where they are."[19]

One of WalkingStick's favorite artists is George Morrison (Grand Portage Band of Chippewa, 1919–2000), who did paint horizons, including a 1980s series of sixty-one paintings called *Horizon*, in which land and sky are glowing abstract fields of color.[20] Morrison used the horizon line the way WalkingStick uses the vertical division in her diptychs. A role model for younger artists, in that he refused to allow his work to be judged on anything but an aesthetic (rather than ethnographic) basis, Morrison once said, "I seek the power of the rock, the magic of the water, the religion of the tree, the color of the wind, and the enigma of the horizon."[21] Many of these are factors in WalkingStick's work as well. The role of light in her paintings is understated but significant. The earliest landscapes in Walkingstick's exhibition at the National Museum of the American Indian are close-ups of conventionally dappled light on the Hudson River (1973) (figs. 5, 48). Thirty years later, she used light in a very different way to illuminate and temporally differentiate the two mountain peaks in *Farewell to the Smokies* (2007) (fig. 127).

While WalkingStick may have been deprived of a geographic upbringing within a Native context, long ago she found a community among avant-garde Native artists. At the time of the inauguration of the Eiteljorg Museum's Fellowship for Native American Fine Art in 1999 (she was a juror for that first exhibition), she noted that Native artists entering mainstream or formalist art conversations "do not lose our identities, only broaden our vision."[22] Her own work reflects a balance between memory and lived experience: "one is momentary and particular, the other is permanent and non-specific."[23] Her goal is to unite the two, to achieve a wholeness including all living things as well as the cosmos by combining the present, past and future—something that she has often achieved, but especially in her most recent work. She once said that she was "more interested in landscape's inherently abstract qualities and its personal meaning than its narrative or decorative qualities." She continued, "It is through abstraction that I perceive transcendence, and in that sense I am perhaps not a landscape painter at all."[24]

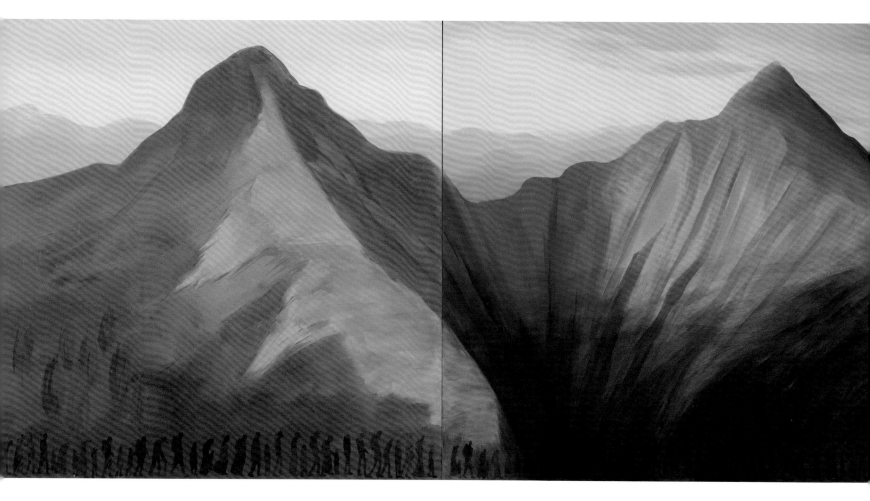

127. *Farewell to the Smokies*, 2007.
Oil on wood panel, 36 x 72 x 1 in.
Denver Art Museum, Colorado;
William, Sr., and Dorothy Harmsen
Collection. 2008.14

PAINTINGS FROM PAINTINGS

128. Detail, *Two Walls*, 2006.

129. Édouard Manet (1832–1883).
The Dead Christ with Angels, 1864.
Oil on canvas, 70.625 x 59 in. The
Metropolitan Museum of Art, New
York; H. O. Havemeyer Collection,
bequest of Mrs. H. O. Havemeyer,
1929 (29.100.51). Image copyright
© The Metropolitan Museum of Art.
Image source: Art Resource, NY.

As it is for most artists, Kay WalkingStick's thought processes and artistic strategies often evolve in response to greatly admired works of art made by others, past and present, as if in visual conversation. When Walking-Stick visits the Metropolitan Museum of Art in New York, for example, she almost always stops to look at Édouard Manet's painting *The Dead Christ with Angels* (1864) (fig. 129). Only half joking, she claims to have to check on her favorite paintings to ensure that the museum is taking good care of them. Some paintings have won her attention and have subsequently "fallen under her care" because she has noted within them qualities that resonate with her own concerns. Perhaps Manet was preoccupied with themes and devices that she knows well and considers central in her own artistic practice. WalkingStick has an eye for various approaches to liminal space in works of art, forms and configurations that she understands as existing somewhere between the corporeal and the incorporeal. She is eager to rediscover the way that Manet and others accomplish this effect and to point out just where such a transition or extra dimension is suggested. Each time she sees *The Dead Christ*, she has a strong sense of "the spiritual life emerging from the solid body in the painting."[1] Sure enough, when I stand before the painting with her, I see—at her prompting—that the feet of Christ seem unmoored and that the head, buoyed by the arm of an angel, looks toward some numinous dimension.[2] Clearly, her relationship with this painting is personal and powerful, related to an internal experience that characterizes some part of her own artistic process.

From the outset of her career, WalkingStick has reflected upon the philosophical implications of a broad range of painted forms. Her reading of the Manet evokes her own quest to represent the transcendental in a relatively broad sense. It is interesting, however, that some other works of art have provided her with much more direct inspiration for both subject matter and the invention of specific visual devices. Throughout this volume, authors discuss WalkingStick's use of Native American art forms in her work, derived well beyond the parameters of her own Cherokee heritage. Yet her thorough knowledge of even-more-far-ranging painting traditions also plays a central role in her work; she has, at times, translated and expressed these influences in provocative canvases that she refers to as "paintings from paintings." A corpus of works that WalkingStick created in Italy that combine mountains and female figures is widely recognized (see Seppi, this volume), but she claims an additional, although less well known, relationship with Italian traditions, for example, by modeling aspects of some work on elements and ideas from much-admired

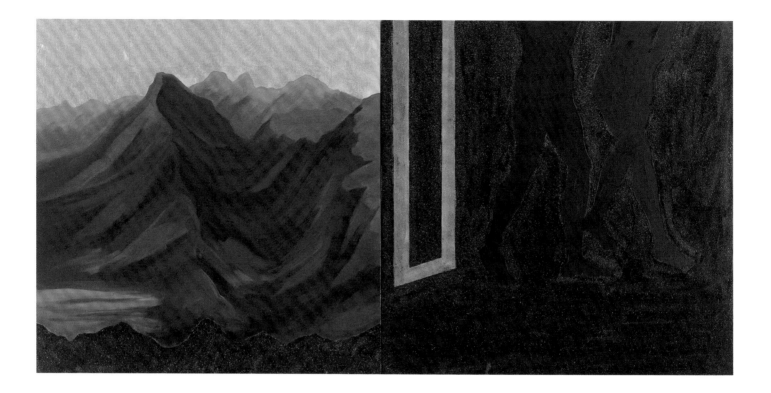

130. *Massacio's Garden*, 2006. Oil, gold leaf, and glass beads on wood panel, 24 x 48 in. Collection of the artist.

paintings. The true scope of these references indicates that her meaningful relationships with an extremely broad range of artists and traditions have not been adequately explored.[3]

In WalkingStick's painting *Massacio's Garden* (2006), for example, she included silhouettes based on figures of Adam and Eve known from *Expulsion from the Garden of Eden* (1428) by the Renaissance painter Masaccio (1401–1428); it is located in the Cappella Brancacci at Santa Maria del Carmine in Florence, where she has visited and sketched many times (fig. 130). WalkingStick's painting is quite different; we see dark suggestions of the figures, but the painting also includes gold leaf and glass beads, making it a rich and sparkling meditation not only on Quattrocento ideas but also on the mosaics and other media more typical of the Byzantine period. Its referent enables WalkingStick's expression of thoughts about darkness and light, on the expansiveness of landscape as opposed to the confines of interior space. This combination of forms is her own, but it is woven through with what we already know about the biblical fall from grace, cited from Masaccio, as well as the conditions of structure and limitation, the rules of the Garden of Eden that we know from centuries of literature and imagery. Many viewers may be even more familiar with the related composition by Michelangelo (1475–1564), *Temptation and Expulsion from the Garden of Eden* (1508–12), located in the Sistine Chapel. The shadows or suggestions of Adam and Eve bring a world of information to this painting with an economy of visual forms, on the basis of our prior experience of them.

Similarly, the right panel of WalkingStick's diptych *Two Walls* (2006) references architectural devices from fresco paintings excavated near Pompeii from the *cubiculum* (bedroom) of the villa of P. Fannius Synistor at Boscoreale (ca. 50–40 BC), which have been on view at the Metropolitan Museum of Art for many years. (fig. 131) The fresco exemplifies a well-known genre, whether the specific painting is recalled or not. On the left panel of *Two Walls*, a silhouetted figure sits upon a mottled golden wall. It cites a fresco by Jacopo Pontormo (1494–1557) called

131. *Two Walls*, 2006. Oil and gold leaf on wood panel, 24 x 48 x 1 in. Collection of the artist.

Vertumnus and Pomona (1520–21) from farther afield; it is still in situ at the Medici country villa at Poggio a Caiano, created for a lunette-shaped space formed by the architectural divisions of a barrel-vaulted hall. The figure is that of a nude youth, reaching for fruit in a garden where pleasure reigns. In *Two Walls*, WalkingStick transgresses time and space for her own purposes, to celebrate Italian light, color, and the significance of painted gestures. She explores relationships between geometric and organic forms that have so preoccupied her for many years now, but here with geographic and culture-specific shapes and colors replete with associations, ready-made and available for her creative translation. The colored walls result from the accretions of paint and light over time, and the lively swags of greenery are the hallmark of a cultivated world, a garden, where nature is known, adored, and bent to serve human purposes, in this case for the enjoyment of the senses. A very different garden than Masaccio's.

WalkingStick has also been deeply inspired by a completely different tradition: Rajput paintings, miniatures from the royal courts of India, that she knows for the most part from books and has mined for the creation of her *Radha and Krishna at Point Reyes* triptych (2007–9) (fig. 132). Some Rajput paintings have long elaborated on the theme of the beauty and the vitality of nature that is linked to the divine love of this couple. The story is sometimes illustrated in set registers that enable the narrative, often with a grove of trees as the leafy shelter that serves as the location of the couple's expressions of love. In WalkingStick's work, the story is also divided into sections, among three square panels. In the first, left-hand panel, Radha looks over her shoulder as she hurries to meet Krishna. In the center, the couple draws together amid a vigorous stand of trees, and in the final frame they embrace in ecstatic sexual union. According to WalkingStick, their intimacy and joy renew the robust forest setting and, in fact, enliven all of nature "for the glory of the whole world."[4] Interestingly, WalkingStick has been painting dancing couples, some in relation to landscape and botanical elements, since 2000.[5] Perhaps she finds

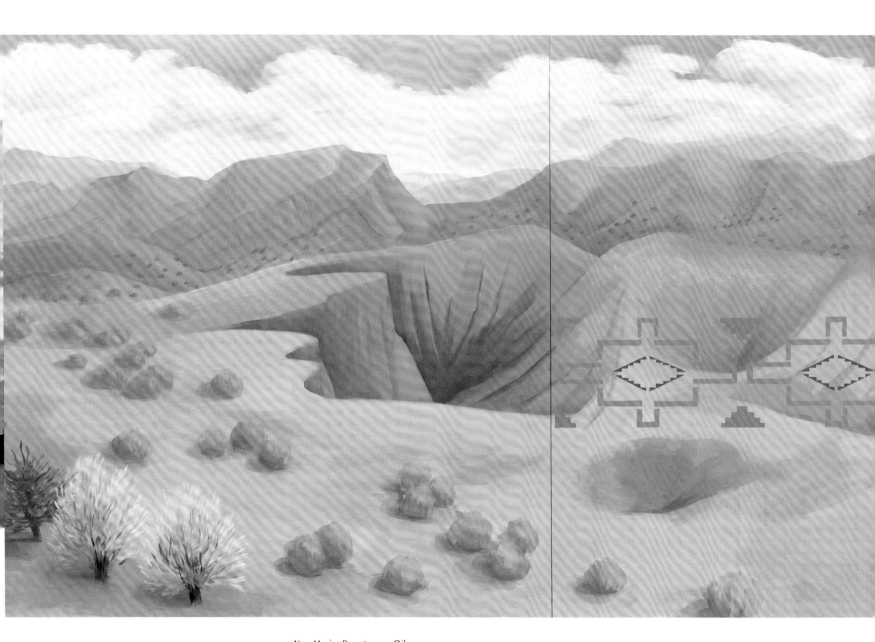

133. *New Mexico Desert*, 2011. Oil on
wood panel, 40 x 80 x 2 in. National
Museum of the American Indian;
purchased through a special gift
from the Louise Ann Williams
Endowment, 2013. 26/9250

KAY WALKINGSTICK
AN AMERICAN ARTIST

The United States is at once new and old, a young nation in an ancient country. As America the immigrant nation sought to articulate its national character in relation to its expatriate roots, the ancient Native nations of the continent struggled almost miraculously to survive. Pointing to her ancestry descending on one side from a white upstate New York family of artists and on the other from Cherokee Walkingsticks deeply rooted in American soil, Kay WalkingStick has always thought of herself as an American artist. Put this way, the thought hardly seems contestable. But the reconciliation of these two fundamental strands of American historical reality—an immigrant nation born of European colonialism and the dispossession-yet-persistence of the nation's Native inhabitants—remains elusive among historians of America and, more specifically for the purposes of this discussion, art historians of American art.

If WalkingStick is an American artist, she creates American art, although what is meant by the term "American art" has been grist for generations of art historians. Barbara Novak, one of the most preeminent among them, once described "the old question 'What is American in American art?" as "an awareness that *what* is American is sometimes not as apt as *how* it is American."[1] In his summary overview of the art histories of American art, John Davis acknowledges a recent "expansion" of the field to include "post-colonial" considerations, and "hybridity" in "forceful new [art historical] work examining Asian American, Native American, and Latina/o production" in ways that challenge "nationalist" readings of American art. He also warned against tying down American art after 1945 with "nationalist baggage" and thus "minimizing the global sweep of later twentieth century art."[2] Moreover, with a view to promoting a "more internationalizing history of American art," a recent discussion of this question asserts that "the term 'American art' has no secure geographical base," and it points to the international origins of many well-known American artists and their transnational interests and experiences.[3]

If by "nationalist baggage" Davis meant a kind of pallid jingoism or the self-imposed blinders that obscure global trends and connections, then we are well forewarned. But these concerns elide the nationalist and very American project of building a modern nation-state on Native land and the accompanying histories of efforts to erase Native presence and sovereignty in America. From a Native point of view, issues of land and place, America's "geographic base," are pointedly American, and the history of American art is thoroughly implicated in them. It is possible to see within the career of Kay WalkingStick a campaign to reclaim this territory and the identity of "American artist."

In the world of WalkingStick as an emerging artist, the grand sum of American accomplishment in the fine arts pointed to New York City in the 1960s and 1970s. The "triumph of American painting," to use art historian and critic Irving Sandler's celebratory phase, signaled a shift of the center of gravity for late modernism from Europe to New York.[4] The advent of

134. Tom Wesselmann (1931–2004), *Nude (For Sedfre)*, 1969. Screenprint; composition: 16.94 x 23 in.; sheet: 23.06 x 29.06 in. The Museum of Modern Art, New York; gift of the artist. Art © Estate of Tom Wesselman / Licensed by VAGA, New York, NY. Digital Image © The Museum of Modern Art / Licensed by SCALA / Art Resource, NY.

135. Joan Semmel (b. 1932), *Hold*, ca. 1971–73. Oil on canvas, 72 x 108 in. Alexander Gray Associates, New York. © 2015 Joan Semmel / Artist Rights Society (ARS), New York.

minimalism, pop, and the eclectic thrust of postmodernism, all of that time and place, confirmed for many New York's artistic primacy. The most influential writers and critics of the day recast American art history to culminate in that New York moment, reading into the most forward-looking New York artistic developments traces of their American forebears. Novak concluded her profoundly influential *American Painting of the Nineteenth Century* with an epilogue that traces a pathway through twentieth-century American art from John French Sloan (1871–1951) to Stuart Davis (1892–1964) to Jackson Pollock to Sol LeWitt.[5] Historian and critic Barbara Rose, in her magisterial book *American Art Since 1900*, broadened and expanded this route through the same material.[6] Art historian Robert Rosenblum, privileging Germanic and Nordic American roots, saw American modernists as the successors to the northern European romantic tradition, which culminated for him in the ethereal works of Mark Rothko.[7] WalkingStick inherited and identified with these narratives.

WalkingStick created her large paintings of the late 1960s and early 1970s in the shadow of New York in the nearby bedroom community of Englewood, New Jersey. Her life-sized silhouettes of nudes in relaxed poses reflect a *Joy of Sex* frankness about what was understood at the time as the sexual revolution, but her theme was really more about sexual liberation.[8] The figures stand or lounge in inviting groups while titles suggest lazy afternoons among friends and lovers (even though most of the figures are in fact self-portraits). The quick-paced social change that so characterized the era confronted the American middle and intellectual classes in particular with age-old and increasingly anachronistic American constructions of race and gender. For her time and her audience, WalkingStick's large paintings posed transgressive questions with their overt references to liberated sexuality.

These pictures participate with but also query the culturally hegemonic American painting of the day. Like the paintings of Al Held (1928–2005), WalkingStick's flat color contrasts and hard-edged contours press the figures flush up against the surface of the picture, creating illusions of slightly overlapping planes of flattened abstract shapes. Pop artist Tom Wesselmann (1931–2004), teaching nearby in Brooklyn, also flattened nudes in this way, although WalkingStick's figures offer an alternative to Wesselman's ironic titillation of the male gaze with his fetishistic emphasis of lips and nipples (fig. 134). WalkingStick's approach was inspired more by Joan Semmel (b. 1932), who preceded her by a few years at Pratt. WalkingStick knew her slightly "from women's groups and those occasional huge SoHo parties and "certainly knew her paintings."[9] Semmel's large, often explicitly posed nudes, notoriously well known in their time, became icons of a kind of feminist sexuality (fig. 135). Unlike Semmel's sexually engaged couples, however, WalkingStick's figures were drawn separately and the bodies share no unified space. (figs. 41, 43, 44) Each is isolated in their own perspective box, the sociability of their groupings an illusion.

In 1974, WalkingStick joined the New York artistic community more formally with her graduate work at Pratt, and thereafter always self-identified as a New York artist, one of the inheritors of the American modernist tradition that coalesced in New York City and one of its postmodern products. Her New York work of the 1970s, not surprisingly, links to American artistic "tendencies and continuities," which Novak (who was teaching at Columbia) described at that very same historical moment as "the integrity of the objects or things of this world which become ... vessels or carriers of metaphysical meaning ... emotive and lyrical, becoming part of a quietistic tradition and reaching through memory to another area of Mind."[10] "Metaphysics and materiality," quoting art historian Lisa Seppi, lie at the core of WalkingStick's long career.[11] Her artistic processes and concerns, her fierce inquiries into American historical memory, and her deep engagement with American Indian social and political consciousness of the day (see Archuleta, this volume), all are distinctly, assertively, American.

Much later in her life, WalkingStick was asked to contribute an essay to a volume that accompanied the exhibition of the monumental painting *The Landing of Columbus* by Albert Bierstadt (1830–1902), America's quintessential painter of monumental Western landscapes. Looking at Bierstadt, she wrote, "I often gave in to the urge to laugh."[12] It was his bombast, his nostalgic sentimentality, his over-the-top theatricality that amused her. But she also recognized the rhetorical power of Bierstadt's hegemonic vision: a resplendent, virtually uninhabited continent (the remnants of its ancient peoples waning to extinction) as the foundation for American civilization. In Italy, WalkingStick painted landscapes that became increasingly identified with her own body. As such, her renderings of land are gendered and often sexualized: pubic-thatched gullies and breastlike peaks. To the extent that one can read the gender of landscapes by Bierstadt, Thomas Moran (1837–1926), or other male painters of the American West, the attitude is one of enticement (anticipating the "kiss of progress" as put by one essayist) or nostalgic concern for the loss of purity.[13] The land is feminized, but with regard to an aggressively masculine standpoint. It is ripe for conquest.

In her expansive paintings of Western landscapes of the last decade, WalkingStick reclaims these iconic American terrains from the traditions of American landscape painting, where they had been cast in the role of envisioning a foundation for a uniquely American empire (figs. 85, 124, 133, 136). By engendering them with her own Native identity, she restores their geological primacy as witnesses to cultural memory. Patterns drawn from Native parfleche and pottery designs inscribed on the surfaces of the picture plane, pushed flat up to the surface like her early silhouettes of nudes, signal more explicitly an ongoing Native presence: assertive, not waning. Positioned between the viewer and majestic renderings of the land, these patterns intervene as a kind of lens or filter and, as such, the paintings insist that American terrain and Native place remain inseparable from each other. WalkingStick demonstrates *how* to be an American artist, to paraphrase Barbara Novak's question, by reminding us that the idea of America cannot be separated from its distinctive geography and the long and contested histories of what that place would become. The idea of America versus the material reality of "facts on the ground," the noble aspirations of its peoples in contradistinction to cruel, very human fragility and failings, the triumph of spirit over mortal limitations—or the "unity of the totally dissimilar" to which WalkingStick often refers—these are distinctively American issues and ironies. WalkingStick's work is American not only owing to her American identity but by virtue of its engagement and confrontation with these particularly American themes.

—David W. Penney

136. *Orilla Verde at the Rio Grande,*
2012. Oil on wood panel, 40 x 80 in.
Collection of the artist, courtesy of
June Kelly Gallery.

137. Kay WalkingStick in her studio,
Easton, Pennsylvania, 2014.

NOTES

Introduction

1. The College Art Association (CAA) is the largest professional organization of arts professionals, particularly university-based teachers of fine arts and art history. CAA members meet once a year in a different host city. Meetings may attract as many as five thousand participants.

2. W. Jackson Rushing, III, and Kay WalkingStick, eds., "Recent Native American Art," special issue, *Art Journal* 51, no. 3 (New York: College Art Association, 1992).

3. Notably *The Decade Show: Frameworks of Identity in the 1980s* (New York: Museum of Contemporary Hispanic Art, New Museum of Contemporary Art, Studio Museum in Harlem, 1990).

4. Roberta Smith, "Three Museums Collaborate to Sum Up a Decade," *New York Times*, May 25, 1990.

5. Eunice Lipton, "Here Today, Gone Tomorrow? Some Plots for Dismantling," in *The Decade Show: Frameworks of Identity in the 1980s* (New York: Museum of Contemporary Hispanic Art, New Museum of Contemporary Art, Studio Museum in Harlem, 1990), 20.

6. Roberta Smith, "At the Whitney, A Biennial with a Social Conscious," *New York Times*, March 5, 1993.

7. Ibid.

8. Ibid.

9. Kay WalkingStick, artist statement in Jaune Quick-to-See Smith, *The Submuloc Show/Columbus Wohs* (Phoenix, AZ: ATLATL, 1992), 66.

10. Roberta Smith, "At the Whitney."

11. Diana Nemiroff, Robert Houle, and Charlotte Townsend-Gault, "Land, Spirit, Power," in *Land, Spirit, Power: First Nations at the National Gallery of Canada*, ed. D. Nemiroff, R. Houle, C. Townsend-Gault (Ottawa, ON: National Gallery of Canada, 1992), 11.

12. Robert Houle, "The Spiritual Legacy of the Ancient Ones," in *Land, Spirit, Power*, 52.

13. Kobena Mercer, "Black Art and the Burden of Representation," *Third Text* 4, no. 10 (Spring 1990): 61–78.

14. Robert Houle, "Kay Walking-Stick," in *Land, Spirit, Power*, 218.

15. This quote is found in a sophisticated analysis of WalkingStick's artistic identity issues: Erin Valentino, "'Mistaken Identity': Between death and pleasure in the art of Kay WalkingStick," in *Third Text*, 8, no. 26 (Spring 1994): 69.

16. Kay WalkingStick, "Seeking the Spiritual," in *Native American Art in the Twentieth Century: Makers, Meanings, Histories*, ed. W. Jackson Rushing, III (London: Routledge, 1999), 185.

17. David Garneau, "Necessary Essentialism and Contemporary Aboriginal Art" (paper presented at "Essentially Indigenous?: A Symposium," National Museum of the American Indian, New York, NY, May 5, 2011).

18. See Jeff Chang, *Who We Be: The Colorization of America* (New York: St. Martin's Press, 2014), 126–209. For Chang's discussion of WalkingStick in *The Decade Show*, see 139–41.

19. George Longfish and Jaune Quick-to-See Smith assisted in the organization of *Contemporary Native American Art* (1983) at the Gardiner Art Gallery, Oklahoma State University, Stillwater, Oklahoma; *Women of Sweetgrass, Cedar, and Sage* (1985) was organized by Quick-to-See Smith at the American Indian Community House Gallery, New York City.

20. Ginger Strand, "All the Limits: Landschaft, Landscape and the Land," in *Badlands: New Horizons in Landscape*, ed. Denise Markonish (North Adams, MA: MASS MoCA, 2008), 82.

21. "The Utukok River Uplands are the core calving area of the Western Arctic Caribou Herd, the largest in Alaska. The population declined from a peak of 490,000 animals to about 325,000 in 2011. The herd ranges over a 140,000-square-mile area. About forty indigenous communities from three cultures—Iñupiat, Yupik, and Athabascan—are located within the range of the herd. For the indigenous peoples, the herd is both a vital link to their cultural heritage and a staple of their diet. Underneath the herd's calving ground lies the largest coal deposit in North America, an estimated four trillion tons of bituminous coal. The photograph shows deeply etched tracks on coal seams made by the herd during their annual migrations over a very long period—likely many centuries or even millennia. It also shows that the coal is right on the surface and consequently any development there will likely employ the ecologically devastating mining process known as mountaintop removal. Even though coal is heavy and difficult to transport, there have nevertheless been past and recent proposals to develop this area."
—Subhankar Banerjee

22. Catherine de Zegher, "arc are ark arm art…act!" in *18ᵗʰ Biennale of Sydney: all our relations* (Australia: Biennale of Sydney, 2012), 101.

23. *Beyond Belief: 100 Years of the Spiritual in Modern Art*, Contemporary Jewish Museum and the San Francisco Museum of Modern Art, Jun. 28–Oct. 27, 2013.

24. Donald Kuspit, "Reconsidering the Spiritual in Art," *Blackbird: An On-line Journal of Literature and the Arts* 2, no. 1 (Spring, 2003): n.p.

25. Geneological research provided by Quembe Walkingstick, 2014, traces the family back to Thomas Orsborne, born August 4, 1660, East Hampton, Sufflolk, New York, died June 23, 1745, Wainscott, Suffolk, Long Island, New York. Quembe Walkingstick, personal papers and conversations with the author, 2014.

26. Kay WalkingStick, "On the Decade Show," unpublished lecture notes for 1990 presentation, Mid-America College Arts Association conference, Kay WalkingStick artist file, Native American Artists Resource Collection, Billie Jane Baguley Library and Archive, Heard Museum, Phoenix, Arizona.

Ash-Milby

1. Jimmie Durham, "A Central Margin," in *The Decade Show: Frameworks of Identity in the 1980s* (New York: Museum of Contemporary Hispanic Art, New Museum of Contemporary Art, Studio Museum in Harlem, 1990), 173.

2. See *Old Settler Roll* (1851), a roster of Cherokee already residing in Oklahoma before 1839, which lists Benjamin, Ezekiel, James, John, Susy and Wilson Walkingstick. Reprinted in Bob Blankenship, *Cherokee Roots*, 3rd ed. (Cherokee, NC: B. Blankenship, 1992), 2:27; Will Chavez, "Lost Now Found: Neglected Cherokee Cemeteries Being Cared for Again," *Cherokee Phoenix and Indians' Advocate*, Fall 2001.

3. Archibald Scraper is listed as active in "Citizen Courts" in 1863, as a Senator and President of the Senate for the Goingsnake District in 1869 and acting as a delegate to Washington, DC, in 1867, 1868, and 1869. Emmet Starr, *History of the Cherokee Indians and Their Legends and Folk Lore* (1921; repr., Millwood, NY: Krauss Reprint, 1977), 268, 296, 299.

4. "Chief Isparhecher, of the Creeks, has proposed a plan by which the Indians are at some time to become part of the United States as an Indian state, and I believe his idea, so far as I understand it, is a good one." *Muskogee Phoenix*, December 16, 1897.

5. "Tahlequah Tattle: Arrow Items About the Cherokee Capital," *Daily Chieftain*, May 12, 1900; *Cherokee Advocate*, May 12, 1900.

6. "Territory News," *Muskogee Phoenix*, Dec 22, 1892. "Simon R. Walkingstick, a full-blood Cherokee Indian, was yesterday admitted to the practice of law in the U.S. court at this place. Mr. Walkingstick has the distinction of being the first Indian ever admitted by their court, upon examination."; "Judge Names Indian as U.S. Commissioner," *Daily Oklahoman*, Jan. 22, 1908.

7. "Mrs. Simon Walkingstick Dead," *Tahlequah Arrow*, Saturday, Feb. 22, 1902.

8. Children of Rebecca "Sis" Chandler Walkingstick: Benjamin Taylor (1905–96), Thomas Lowell (1909–10), Galela Leona (1910–2005), Oliver Kenneth "O. K." (1912–98), Howard Chandler (1915–2002), and Lorena May (1919–21). Quembe Walkingstick, Joy Walkingstick Couch, and Kay WalkingStick, personal papers and separate personal communications with the author, 2014.

9. The family reports that he attended an "Indian boarding school at Bacone," but it is more likely that he attended an Indian preparatory school affiliated with Bacone Indian College.

10. Starr, *History of the* Cherokee, 591–92.

11. According to Kay WalkingStick, Charles McKaig worked at Bailey Banks & Biddle in Philadelphia and at H. J. Howe in Syracuse.

12. Colin G. Calloway, *The Indian History of an American Institution: Native Americans and Dartmouth* (Hanover, NH: Dartmouth College Press, 2010), 141–43. Top of Form Bottom of Form

13. Joy Walkingstick Couch, interview with the author, Villas, New Jersey, August 18, 2014.

14. Sy slept at his grandparents' house around the corner, according to Kay WalkingStick, personal communication with the author, December 2014.

15. Kay WalkingStick, multiple personal conversations with the author, 2014.

16. Kay WalkingStick, telephone conversation with the author, June 2013.

17. Syracuse China Corporation, which manufactured and sold fine china, operated from 1871 to 2009; Murray McKaig also earned a master of fine arts degree in illustration from Syracuse University.

18. Charles McKaig Walkingstick is also a mixed-media artist and has worked as a graphic designer for the US Postal Service. He received recognition for his work at the 2005 National Veterans Creative Arts Festival in Denver and has pursued his artistic practice primarily in his post-retirement years. "Art Briefs," *Cherokee Phoenix*, last modified December 30, 2005, accessed November 26, 2014, http://www.cherokeephoenix .org/Article/index/1278; Charles Walkingstick, personal communication, November 26, 2014.

19. David Echols, personal communication with the author, December 12, 2014.

20. Kay WalkingStick, "No Reservations" in *Changing Hands: Art Without Reservation, III*, Ellen N. Taubman and David R. McFadden, eds. (New York: Museum of Arts and Design, 2012), 52.

21. Betsy Theobald Richards, personal communication with the author, November 26 and December 1, 2014.

22. M. L. [Martin Last], "Walkingstick," *ARTnews* (November 1969), 88.

23. WalkingStick, "No Reservations," 52.

24. Lisa Ann Seppi, "Metaphysics and Materiality: Landscape Painting and the Art of Kay WalkingStick" (PhD diss., University of Illinois Urbana-Champaign, 2005), 39.

25. In previously published interviews and biographical summaries, WalkingStick's assertion that she "never knew" her father has often been misinterpreted as that she never met him or that he had no direct influence on her identity or within her art practice.

26. Margaret Archuleta, "Kay WalkingStick (Cherokee)," in *Path Breakers: The Eiteljorg Fellowship for Native American Fine Art, 2003* (Indianapolis, IN: Eiteljorg Museum of American Indians and Western Art, 2003), 15.

27. WalkingStick, "No Reservations," 53.

28. "I met a Cherokee artist Kay WalkingStick, [who] came to my house because I wanted her in the show that Jean Fisher and I curated. I just met her at that time. She doesn't know how seriously our families are on different sides of the political fence. It's like an Irish situation. Her family is really on the enemy side of my family. We liked each other so much it was as though we needed each other, we just felt completely relaxed and completely at home from the beginning." Jimmie Durham in Nikos Papastergiadis and Laura Turney, "On Becoming Authentic: Interview with Jimmie Durham," *Prickly Pear Pamphlet* no. 10 (Cambridge, MA: Prickly Pear Press, 1996), 24.

29. The five-hundredth anniversary of the arrival of Christopher Columbus in the Americas, also known as the Columbus Quincentenary or Quincentennial.

30. Seppi, "Metaphysics and Materiality," 160.

31. Seppi discusses WalkingStick's work *Sex, Fear, and Aging* (1995) at length in her dissertation, which explicitly explores the artist's feelings about aging and sexuality. Ibid., 161–67.

32. See Kay WalkingStick, "Seeking the Spiritual," in *Native American Art in the Twentieth Century: Makers, Meanings, Histories*, ed. W.

31. Around 1993, approximately four years after WalkingStick's first husband died unexpectedly, she started participating in a weekly meditation group run by a Christian woman, where they read in class about Christian saints and theology. She also started going to the Unitarian church in Ithaca, but was turned off by the experience. As she put it, God wasn't there. "I was looking for God." Kay WalkingStick, phone conversation with the author, August 5, 2003. Recently she added that the intellectual and doctrinal reasons that prevented her from participating in the Protestant religion of her childhood didn't exist in Catholicism, which is why she became a Catholic. WalkingStick, phone conversation with the author, January 29, 2015.

32. WalkingStick, phone conversation with the author, January 7, 2014.

33. Kay WalkingStick, "Exploration and Transformation: Painting in Rome" (unpublished manuscript, November, 1997).

34. Della Thompson, ed., *The Concise Oxford Dictionary of Current English*, 9th ed. (Oxford: Clarendon Press, 1995), s.v. "ecstasy" and "rapture," 430, 1137.

35. Barbara G. Walker, "Ecstasy," in *Woman's Encyclopedia*, 269.

36. Like most American artists who trained in mainstream art institutions in the United States between the 1950s and 1970s, WalkingStick studied the Western canon of art history. Although aware of Eastern and non-Western art, at this point in her career she continued to be most influenced by Western art sources. WalkingStick, phone conversation with the author, January 29, 2015.

37. In WalkingStick's early diptychs, the abstract motifs rendered in thick encaustic and the illusionistic landscapes rendered in oil paint were isolated between two panels. What WalkingStick described as a "speed bump," a structural device created by using two canvas stretchers made of varying depths, maintained this strict division. Format and structure thus served to underscore conceptual differences between the aesthetic styles and imagery. Morgan, "Kay WalkingStick, Interview," 13.

38. WalkingStick, phone conversation with the author, August 1999. See also *Artist Talk: Kay WalkingStick—A Painted Life*, YouTube video, 59:38, from a lecture delivered at the Smithsonian's National Museum of the American Indian, Washington, DC, on April 16, 2011. http://www.youtube.com/watch?v=o5dhsYkG9dI.

39. "Artist Statement," Kay WalkingStick's website, accessed November 9, 2004, http://www.kaywalkingstick.com/statement/index_new.htm.

40. For a discussion of the role of dance in religion, see David Brown, "The Dancer's Leap," in *God and Grace of Body: Sacrament in Ordinary* (New York: Oxford University Press, 2007), 61–119.

41. Marcia Pointon, "Reading the Body," in *Naked Authority: The Body in Western Painting 1830–1908* (Cambridge: Cambridge University Press, 1990), 23.

42. WalkingStick, phone conversation with the author, December 18, 2004.

43. Ibid.

44. Kay WalkingStick, "Seeking the Spiritual," in *Native American Art in the Twentieth Century: Makers, Meanings, Histories*, ed. W. Jackson Rushing (London: Routledge, 1999), 186.

45. Ibid., 184.

46. Richard Francis, "Negotiating Rapture, An Introduction," in *Negotiating Rapture: The Power of Art to Transform Lives* (Chicago: Museum of Contemporary Art, 1996), 6.

47. WalkingStick, interview with the author, July 17, 1999.

Horton

1. WalkingStick considers *ACEA* and another series of four, *Il Cortile* (2003), inspired by plants in the garden courtyard of her Roman apartment, to be closely related. Kay WalkingStick, e-mail to the author, May 29, 2014.

2. Immanuel Kant, "What does it mean to orient oneself in thinking?" in *Kant: Political Writings*, 2nd ed., trans. H. B. Nisbet (1786; repr. Cambridge: Cambridge University Press, 1991), 238.

3. Kay WalkingStick, interview with the author in WalkingStick's studio in New York City, December 19, 2013.

4. Ibid.

5. WalkingStick first traveled to Italy for a few days in the late 1970s, but says "It was Rome in '96 that really did it." She taught in Rome for the study-abroad program of the Architecture, Art, and Planning Department at Cornell University. Ibid.

6. ACEA is the local utility company that worked with the Rome city council to turn the plant into a permanent museum housing a portion of the city's Musei Capitolini collection in 2005. "History of the Museum," Musei Capitolini Centrale Montemartini, accessed March 31, 2014, http://en.centralemontemartini.org/il_museo/storia_del_museo.

7. In Greek mythology, Pygmalion is a sculptor who carves a statue of a female figure that is so realistic and beautiful he falls in love with her, bringing her to life with a kiss.

8. WalkingStick, interview with the author, December 19, 2013.

9. Alfred Gell, *Art and Agency: An Anthropological Theory* (Oxford: Clarendon Press, 1998), 80–81, 86.

10. Bacchus is the Roman name for Dionysus, the Greek god of winemaking and ritual madness.

11. Euripides, *Bacchae*, in *The Tragedies of Euripides*, trans. T. A. Buckley (London: Henry G. Bohn, 1850), lines 705–10.

12. Friedrich Wilhelm Nietzsche, *The Birth of Tragedy* (1872; Oxford: Oxford University Press, 2000). On the influence of Nietzsche on American modernism and primitivism, see W. Jackson Rushing, *Native American Art and the New York Avant-Garde: A History of Cultural Primitivism* (Austin: University of Texas, 1995), 121–68.

13. Matisse was likely inspired by witnessing a Catalonian folk dance and a Parisian version of a Provençal farandole. The Russian dance company Ballets Russes also debuted in Paris in May 1909. Jack Flam, *Matisse: The Dance* (Washington, DC: National Gallery of Art, 1993), 24–25.

Lippard

1. Kay WalkingStick, quoted in Holland Cotter, Thomas W. Leavitt, and Judy Collischan, *Kay WalkingStick: Paintings, 1974–1990* (Brookville, NY: Hillwood Art Museum, Long Island University, 1991), 34.

2. Kay WalkingStick, quoted from undated personal papers, in Margaret Archuleta, "Kay WalkingStick (Cherokee)," in *Path Breakers: The Eiteljorg Fellowship for Native American Fine Art, 2003* (Indianapolis, IN: Eiteljorg Museum of American Indians and Western Art, 2003), 28.

3. Kay WalkingStick in *Native Views: Influences of Modern Culture, A Contemporary Native American Art Exhibition*, ed. Sara Mark Lesk (Ann Arbor, MI: Artrain USA, 2004), 35.

4. WalkingStick, author's personal papers.

5. *American Landscape*, June Kelly Gallery, New York, New York, April 12–May 14, 2013.

6. Anne Barclay Morgan, "Kay WalkingStick, Interview" in *Art*

Papers 19 (November/December 1995), 12–15.

7. Ibid.

8. "Native American Women Artists," in *Women Artists of Color: A Bio-Critical Sourcebook to 20th Century Artists in the Americas,* Phoebe Farris, ed. (Westport, CT: Greenwood Press, 1999), 133.

9. Kay WalkingStick's artist statement in Margaret Archuleta and Nora Naranjo-Morse, *Art in 2 Worlds: The Native American Fine Art Invitational, 1983–1997* (Phoenix, AZ: Heard Museum, 1999), 42.

10. Kay WalkingStick, quoted in Patricia Malarcher, "The Meanings of 'Duality' in Art," *New York Times,* December 22, 1985.

11. Malarcher, "The Meaning of 'Duality' in Art."

12. "Artist's Statement," Kay WalkingStick's website, last modified 2010, http://www.kaywalkingstick.com/statement/index_new.htm.

13. Paul Chaat Smith, "After the Gold Rush," in *Off the Map: Landscape in the Native Imagination,* Kathleen Ash-Milby, ed. (Washington, DC: National Museum of the American Indian, Smithsonian Institution, 2007), 70–71.

14. Kay WalkingStick, quoted in Cotter et al., 34.

15. Kathleen Ash-Milby, ed., *Off the Map: Landscape in the Native Imagination* (Washington, DC: Smithsonian National Museum of the American Indian, 2007), 30.

16. Jaune Quick-to-See Smith in Paul Brach et al., *Our Land/ Ourselves: American Indian Contemporary Artists* (Albany, NY: University Art Gallery, University at Albany, State University of New York, 1990), vi.

17. First quote in Morgan, 13; second quote in Lawrence Abbott, *I Stand in the Center of the Good: Interviews with Contemporary Native American Artists* (Lincoln: University of Nebraska Press, 1994), 274.

18. Quick-to-See Smith, v.

19. Bruce Bernstein, "Philosophies, Histories, Identities," in *Contemporary Masters: The Eiteljorg Fellowship for Native American Fine Art, Vol. 1* (Indianapolis: The Eiteljorg Museum of American Indians and Western Art, 1999), 10.

20. For more information about Morrison, see W. Jackson Rushing and Kristin Makholm, *Modern Spirit: The Art of George Morrison* (Norman, OK: University of Oklahoma Press, 2013).

21. George Morrison as told to Margot Fortunato Galt, *Turning the Feather Around: My Life in Art* (St. Paul: Minnesota Historical Society Press, 1998), 175.

22. WalkingStick, quoted in Bernstein, 6.

23. Ibid., quoted in Cotter et al., *Paintings, 1974–1990,* 34.

24. Kay WalkingStick, unpublished notes "On Spirituality in Landscape: WCA Panel Talk" (slide and lecture presentation, Women's Caucus for Art Annual Convention, San Francisco, CA, January 1989; artist's lecture notes archived in Kay WalkingStick artist file, Native American Artists Resource Collection, Billie Jane Baguley Library and Archives, Heard Museum, Phoenix, Arizona).

Ostrowitz

1. Kay WalkingStick, interview with the author, Jackson Heights, New York, March 15, 2012.

2. Kay WalkingStick, interview with the author, Metropolitan Museum of Art, New York, April 26, 2012.

3. As an exception, Kate Morris discussed Masaccio's influence in WalkingStick's depictions of the human body in "Places of Emergence: Painting Genesis" in *Off the Map: Landscape in Native Imagination* (Washington, DC: National Museum of the American Indian, Smithsonian Institution, 2007), 50–51.

4. Kay WalkingStick, e-mail message to the author, July 29, 2014.

5. Kay WalkingStick, telephone interview with the author, February 18, 2013, and e-mail message to the author, July 31, 2014.

Afterword

1. Barbara Novak, *American Painting of the Nineteenth Century: Realism, Idealism and the American Experience* (New York: Praeger Publishers, 1969), 9.

2. John Davis, "The End of the American Century: Current Scholarship on the Art of the United States," *Art Bulletin* 85, no. 3 (2003): 545.

3. Barbara Groseclose and Jochen Wierich, eds. *Internationalizing the History of American Art* (University Park: Pennsylvania State University Press, 2009), 6–7.

4. Irving Sandler, *The Triumph of American Painting: A History of Abstract Expressionism* (New York: Praeger Publishers, 1970).

5. Novak, *American Painting,* 262–88.

6. Barbara Rose, *American Art Since 1900: Revised and Expanded Edition* (New York: Praeger Publishers, 1975).

7. Robert Rosenblum, *Modern Painting and the Northern Romantic Tradition: Friedrich to Rothko* (New York: Harper & Row, 1975). WalkingStick mentioned this text in particular during a recent conversation with the author.

8. See Alex Comfort, *The Joy of Sex* (New York: Simon and Schuster, 1972); this book, revolutionary for the time, captures the kind of casual, matter-of-fact attitude toward human sexuality in keeping with WalkingStick's late-sixties nudes.

9. Kay WalkingStick, email communication with the author, December 2014.

10. Novak, *American Painting,* 217.

11. Lisa Ann Seppi, "Metaphysics and Materiality: Landscape Painting and the Art of Kay WalkingStick" (PhD diss., University of Illinois Urbana-Champaign, 2005).

12. Kay WalkingStick, "A Cherokee Artist Looks at 'The Landing of Columbus,' by Albert Bierstadt," in *Primal Visions: Albert Bierstadt "Discovers" America,* ed. Diane P. Fischer (Montclair, NJ: Montclair Art Museum, 2001), 37.

13. Nancy K. Anderson, "'The Kiss of Enterprise': The Western Landscape as Symbol and Resource," in *The West as America: Reinterpreting Images of the Frontier, 1820–1920,* ed. W. Truettner (Washington, DC: National Museum of American Art and Smithsonian Institution Press, 1991).

BIOGRAPHICAL TIMELINE

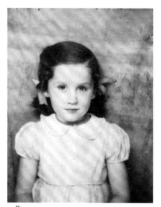

138. 1941

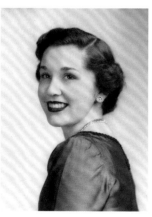

139. 1959

140. Kay WalkingStick and
Michael Echols, 1959.

March 2, 1935: Margaret Kay Walkingstick is born in Syracuse, New York. She is the youngest of five children born to Margaret Emma McKaig (1898–1967) and Simon Ralph Walkingstick, Jr. (1896–1970): Syverston "Sy" Ralph (1920–1945), Charles "Mack" (b. 1922), Elizabeth "Betty" (1923–2015), and Carol Joy (b. 1927).

1944 (approx.): Changes the spelling of her last name, replacing the lower case s with an uppercase S.

1945: Syvertson Ralph Walkingstick is killed in action in Luzon, Philippines, during WWII.

1951: Kay and Emma move to Bethayres, Pennsylvania.

1952: Graduates from Lower Moreland High School, Bethayres, Pennsylvania.

1952–55: Works at Quaker City Gear Works as a receptionist, then as a waitress at the Chatterbox Restaurant, where she meets her future husband, Robert Michael Echols.

1955: Enrolls in the Fine Arts program at Beaver College (now Arcadia University) in Glenside, Pennsylvania. WalkingStick receives a half tuition scholarship and works at Bell Telephone as an operator in evenings and on weekends.

1959: Earns Bachelor of Fine Arts degree from Beaver and marries Robert Michael Echols one month later. The couple moves to State College, Pennsylvania.

1960: The couple moves to New York City and then to Palisades Park, New Jersey. Kay paints in her kitchen and Michael begins work in Manhattan. Their son, Michael David Echols, is born in October.

1961: The family moves to Fort Lee, New Jersey.

1962: Daughter, Erica WalkingStick Echols, is born.

1964: The family moves to Englewood, New Jersey.

1966: WalkingStick rents a room for painting in an office building in Teaneck, New Jersey, for one year.

1967: Margaret Emma McKaig passes away after a long illness in Syracuse, New York.

1969: WalkingStick has first solo exhibition at Gallery 267 in Leonia, New Jersey, followed by her first solo exhibition in New York City, at Cannabis Gallery on Mercer Street. She receives first review in *ARTnews*, by Martin Last.

1970: Simon Ralph Walkingstick, Jr., passes away in Wildwood Crest, New Jersey.

1970–73: WalkingStick works as a painting instructor at Edward Williams College of Fairleigh

141. Kay WalkingStick and Erica Echols, 1962.

142. The artist with *Messages to Papa*, May 1975.

143. The artist in her studio, ca. 1984.

Dickinson University, Teaneck, New Jersey.

1970–71: Completes two one-month summer artist residencies at the McDowell Colony, Peterborough, New Hampshire.

1972: WalkingStick and her husband purchase a house in Englewood, and she converts a spare bedroom into a painting studio.

1973: With full support from a Danforth Foundation Graduate Fellowship for Women, she begins attending Pratt Institute in Brooklyn, New York, studying under Gerald Hayes.

1975: Graduates with a master of fine arts degree from Pratt Institute. Rents space in another artist's studio in Manhattan to show her work to prospective galleries.

1975–79: Teaches painting and drawing at Upsala College, East Orange, New Jersey.

1976: Has solo exhibition, Soho Center for Visual Arts, New York City. Attends artist residency, Yaddo artist's community, Saratoga Springs, New York.

1978: After a studio visit, Bertha Urdang agrees to give WalkingStick a solo exhibition at Bertha Urdang Gallery in New York City and represents her until 1984.

1978–85: WalkingStick teaches painting and drawing at the Art Center of Northern New Jersey, New Milford.

1979: Has solo exhibition at Wenger Gallery in San Diego, California; Wenger represents her until 1988.

1980: Continues to gain national acclaim and participates in *Four Native American Women* at the Southern Plains Indian Museum in Anadarko, Oklahoma. Rents a new studio in the Meatpacking District in Lower Manhattan, while commuting from Englewood, New Jersey. In 1984 she sublets it to another artist and only uses the studio for showings until 1988.

1981: Has solo exhibition, *Painting on Paper*, at Bertha Urdang Gallery. Receives Fellowship Award, New Jersey State Council on the Arts.

1983: Attends artist residency, the William Flanagan Memorial Creative Persons Center, Edward F. Albee Foundation of Montauk, New York. Invited by George Longfish to participate in the exhibition *Contemporary Native American Art*, curated by Richard A. Bivins at the Gardiner Gallery, Oklahoma State University, Stillwater.

1983–84: Received Visual Artists Fellowship, National Endowment for the Arts, Washington, DC.

1984: Attends artist residency at Fort Lewis College, Durango, Colorado. Her experience in the Rockies reignites her passion for landscape. Invited to participate in an exhibition at Gallery

154. *Volute/Volupte*, 2009. Oil on
wood panel, 36 x 72 x 1.25 in.
Collection of the artist.

141. Kay WalkingStick and Erica Echols, 1962.

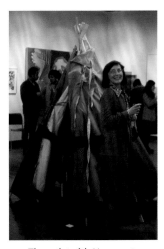

142. The artist with *Messages to Papa*, May 1975.

143. The artist in her studio, ca. 1984.

Dickinson University, Teaneck, New Jersey.

1970–71: Completes two one-month summer artist residencies at the McDowell Colony, Peterborough, New Hampshire.

1972: WalkingStick and her husband purchase a house in Englewood, and she converts a spare bedroom into a painting studio.

1973: With full support from a Danforth Foundation Graduate Fellowship for Women, she begins attending Pratt Institute in Brooklyn, New York, studying under Gerald Hayes.

1975: Graduates with a master of fine arts degree from Pratt Institute. Rents space in another artist's studio in Manhattan to show her work to prospective galleries.

1975–79: Teaches painting and drawing at Upsala College, East Orange, New Jersey.

1976: Has solo exhibition, Soho Center for Visual Arts, New York City. Attends artist residency, Yaddo artist's community, Saratoga Springs, New York.

1978: After a studio visit, Bertha Urdang agrees to give WalkingStick a solo exhibition at Bertha Urdang Gallery in New York City and represents her until 1984.

1978–85: WalkingStick teaches painting and drawing at the Art Center of Northern New Jersey, New Milford.

1979: Has solo exhibition at Wenger Gallery in San Diego, California; Wenger represents her until 1988.

1980: Continues to gain national acclaim and participates in *Four Native American Women* at the Southern Plains Indian Museum in Anadarko, Oklahoma. Rents a new studio in the Meatpacking District in Lower Manhattan, while commuting from Englewood, New Jersey. In 1984 she sublets it to another artist and only uses the studio for showings until 1988.

1981: Has solo exhibition, *Painting on Paper*, at Bertha Urdang Gallery. Receives Fellowship Award, New Jersey State Council on the Arts.

1983: Attends artist residency, the William Flanagan Memorial Creative Persons Center, Edward F. Albee Foundation of Montauk, New York. Invited by George Longfish to participate in the exhibition *Contemporary Native American Art*, curated by Richard A. Bivins at the Gardiner Gallery, Oklahoma State University, Stillwater.

1983–84: Received Visual Artists Fellowship, National Endowment for the Arts, Washington, DC.

1984: Attends artist residency at Fort Lewis College, Durango, Colorado. Her experience in the Rockies reignites her passion for landscape. Invited to participate in an exhibition at Gallery

144. *Las Platas*, 1984. Oil stick on paper, 24 x 24 in. Collection of the artist.

145. David Echols and Erica Echols, ca. 1991.

146. Kay WalkingStick, 1995.

53, Cooperstown, New York, dedicated to the American elm in New York State; creates *Death of the Elm*, her first experimentation with the diptych format. Has solo exhibitions at Wenger Gallery in San Diego, California, and Bertha Urdang Gallery. Enlarges her bedroom studio by removing a wall to another bedroom.

1985: Attends artist residency, Ohio State University, Columbus. Selected for a second Fellowship Award by the New Jersey State Council on the Arts. Participates in *Women of Sweetgrass, Cedar, and Sage: Contemporary Art by Native American Women*, organized by Jaune Quick-to-See Smith, at the American Indian Community House Gallery, New York City.

1986–88: Teaches painting and drawing at Montclair Art Museum, New Jersey. Works as a curator for the William Carlos Williams Performing Arts Center in Rutherford, New Jersey.

1987: Has solo exhibition, M-13 Gallery in SoHo, New York; M-13 represents her until 1992.

1988: Begins position as assistant professor of art, Cornell University, Ithaca, New York. Has solo exhibition, Wenger Gallery in Los Angeles, California. Uses studio space in Cornell art building on the Quad.

1989: Robert Michael Echols dies suddenly in his sleep. WalkingStick becomes guest artist, Brandywine Workshop, Philadelphia, Pennsylvania.

1990: Leaves Cornell and accepts position as assistant professor in the art department at State University of New York (SUNY) at Stony Brook and moves to Long Island City, Queens, New York. She uses a large front room in her apartment as her studio. Has solo exhibition, M-13 Gallery. Featured in the book *Mixed Blessings: New Art in a Multicultural America* by Lucy Lippard. Exhibitions include *The Decade Show, Frameworks of Identity in the 1980s* in New York, organized by The New Museum of Contemporary Art in cooperation with The Studio Museum in Harlem and the Museum of Contemporary Hispanic Art.

1991: Receives Richard A. Florsheim Art Fund Award, Tampa, Florida. Has solo retrospective, *Kay WalkingStick: Paintings, 1974–1990*, which opens at Hillwood Art Museum, Long Island University, C. W. Post Campus, Brookville, New York, and travels to the Heard Museum, Phoenix, Arizona, and Hartwick College Gallery, Hartwick College, Oneonta, New York. Was included in several significant Native American group exhibitions: *The Submuloc Show/Columbus Wohs*, The Evergreen State College, Olympia, Washington; *Our Land/Ourselves, American Indian Contemporary Artists*, University Art Gallery, State University of New York at Albany; *Shared Visions: Native American Painters and Sculptors in the Twentieth Century*, Heard Museum.

1992: Leaves SUNY Stony Brook and is rehired by Cornell University. Buys a house in Ithaca. Awarded a NYSCA grant for painting by the New York Foundation for the Arts. Selected by

147. Kay WalkingStick during Cairo Biennial, *Strategies of Narration*, Cairo, Egypt, 1994.

148. Kay WalkingStick during her first trip to Rome, 1996.

the Rockefeller Conference and Study Center for an artist's residency in Bellagio, Italy. Awarded the UUP Junior Faculty Award, by SUNY Stony Brook, New York.

1993: Has solo exhibition, Galerie Calumet, Heidelberg, Germany.

1994: Has solo exhibition, *Paintings and Works on Paper*, June Kelly Gallery in SoHo, which continues to represent her to the present. Granted the Joan Mitchell Foundation award. Featured in the Cairo Biennial, USIA Exhibit, *Strategies of Narration*, curated by Deborah Cullen, Cairo, Egypt.

1995: The Heard Museum selects WalkingStick as Artist in Residence. Kay WalkingStick is included in H. R. Janson's *History of Art* (5th ed.). Teaches and shows her work at the Atlantic Center for the Arts in New Smyrna Beach, Florida. Made an associate professor of art at Cornell University, Ithaca, New York.

1996: Travels to Italy for the first of the three semesters she spends teaching in Rome and traveling. Soon after returning to Ithaca, she is in a serious automobile accident and has a severe concussion. Stops painting for about six months but continues to teach during her recuperation. Receives National Honor Award for Achievement in the Arts, Women's Caucus for Art, Boston.

1998: American Academy in Rome selects WalkingStick for the Visiting Artist/Scholar Program, fall residency. Becomes a full professor of art at Cornell University.

1999: *Recent Drawings: The Italian Suite*, shows at June Kelly Gallery.

2000: The first six months of 2000 are spent in Rome with the Cornell in Rome program. *Kay WalkingStick: Works on Paper from The Italian Suite, 1997–1999 and Dancing to Rome*, Olive Tjaden Gallery, Cornell University.

2002: *Haptic Memory: Recent Paintings* shows at June Kelly Gallery, featuring the golden dancing figures influenced by her Italian travels. WalkingStick travels for a week in Montana following the trail of Chief Joseph and his band to make preparatory drawings for an exhibition at the Smithsonian's National Museum of the American Indian (NMAI).

2003: Selected for the Distinguished Artist Award by the Eiteljorg Museum of American Indians and Western Art, Indianapolis, for *Path Breakers: Eiteljorg Fellowship for Native American Fine Art, 2003*. Other exhibitions include *Sensual Texture: the Art of Kay WalkingStick*, a solo exhibition, also at the Eiteljorg Museum, and a solo installation in *Continuum: 12 Artists*, NMAI in New York, organized by Truman Lowe.

2004: Participates in "A Conversation with Kay WalkingStick" at The Metropolitan Museum of Art, New York, moderated by curator Lowery Sims. The retrospective *Kay WalkingStick: Mythic*

149. (left to right) Nadia Myre, Nora Naranjo-Morse, Robert Houle, Hulleah Tsinhajinnie, Corky Clairmont, and Kay WalkingStick at the opening for *Path Breakers: Eiteljorg Fellowship for Native American Fine Art*, Indianapolis, Indiana, November 2003.

150. *Dialogue with the Cosmos*, 2008 (detail), Montclair Art Museum.

Dances, Paintings from Four Decades opens at the Southeast Missouri Regional Museum, Cape Girardeau, Missouri, and travels to the University Art Gallery at Indiana State University in Terre Haute, Indiana, in 2005.

2005: Retires from Cornell University and is designated professor emerita. Is diagnosed and treated for colon cancer.

2006: Appointed to Board of Trustees, Montclair Art Museum; serves until 2010.

2007: June Kelly Gallery opens *Kay WalkingStick: New Paintings*. At the opening reception, she meets her future husband, Dirk Bach.

2008: *American Abstraction: Dialogue with the Cosmos,* an exhibition of a site-specific installation work, opens at the Montclair Art Museum and is on view for one year. WalkingStick and Bach travel together to Amsterdam and Rome.

2009: Rt. Rev. Carol T. Gallagher, WalkingStick's niece, performs a blessing ceremony for Kay WalkingStick and Dirk Bach at St. Mark's Episcopal Church in Jackson Heights, New York.

2010: The Montana Artists Refuge, an artist's colony and retreat in Basin, Montana, invites WalkingStick as its guest artist. PBS airs *Art Through Time: A Global View*, a thirteen-part series that examines themes that connect works of art created throughout the world in different eras which reflect diverse cultural perspectives and shared human experiences. Segment ten, "The Natural World," includes WalkingStick's interview about her life and work. *Kay WalkingStick: Prints*, Eiteljorg Museum.

2011: Awarded an honorary doctorate of humane letters from Arcadia University (formerly known as Beaver College), Glenside, Pennsylvania. Receives a three-year Lee Krasner lifetime achievement award from the Pollock-Krasner Foundation. *Living in the City, Painting in the Wild* shows at June Kelly Gallery.

2012: WalkingStick's artwork continues to be shown in national exhibits such as *Shapeshifting: Transformations in Native American Art* at the Peabody Essex Museum, Salem, Massachusetts.

2013: Travels to the Sierra Nevada in preparation for her next body of work. *Kay WalkingStick: American Landscape* shows at June Kelly Gallery. WalkingStick and Bach marry in Jackson Heights, Queens.

2014: WalkingStick and Bach buy a Victorian home in the historic district of Easton, Pennsylvania.

2015: *Kay WalkingStick: An American Artist* opens at the NMAI in Washington, DC.

151. Kay WalkingStick and Dirk Bach, 2009.

152. Joy Walkingstick Couch and Kay WalkingStick. Villas, New Jersey, 2014.

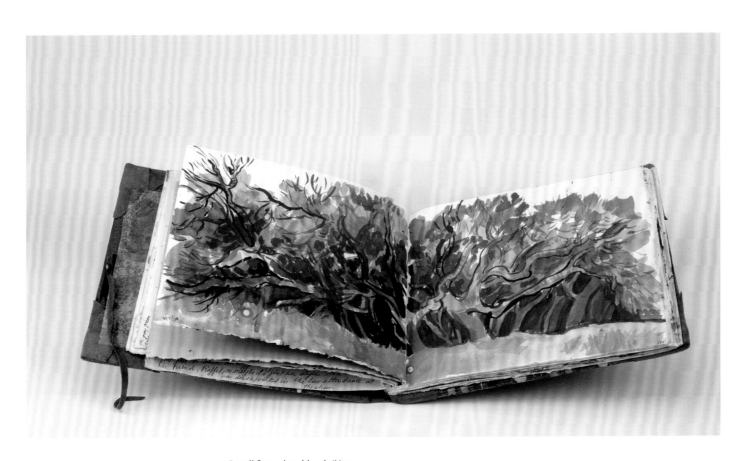

153. Detail from sketchbook (New
Zealand, Ramapo River), 2008–9.
11.25 x 13.5 x 1.25 in. Collection of
the artist.

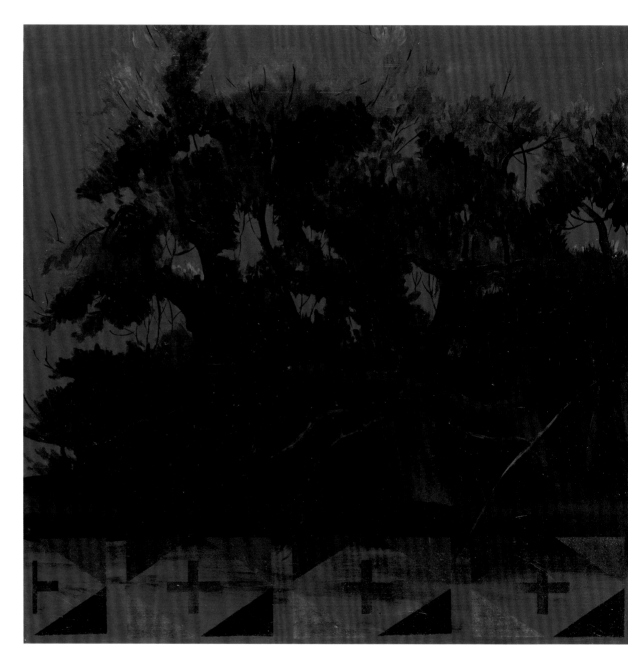

154. *Volute/Volupte*, 2009. Oil on
wood panel, 36 x 72 x 1.25 in.
Collection of the artist.

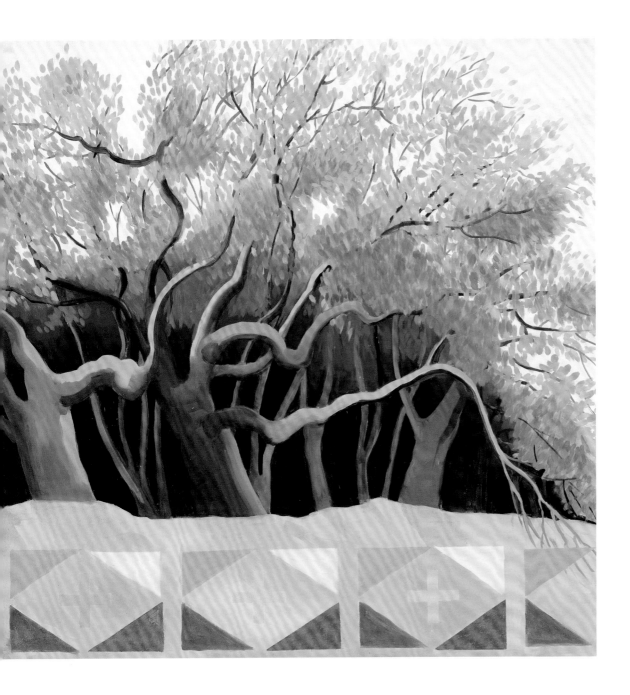

SELECTED EXHIBITIONS

SOLO EXHIBITIONS

Kay WalkingStick: American Landscape, June Kelly Gallery, New York, NY, 2013

Living in the City, Painting in the Wild, June Kelly Gallery, New York, NY, 2011

Kay WalkingStick: Prints, Eiteljorg Museum of American Indians and Western Art, Indianapolis, IN, 2010

American Abstraction: Dialogue with the Cosmos, Montclair Museum of Art, Montclair, NJ, 2008

Kay WalkingStick: New Paintings, June Kelly Gallery, New York, NY, 2007

Kay WalkingStick: Mythic Dances, Paintings from Four Decades, Southeast Missouri Regional Museum, Cape Girardeau, MO, 2004; University Art Gallery, Indiana State University, Terre Haute, Indiana, 2005

Sensual Texture: The Art of Kay WalkingStick, Eiteljorg Museum of American Indians and Western Art Indianapolis, IN, 2003

Haptic Memory: Recent Paintings, June Kelly Gallery, New York, NY, 2002

Kay WalkingStick: Works on Paper from The Italian Suite, 1997–1999 and Dancing to Rome, Olive Tjaden Gallery, Cornell University, Ithaca, NY, 2000

Recent Drawings: The Italian Suite, June Kelly Gallery, New York, NY, 1999

Works on Paper, Atlanta Center for the Arts, New Smyrna Beach, FL, 1995

Paintings and Works on Paper, June Kelly Gallery, New York, NY, 1994

Galerie Calumet, Heidelberg, Germany, 1993

Kay WalkingStick: Paintings, 1974–1990, Hillwood Art Museum, Long Island University, C. W. Post Campus, Brookville, NY; Heard Museum, Phoenix, AZ; Hartwick College Gallery, Hartwick College, Oneonta, NY, 1991

Elaine Horwitch Gallery, Scottsdale, AZ, 1991

M-13 Gallery, New York, NY, 1990 and 1987

Wenger Gallery, Los Angeles, 1988

Wenger Gallery, San Diego, CA, 1984 and 1979

Bertha Urdang Gallery, New York, NY, 1984 and 1978

Soho Center for Visual Arts, New York, NY, 1976

Cannabis Gallery, New York, NY, 1969

SELECTED GROUP EXHIBITIONS

The Third Crow's Shadow Institute of the Arts Biennial, Hallie Ford Museum of Art at Willamette University, Salem, OR, 2012

Shapeshifting: Transformations in Native American Art, Peabody Essex Museum, Salem, MA, 2011

Vantage Point: The Contemporary Native Art Collection, Smithsonian's National Museum of the American Indian, Washington, DC, 2010

Native Voices: Contemporary Indigenous Art, Kentler International Drawing Space, Brooklyn, NY, 2008

From the Inside Out: Feminist Art Then and Now, St. John's University, Dr. M. T. Geoffrey Yeh Art Gallery, Queens, NY, 2007

Native Views: Influences of Modern Culture, Artrain, 2007, 2006, 2005, 2004

About Face: Self-Portraits by Native American, First Nations, and Inuit Artists, Wheelwright Museum of the American Indian, Santa Fe, NM, 2005

Crosscurrents in the Mainstream, Jane Voorhees Zimmerli Art Museum, New Brunswick, NJ, 2004

Path Breakers: Eiteljorg Fellowship for Native American Fine Art, Eiteljorg Museum of American Indians and Western Art, Indianapolis, IN, 2003

Continuum: 12 Artists, Smithsonian's National Museum of the American Indian, George Gustav Heye Center, New York, NY, 2003

Skowhegan 2002–2003 Faculty Exhibition, Institute of Contemporary Art at Maine College of Art, Portland, ME, 2003

In Search of the Dream: The American West, Bruce Museum of Arts and Science, Greenwich, CT, 2002

The Heritage of Our Ancestors: Work by Jaune Quick-to-See Smith and Kay WalkingStick, Bayly Art Museum (Fralin Museum of Art), University of Virginia, Charlottesville, VA, 1999

Ceremonial, Scuola dei Tiraoro e dei Battioro, Venice Biennale, Venice, Italy, 1999

Waxing Poetic: Encaustic Art in America, Montclair Art Museum, Montclair, NJ, 1999

3 Artists, 3 Stories, New Jersey Center for Visual Arts, Summit, NJ, 1999

Art in 2 Worlds: The Native American Fine Art Invitational 1983–1997, Heard Museum, Phoenix, AZ, 1999

Nourishing Hearts, Creative Hands: Contemporary Art by Native American Women, Hampton University Museum, VA, 1998

Earthly Visions, Landscape: Real and Imagined, Jan Cicero Gallery, Chicago, IL, 1998

Native Abstraction: Modern Forms, Ancient Ideas, Museum of Indian Arts and Culture, Santa Fe, NM, 1997

Community of Creativity: A Century of MacDowell Colony Artists, Currier Gallery of Art, Manchester, NH, 1996

Cherokee: The Fire Takers, Cherokee National Museum, Tahlequah, OK, 1996

Setting the Stage: A Contemporary View from the West, Eiteljorg Museum of American Indians and Western Art, Indianapolis, IN, 1995

Indian Humor, American Indian Contemporary Arts, San Francisco, CA, 1995

Strategies of Narration, Cairo Biennial, USIA Exhibit, Cairo, Egypt, 1994

Multiplicity: A New Cultural Strategy, Museum of Anthropology, University of British Columbia, Vancouver, BC, Canada, 1993

Indian Territories: 20th Century American Artists Dismantle 19th Century Euro-American Myths, Renee Fotouhi Gallery, East Hampton, NY, 1993

Land, Spirit, Power: First Nations at the National Gallery of Canada, National Gallery of Canada, Ottawa, ON, Canada, 1992

Decolonizing the Mind, Center on Contemporary Art, Seattle, WA, 1992

Artifacts of Various Civilizations, Howard Yezerski Gallery, Boston, MA, 1992

Six Directions, Calumet Galerie, Heidelberg, Germany, 1992

Shared Visions, Native American Painters and Sculptors in the Twentieth Century, Heard Museum, Phoenix, AZ, 1991

The Submuloc Show/Columbus Wohs, Evergreen State College, Olympia, WA, 1991

Our Land/Ourselves: American Indian Contemporary Artists, University Art Gallery, State University of New York, Albany, NY, 1991

The Decade Show: Framework of Identity in the 1980s, New Museum of Contemporary Art, Studio Museum of Harlem, Museum of Contemporary Hispanic Art, New York, NY, 1990

We the People, Artists Space, New York, NY, 1987

39th Annual Purchase Exhibition, American Academy and Institute of Arts and Letters, New York, NY, 1987

Carl N. Gorman Museum (two-person with Kay Miller), University of California, Davis, CA, 1985

Second Biennial Native American Fine Arts Invitational, Heard Museum, Phoenix, AZ, 1985

Terminal Show, Brooklyn Terminal, Brooklyn, NY, 1983

Tribute to Bertha Urdang, Israel Museum, Jerusalem, Israel, 1982

Dark Thoughts, Black Paintings, Pratt Manhattan Center, New York, NY, 1981

Invitational 1981, Jersey City Museum, Jersey City, NJ, 1981

New Jersey Artists, Third Biennial Exhibition, Newark Museum, Newark, NJ, 1981

Marking Black, Bronx Museum of the Arts, Bronx, NY, 1980

New Jersey State Museum (two-person with Peter Tilgner), Trenton, NJ, 1975

Fourth Annual Contemporary Reflections 1974–75, Aldrich Museum, Ridgefield, CT, 1975

Works on Paper, Women Artists, Brooklyn Museum, Brooklyn, NY, 1975

SELECTED BIBLIOGRAPHY

Abbott, Lawrence. *I Stand in the Center of the Good: Interviews with Contemporary Native American Artists*. Lincoln: University of Nebraska Press, 1994.

Albright-Knox Art Gallery. *The Painting and Sculpture Collection: Acquisitions since 1972*. New York: Hudson Hills Press, 1987.

Aldrich, Larry. *Fourth Annual Contemporary Reflections 1974–1975*. Ridgefield, CT: Aldrich Contemporary Art Museum, 1975.

American Indian Portraits. Detroit: Macmillan Reference USA, 2000.

Archuleta, Margaret, ed. *Art in 2 Worlds: The Native American Fine Art Invitational, 1983–1997*. Phoenix, AZ: Heard Museum, 1999.

———. "Kay WalkingStick." In *Path Breakers: The Eiteljorg Fellowship for Native American Fine Art, 2003*. Indianapolis, IN: Eiteljorg Museum of American Indians and Western Art in association with University of Washington Press, 2003.

———. "Native Streams." In *Swimming Upstream: Diversity in Native American Art at the End of the Twentieth Century*. Chicago: Jan Cicero Gallery and Turman Art Gallery of Indiana State University, 1996.

Archuleta, Margaret, and Rennard Strickland, eds. *Shared Visions: Native American Painters and Sculptors in the Twentieth Century*. New York: New Press, 1993.

Arettam, Joanna. *Spirit Maps: Follow the Exquisite Geometry of Art and Nature Back to Your Center*. Boston: Red Wheel, 2001.

Ash-Milby, Kathleen. "The Indian as 'Artist': Native American Art at the Rockwell Museum of Western Art." In *People, Places and Ideas: The Rockwell Museum of Western Art*. Edited by Suzan Campbell. Corning, NY: Rockwell Museum of Western Art, 2001.

———. "Still in the Shadows: Native American Art in the Twenty-First Century." In *Transcultural New Jersey: Diverse Artists Shaping Culture and Communities*. New Brunswick, NJ: Rutgers, 2004.

Ash-Milby, Kathleen, ed. *Off the Map: Landscape in the Native Imagination*. Washington, DC: National Museum of the American Indian, Smithsonian Institution, 2007.

Baldit, Catherine. *L'art contemporain des Indiens du Sud-Ouest des États-Unis*. Tournai, Belgium: La Renaissance du livre, 2002.

Baldwin, Victoria. "Beside and Beyond the Mainstream." *Artweek* 16, no. 36 (November 2, 1985).

Barreiro, José, ed. "View from the Shore: American Indian Perspectives on the Quincentenary." *American Indian Quarterly* (Fall 1990): 1–109.

Barrett, Terry. *Making Art: Form & Meaning*. New York: McGraw-Hill, 2011.

Bates, Sarah, Jolene Rickard, and Paul Chaat Smith. *Indian Humor*. San Francisco: American Indian Contemporary Arts, 1995.

Belag, Andrea, Robert Ferguson, and Cynthia H. Sanford. *1981 Invitational*. Jersey City, NJ: Jersey City Museum, 1981.

Belton, Robert J., ed. *Art: The World of Art, from Aboriginal to American Pop, Renaissance Masters to Postmodernism*. New York: Watson-Guptill Publications, 2002.

Berlo, Janet Catherine, and Ruth B. Phillips. *Native North American Art*. 2nd ed. New York: Oxford University Press, 2015.

Birmingham, Mary, ed. *Montclair Art Museum: Selected Works*. Montclair, NJ: The Museum, 2002.

Blaugrund, Annette. *The 177th Annual, an Invitational Exhibition: May 1–June 9, 2002*. New York: National Academy of Design, 2002.

Blomberg, Nancy J. *[Re]inventing the Wheel: Advancing the Dialogue on Contemporary American Indian Art*. Denver: Denver Art Museum, 2008.

Blum, June. *Works on Paper/Women Artists*. New York: Women in the Arts Foundation, Brooklyn Museum, 1975.

Bradley, L. "David Frumer/Kay WalkingStick." *Arts Magazine* 50, no. 10 (1978): 50.

Braff, Phyllis. "Myths of the American Indian and Significant Photographs." *New York Times*, August 15, 1993.

———. "A Special Regard for Nature's Forces." *New York Times*, April 14, 1992.

Brett, Nancy. *Painting as Percept: February 2 to February 28, 1980*. New York: Ericson Gallery, 1980.

Brinckerhoff, Deborah. *In Search of the Dream: The American West*. Greenwich, CT: Bruce Museum, 2002.

Broder, Patricia Janis. *Earth Songs, Moon Dreams: Paintings by American Indian Women*. New York: St. Martin's, 1999.

Bryant, Elizabeth. *Interface/Interface, Interpreting the Real*. Seattle: Cultural Affairs Division, Security Pacific Gallery, 1991.

Calloway, Colin G. *First Peoples: A Documentary Survey of American Indian History*. 4th ed. Boston, MA: Bedford/St. Martin's, 2012.

Castle, Fredrick Ted. Review of "Kay WalkingStick at Bertha Urdang." *Art in America* 72, no. 2 (February 1984): 147–48.

Chang, Jeff. *Who We Be: the Colorization of America*. New York: St. Martin's Press, 2014.

Chayat, Sherry. "Syracuse Native's Retrospective Show at Cornell." *Syracuse Herald*, January 30, 1994.

Cheney, Liana. *Self-Portraits by Women Painters*. London: Scholar Press, 2000.

Colleary, Elizabeth T. *Legacies: Contemporary Art by Native American Women*. New Rochelle, NY: Castle Gallery, College of New Rochelle, 1995.

Collischan, Judy. *End Papers, Drawings 1890–1900, 1990–2000*. Purchase, NY: Neuberger Museum of

Art, Purchase College, 2000.

———. *Lines of Vision: Drawings by Contemporary Women*. 1st ed. New York: Hudson Hills, 1989.

Conceptual Art: Four Native American Women Artists. Anadarko, OK: Southern Plains Indian Museum and Crafts Center, 1980. Brochure.

Consolini, Marella, Linda Earle, and Mark Bessire. *Skowhegan 2002–2003 Faculty Exhibition at Maine College of Art*. Portland, ME: Maine College of Art, 2003.

Cotter, Holland. "Last Chance." *New York Times*, May 10, 2013.

———. "Kay WalkingStick." *New York Times*, October 25, 2002.

Cotter, Holland, Thomas W. Leavitt, and Judy Collischan. *Kay WalkingStick: Paintings, 1974–1990*. Brookville, NY: Hillwood Art Museum, 1991.

Cullen, Deborah. *Strategies of Narration: Mel Edwards, Faith Ringgold, Juan Sánchez, Michelle Stuart, Kay WalkingStick*. Cairo Biennale. New York: Printmaking Workshop, 1994.

Daniel, Jeff. "Two Hidden Gems: Images on Paper by Native American Artists and Last Glimpses of Endangered Species." *St. Louis Dispatch*, October 24, 1996.

Donohue, Marlena. Review of WalkingStick exhibition at the Wenger Gallery. *Los Angeles Times*, February 26, 1988.

Dillon, Alice, Marie-Noelle du Bois, and Sheila Stone, eds. *3 artists, 3 stories: Nancy Cohen, Kay WalkingStick, Bisa Washington*. Summit, NJ: Visual Arts Center of New Jersey, 2000. Brochure.

Dubin, Margaret Denise. *Native America Collected: The Culture of an Art World*. Albuquerque: University of New Mexico Press, 2001.

Durham, Jimmie. "A Central Margin." In *The Decade Show: Frameworks of Identity in the 1980s*. Edited by Louis Young. New York: Museum of Contemporary Hispanic Art, New Museum of

Contemporary Art, and Studio Museum of Harlem, 1990.

———. "Savage Attacks on White Women, As Usual." *We the People*. New York: Artists Space, 1987.

Dyne, Lyn. "Artist Wants Her Work to Whisper." *Phoenix Gazette*, September 23, 1991.

Ebony, David. "Kay WalkingStick at June Kelly." *Art in America* 91, no. 4 (April 2003): 143–44.

Everett, Deborah, and Elayne Zorn, eds. *Encyclopedia of Native American Artists*. Westport, CT: Greenwood Press, 2008.

Farris, Phoebe, ed. *Women Artists of Color: A Bio-Critical Sourcebook to 20th Century Artists in the Americas*. Westport, CT: Greenwood Press, 1999.

Ficher-Rathus, Lois. *Understanding Art*. 4th ed. Englewood Cliffs, NJ: Prentice Hall, 1995.

Fischer, Diane P., ed. "A Cherokee Artist Looks at 'The Landing of Columbus' by Albert Bierstadt." In *Primal Visions: Albert Bierstadt "Discovers" America*. Montclair, NJ: Montclair Art Museum, 2001.

Frackman, Noel. "Works on Paper—Women Artists." *Feminist Art Journal* (Winter 1975–76).

Frank, Peter. Review of WalkingStick exhibition at Bertha Urdang Gallery. *ARTnews* 77, no. 6 (Summer 1978): 205.

Gangelhoff, Bonnie. "The Next Generation." *Southwest Art* 33, no. 3 (2003): 186–97.

Garrison, Elizabeth. *ABC: An Alphabet Book from the Hallie Ford Museum of Art*. Salem, OR: Hallie Ford Museum of Art, Willamette University, 2013.

Gaze, Delia. *Dictionary of Women Artists*. London: Fitzroy Dearborn Publishers, 1997.

Goshorn, Shan. "A Misconception about Indians." *New York Times*. December 3, 1995.

Gouma-Peterson, Thalia, Jaune Quick-to-See Smith, and Elizabeth

Woody. *We, the Human Beings: 27 Contemporary Native American Artists*. Wooster, OH: College of Wooster Art Museum, 1992.

Halasz, Piri. "Art: A Melange of Modern." *New York Times*, April 29, 1973.

Hammond, Harmony, and Jaune Quick-to-See Smith. *Women of Sweetgrass, Cedar, and Sage: Contemporary Art by Native American Women*. New York: Gallery of the American Indian Community House, 1985.

Hansen, T. Victoria. *Presswork: The Art of Women Printmakers.* United States: Lang Communications, 1991.

Hartman, Diane A. *The Soaring Spirit: Contemporary Native American Arts*. Morristown, NJ: Morristown Museum, 1987.

Harrison, Helen. "Intense Observations from Several Schools." *New York Times*, July 25, 1993.

Hartje, Katrina. *Signale: Indianischer Künstler*. Berlin: Galerie Akmak, 1984.

Heard Museum. *Second Biennial Native American Fine Arts Invitational*. Phoenix, AZ: Heard Museum, 1985. Brochure.

Heller, Jules, and Nancy G. Heller, eds. *North American Women Artists of the Twentieth Century*. New York: Garland Publications, 1995.

Henry, Gerrit. "Review: Kay WalkingStick: June Kelly." *ARTNews* 98, no. 7 (Summer 1999): 158.

Hutchinson, Elizabeth. Review of "Women Artists of Color: A Bio-Critical Sourcebook to 20th Century Artists in the Americas, Phoebe Farris, ed." *Aurora, The Journal of the History of Art* 1 (2000).

Indyke, Dottie. "Kay WalkingStick, a Contemporary Artist's Journey." *Southwest Art* 30, no. 7 (2000): 44–46.

Ittner, John. Review of *Marking Black* at Bronx Museum of the

Arts. *New York Post*, March 28, 1980.

Janson, H. W., and Anthony F. Janson. *History of Art*. 5th ed. Englewood Cliffs, NJ: Prentice Hall/Abrams, 1997.

Jemisin, Noah. *Bob Blackburn's Printmaking Workshop: The Artists of Color*. New York: The Workshop, 1992.

Jones, Kellie. "Kay WalkingStick." *Village Voice*, May 16, 1989: 10.

King, George G., and Naomi Vine. *Changing Horizons: Landscape on the Eve of the Millennium*. Katonah, NY: Katonah Museum of Art, 1996.

Klein, Sheri R. "Comic Liberation: The Feminist Face of Humor in Contemporary Art." In *Art Education* 61, no. 2 (2008): 47–62.

Koenig, Robert. *Structures: Thirteen New Jersey Artists: January 22–March 25, 1984*. Montclair, NJ: Montclair Art Museum, 1984.

Kresge Art Museum. *Selections from the Kresge Art Museum Collection VI: Recent Contemporary Acquisitions*. East Lansing, MI: Kresge Art Museum, Michigan State University, 1997.

Lawrence, Robin. "Native Tradition Spoken in Language of Post-Modernism." *Saturday Review*, December 31, 1993.

Last, Martin. Review of WalkingStick exhibition at Cannabis Gallery. *ARTnews* (November 1969): 88.

Lewallen, Arlene. *Nourishing Hearts, Creative Hands: Contemporary Art by Native American Women*. Hampton, VA: Hampton University Museum, 1998.

Lippard, Lucy R. *Mixed Blessings: New Art in a Multicultural America*. New York: Pantheon Books, 1990.

Longfish, George, Joan Randell, and Erin Younger. *Contemporary Native American Art*. Stillwater, OK: Oklahoma State University, 1983.

Malarcher, Patricia. "The Meanings of 'Duality' in Art." *New York Times*, December 22, 1985.

Mattera, Joanne. *The Art of Encaustic Painting: Contemporary Expression in the Ancient Medium of Pigmented Wax*. New York: Watson-Guptill Publications, 2001.

Matuz, Roger, ed. *St. James Guide to Native North American Artists*. Detroit, MI: St. James, 1998.

McManas-Zurco, Kitty. *Four Native American Painters*. Wooster, OH: College of Wooster Art Museum, 1985.

McMaster, Gerald, and Clifford E. Trafzer, eds. *Native Universe: Voices of Indian America*. Washington, DC: National Museum of the American Indian, Smithsonian Institution, in association with National Geographic, 2004.

Mendelsohn, Meredith. "Sense and Sensuality: Painter Kay WalkingStick Seeks Sensory Overload." *ARTNews* 103, no. 9 (October 2004): 132–36.

Miller, Elise. "Less Is Less." *San Diego Magazine* (October 1979).

Moorman, Margaret. "Applying Physical Artistry to Canvas." *Long Island Newsday*, April 19, 1990.

Morgan, Anne Barclay. "Kay WalkingStick." *Art Papers* 19 (November/December 1995): 12–15.

Morris, Kate. "Picturing Sovereignty: Landscape in Contemporary Native American Art." In *Painters, Patrons, and Identity: Essays in Native American Art to Honor J. J. Brody*. Edited by Joyce M. Szabo, 187–209. Albuquerque: University of New Mexico, 2001.

———. *Picturing Sovereignty: Land and Identity in Contemporary Native American Art*. PhD diss., New York, Columbia University, 2001.

———. "Places of Emergence: Painting Genesis." In *Off the Map: Landscape in the Native Imagination*. Edited by Kathleen Ash-Milby, 47–54. Washington,

DC: National Museum of the American Indian, Smithsonian Institution, 2007.

Nahwooksy, Fred, and Richard Hill, Sr., eds. *Who Stole the Tee Pee?* Phoenix: Atlatl, 2000.

Navas-Nieves, Tarina. *Personal Paradise: Contemporary Perspectives on Landscape Painting*. Colorado Springs, CO: Colorado Springs Fine Arts Center, 2009.

Nemiroff, Diana, Robert Houle, and Charlotte Townsend-Gault. *Land, Spirit, Power: First Nations at the National Gallery of Canada*. Ottawa, ON: National Gallery of Canada, 1992.

Nilson, Richard. "Painting the Native Soul, Mother Earth Talks Through Artist's Work." *Arizona Republic*, September 16, 1991.

Osburn-Bigfeather, Joanna, Rayna Green, Gregory Cajete, and Lucy R. Lippard. *Native Views: Influences of Modern Culture*. Ann Arbor, MI: Artrain USA, 2004.

Ostrowitz, Judith. *Interventions: Native American Art for Far-flung Territories*. Seattle: University of Washington, 2009.

Pearlstone, Zena, and Allan J. Ryan. *About Face: Self-Portraits by Native American, First Nations, and Inuit Artists*. Santa Fe: Wheelwright Museum of the American Indian, 2006.

Penn, W. S. *The Telling of the World: Native American Stories and Art*. New York: Stewart, Tabori & Chang, 1997.

Penney, David W. *Art des Indiens d'Amérique du Nord*. Paris: Terrail. 1998.

———. *Native American Art Masterpieces*. New York: Hugh Lauter Levin Associates, 1996.

Penney, David W., and George C. Longfish. *Native American Art*. New York: Hugh Lauter Levin Associates, 1994.

Perlman, Meg. "Kay WalkingStick." *ARTnews* 82, no. 10 (December 1983): 165.

Perreault, John. "On Jewelry and Other Pleasures." In *Adornments*. New York: Bernice Steinbaum Gallery, 1985.

Peterson, Michelle. "Honoring Her Heritage." *Ithaca Times*, July 16, 2003.

Phillips, Deborah C. "Kay WalkingStick." *ARTnews* 80, no. 6 (June 1981): 236.

Plagens, Peter. "Kay WalkingStick: American Landscape." *Wall Street Journal*, April 27, 2013.

Potter, Duane. *Q, a Journal of Art*. Ithaca NY: Dept. of Art, Cornell University (1991): 52–55.

Power, Susan. *Art of the Cherokee: Prehistory to the Present*. Athens, GA: University of Georgia Press, 2007.

Raynor, Vivien. "All that glitters isn't always gold." *New York Times*, May 29, 1983.

———. "Art; One Show at 2 Galleries in Newark." *New York Times*, February 8, 1981.

———. "Landscapes That Call for Saving Nature." *New York Times*, August 25, 1996.

———. "The Male Figure, Dual Images, and Landscapes." *New York Times*, March 26, 1989.

———. Review of *Kay Rosen/Kay WalkingStick*. *New York Times*, June 19, 1981.

Reed, Joyce Whitebear. *The Post-Colonial Landscape: A Billboard Exhibition*. Saskatoon, Canada: Mendel Art Gallery, 1993.

Remer, Abby. *Discovering Native American Art*. Worcester, MA: Davis Publications, 1997.

Rigby, Ida K. "Psychological Fields." *Artweek* 10, no. 33 (1980): 17.

Roberts, Lisa A. "Beyond the Body: Metaphysics and Materiality in the Art of Kay WalkingStick." In *Kay WalkingStick*. Miami: Kendall Campus Art Gallery, Miami-Dade Community College, 1999.

———. "Kay WalkingStick." In *St. James Guide to Native North American Artists*. Edited by Roger Matuz, 610–13. Detroit, MI: St. James, 1998.

Rushing, W. Jackson, III, ed. *Native American Art in the Twentieth Century: Makers, Meanings, Histories*. London: Routledge, 1999.

Rushing, W. Jackson, III, and Kay WalkingStick, eds. *Art Journal: Recent Native American Art* 51, no. 3 (Autumn 1992).

Seppi, Lisa Ann. "Metaphysics and Materiality: Landscape Painting and the Art of Kay WalkingStick." PhD diss., University of Illinois at Urbana-Champaign, 2005.

Schwendener, Martha. "A Harmonic View of Nature, in a Cultural Tangle." *New York Times*, September 3, 2010.

Sheets, Hilarie M. Review of *Continuum*. *ARTnews* 102, no. 7 (Summer 2003): 152.

Shirey, David L. "'New Realism' on View at the Morris Museum." *New York Times*, November 14, 1976.

Smith, Jaune Quick-to-See. *The Submuloc Show/Columbus Wohs: A Visual Commentary on the Columbus Quincentennial from the Perspective of America's First People*. Phoenix, AZ: ATLATL, 1992.

Sonneborn, Liz. *A to Z of Native American Women*. New York: Facts on File, 1998.

Spitzer, Judith, and Yigal Zalmona. *Artist's Tribute to Bertha Urdang*. Jerusalem: Israel Museum, 1982.

Starr, Day. "American Indian Images of Nature's Essences." *New York Newsday*, January 11, 1994.

Stavitsky, Gail. *Waxing Poetic: Encaustic Art in America*. Montclair, NJ: Montclair Art Museum, 1999.

Storum, Doug. "Kay WalkingStick: A High-Energy Arcing Artist." *Now! Magazine, Durango Herald*, November 1–7, 1984.

Swenson, Sally, Joan Arbeiter, and Beryl Smith, eds. Vol. 2 of *Lives and Works: Talks with Women Artists*. Lanham, MD: Scarecrow Press, 1997.

Taubman, Ellen N., and David R. McFadden, eds. *Changing Hands: Art without Reservation 3/Contemporary Native North American Art from the Northeast and Southeast*. New York: Museum of Arts and Design, 2012.

Thibodeaux, Julianna. "Art Tribe: Eiteljorg Museum Fellowship Takes on Multiple Meanings," *Native Peoples* (May/June 2010), 29–33.

Touchette, Charleen. "Brave Hearted Native American Women Artists." *Signals: Women's News, Culture, Politics* 2, no. 2 (July/August 1993), 6–11.

———. *NDN Art*. Albuquerque, NM: Fresco Fine Art Publications, 2003.

Tremblay, Gail. "Kay Walking-Stick." In *New Native Art Criticism: Manifestations*. Edited by Nancy M. Mithlo, 184–85. Santa Fe: Museum of Contemporary Native Arts, 2011.

Valentino, Erin. "'Mistaken Identity': Between Death and Pleasure in the Art of Kay WalkingStick." *Third Text* 8, no. 26 (Spring 1994): 61–73.

Vezolles, Christy A. "Personal Journeys: Kay WalkingStick's Paintings Reveal an Exploration of Land, History and Spirit." *Western Art Collector* 32 (April 2010): 56–61.

Vine, Richard. "Kay WalkingStick at June Kelly." *Art in America* 83, no. 1 (January 1995): 106.

WalkingStick, Kay. Interview by Mija Riedel, December 14–15, 2011, transcript. Archives of American Art's Nanette L. Laitman Documentation Project for Craft and Decorative Arts in America, Smithsonian Institution, Washington, DC.

———. "No Reservations," In *Changing Hands: Art Without Reservation 3: Contemporary Native North American Art from the Northeast and Southeast.* Edited by Ellen N. Taubman and David R. McFadden, 52–53. New York: Museum of Arts and Design, 2012.

———. "Democracy Inc.: Kay WalkingStick on Indian Law." *Artforum* 30 (November 1991): 20–21.

———. "Like a Longfish Out of Water." *Northeast Indian Quarterly* 7, no. 3 (Fall 1989): 16–23.

———. "Native American Art in the Postmodern Era." *Recent Native American Art, Art Journal* 51, no. 3 (Fall 1992): 15–17.

———. "Seeking the Spiritual." In *Native American Art in the Twentieth Century: Makers, Meanings, Histories*. Edited by W. Jackson Rushing, III. London and New York: Routledge, 1999, 184–88

WalkingStick, Kay, and Ann E. Marshall. *So Fine!: Masterworks of Fine Art from the Heard Museum*. Phoenix: Heard Museum, 2001.

WalkingStick, Kay, and Cynthia Nadleman. *Kay WalkingStick: Recent Paintings*. New York: June Kelly Gallery, 2007. Brochure.

Waller, Sydney L., et al. *Homage to the American Elm: Photography, Painting, Sculpture, Drawings and Installations by Contemporary New York Artists: Gallery 53, Cooperstown, New York*. New York: Arts Communications, 1985.

Watkins, Eileen. "Bold Work Brings Ancient Concepts into Modern Age." *Sunday Star Ledger*, July 26, 1992.

———. "Englewood Gallery Typifies Bull Market West of Hudson." *Newark Star Ledger*, December 22, 1987.

———. Review of WalkingStick exhibition at M-13 Gallery. *Newark Star Ledger*, December 22, 1987.

———. "Sacred Earth." *The Jersey Journal*, July 31, 1992.

Welish, Majorie. Review, "Susan Hoeltzel, Kay WalkingStick, and David Frumer at Bertha Urdang." *Art in America* 66, no. 5 (September–October 1978): 128.

Weston, Wendy. "A World-Class American Indian Art Collection: Montclair Art Museum." *Native Peoples* 21, no. 3 (2008): 64.

Wilson, Judith, and Moira Roth. *Autobiography, in Her Own Image*. New York: INTAR, Latin American Gallery, 1988.

Wolfe, Townsend. *National Drawing Invitational: January 26–March 11, 2001*. Little Rock: Arkansas Arts Center, 2001.

Wolff, Theodore. "12 Artists Go Back to Perceptual Basics." *Christian Science Monitor*, 1981. Top of Form

Women in the Arts Foundation. *Artist's Choice, 1976–1977*. New York: WIA, 1976.

Wyckoff, Lydia L., ed. *Visons and Voices: Native American Painting from the Philbrook Museum of Art*. Tulsa, OK: Philbrook Museum of Art, 1996.

Yoskowitz, Robert. "Kay Walking-Stick." *Arts Magazine* 54, no. 10 (September 1, 1981): 12. Bottom of Form

Yau, John, and Stanley I. Grand. *Kay WalkingStick: Mythic Dances, Paintings from Four Decades*. Cape Girardeau, MO: Southeast Missouri Regional Museum, 2004.

Young, Phil. *For the Seventh Generation: Native Americans Counter the Quincentenary, Columbus, New York*. New Bell, NY: Golden Artist Colors, 1992.

Zeaman, John. "Two Painters Profoundly Part Ways on the Surface." *Sunday Recorder* (Hackensack, NY), October 23, 1983.

Zimmer, William. "ART; Life Stories in an Artistic Framework." *New York Times*, December 26, 1999.

———. "Charcoal on Paper." New York Times, June 21, 1992.

———. "Light and Heat from American Indian Women." *New York Times*, September 24, 1995.

———. "Lucidity in Jersey City and High Spirits in Montclair." *New York Times*, January 19, 1986.

EXHIBITION CHECKLIST

Who Stole My Sky, 1971. Acrylic on stacked canvas and painted wood frame, 25.4 x 25.4 x 5.75 in. Collection of Marilyn and Charles Arak. (p. 55)

Fantasy for a January Day, 1971. Acrylic on canvas, 50 x 56 in. Collection of the artist. (p. 52)

Me and My Neon Box, 1971. Acrylic on canvas, 54 x 60 in. Collection of the artist. (p. 50)

April Contemplating May, 1972. Acrylic on canvas, 50 x 50 in. Collection of the artist. (p. 52)

Feet Series Arrangement, 1972. Acrylic on canvas, 6 panels, 20 x 20 in. each. Collection of the artist. (p. 53)

Hudson Reflection, III, 1973. Acrylic on canvas, 40 x 48 in. Collection of Joy Walkingstick Couch. (p. 14)

Hudson Reflection, VI, 1973. Acrylic on canvas, 48 x 50 in. Collection of the artist. (p. 57)

Tepee Form, 1974. Acrylic and ink on canvas, 71.5 x 60 x 2 in. Collection of René and Norm Levy. (p. 61)

A Sensual Suggestion, 1974. Acrylic on canvas, 42 x 48 in. Collection of the artist. (p. 59)

Untitled studies, 1974. Acrylic and ink on paper, 14 x 17 in. each (3 panels). Collection of the artist. (p. 62)

Chief Joseph series, 1974–76. Acrylic, ink, and saponified wax on canvas, 20 x 15 in. each (30 panels of a 36-panel series). National Museum of the American

Indian 26/5366.000–026; panels 24, 29, and 34, collection of Tony Abeyta. (pp. 47, 64, 65)

For John Ridge, 1975. Acrylic, ink and saponified wax on canvas, 60 x 72 in. Gilcrease Museum. (p. 63)

Sakajeweha, Leader of Men, 1976. Acrylic, saponified wax, and ink on canvas, 72 x 96 in. New Jersey State Museum, gift of the artist in memory of R. Michael Echols. FA1992.25 (p. 7)

Untitled drawing, June 22, 1977. Charcoal and graphite on paper, 20 x 20 in. Collection of the artist.

Untitled drawing, August 12, 1977. Charcoal and graphite on paper, 20 x 20 in. Collection of the artist. (p. 68)

Untitled drawing II, August 12, 1977. Charcoal and graphite on paper, 20 x 20 in. Collection of the artist.

Untitled drawing, August 17, 1977. Charcoal and graphite on paper, 20 x 20 in. Collection of the artist. (p. 68)

Untitled drawing, September 15, 1977. Charcoal and graphite on paper, 20 x 20 in. Collection of the artist.

Untitled drawing, September 15, 1978. Charcoal and graphite on paper, 20 x 20 in. Collection of the artist. (p. 68)

The Night Café, 1981. Acrylic, saponified wax, modeling paste, and crushed seashells on canvas, 56 x 56 x 4.25. Collection of the artist. (p. 78)

Genesis/Violent Garden, 1981. Acrylic, saponified wax, ink, modeling paste, broken seashells, and sparkles on canvas, 56 x 56 x 4.5 in. Metropolitan Museum of Art, gift of the artist, 1993. (p. 71)

Cardinal Points, 1983–85. Acrylic and saponified wax on canvas, 60 x 60 x 4.5 in. Collection of the Heard Museum. (p. 8)

Montauk, I, 1983. Acrylic, saponified wax, ink, and pebbles on canvas, 56 x 56 x 4.25 in. Collection of the artist. (p. 73)

Montauk, II (Dusk), 1983. Acrylic, saponified wax, and ink on canvas, 56 x 56 x 4.25 in. Collection of the artist. (pp. 74, 75)

Las Platas, 1984. Oil stick on paper, 24 x 24 in. Collection of the artist. (p. 172, 206)

Eden, Perceptual Dilemma, 1985–87. Oil on canvas (left), saponified wax and acrylic on canvas (right), 36 x 72 x 3.5 in. The Museum of Contemporary Art San Diego; gift of the S. W. Family Trust in memory of Muriel Wenger. (pp. 80–81)

Late Summer on the Ramapo, 1987–91. Acrylic and saponified wax on canvas, 48 x 96 x 3.5 in. Collection of the artist. (p. 88)

Hermosa Ridge, Variation, 1988. Acrylic and saponified wax (left), oil on canvas (right), 28 x 28 x 4 in.; 28 x 28 x 1 in. Collection of David Echols.

Loss, 1989. Acrylic and saponified wax on canvas (left), oil on canvas

(right), 36 x 72 x 3.5 in. Collection of the artist. (p. 93)

I Can't Make It Without You, II, 1989. Charcoal on paper, 21.5 x 43 in. Collection of the artist. (p. 34)

Is that You? IV, 1989. Charcoal on paper, 20 x 40 in. Collection of the artist. (p. 93)

The Abyss, 1989. Oil on canvas (left), acrylic and saponified wax on canvas (right), 36 x 72 x 2 in. Collection of the artist. (pp. 90–91)

Letting Go from Chaos to Calm, 1990. Acrylic, saponified wax, and ink on canvas, 48 x 96 x 3.5 in. The Rockwell Museum. (p. 94)

Tears/ ᏗᏎᎼᏬᏒ, 1990. Mixed media, 18.25 x 16.5 x 12 in. Collection of the artist. (pp. 104, 106)

Night/ ᎤᏒᎢ (Usvi), 1991. Oil, acrylic, saponified wax and copper on canvas, 36.25 x 72.25 x 2 in. Montclair Art Museum, purchased with funds provided by Alberta Stout. 2000.10 (p. 17)

Where Are the Generations?, 1991. Copper, acrylic, and saponified wax on canvas (left), oil on canvas (right), 28 x 56 x .5 in. Collection of Jim and Keith Straw. (p. 107)

The Wizard Speaks, the Cavalry Listens, 1992. Copper, oil stick, canvas, and fabric belt on wood, 11 x 12 x 2 in. Collection of the artist. (p. 108)

Remnant of Cataclysm, 1992. Acrylic, saponified wax, oil, and copper on canvas, 28 x 56 in. Collection of the artist. (p. 20)

Remnant of Cataclysm, II, 1992. Charcoal on paper, 30 x 60 in. Private collection. (p. 96)

Spirit Center, II, 1992. Oil stick on paper, mounted on canvas, 30 x 60 x .75 in. Collection of the artist. (p. 97)

Eternal Chaos/Eternal Calm, 1993. Acrylic on canvas, 20.5 x 41 in. Collection of the artist. (p. 151)

Talking Leaves, 1993. Artist's book: oil stick, gouache, collage on paper, 22 x 24.75 x 1.5 in. Kay WalkingStick Collection, Billie Jane Baguley Library and Archives, Heard Museum, Phoenix, Arizona. RC 165(7):1 (pp. 111, 112–13, 116, 117, 118–19, 120)

Seeking the Silence, I, 1994. Oil stick on paper, mounted on canvas, 32 x 64 in. Collection of Ann K. Russell. (p. 151)

Eve Energy, 1996. Gouache on gessoed paper, 19.5 x 38 in. Collection of the artist. (p. 130)

Venere Alpina, 1997. Oil on canvas (left), steel mesh over acrylic, saponified wax, and plastic stones (right), 32 x 64 in. Collection of the artist. (p. 138)

My Memory, 1997. Charcoal on paper, 25 x 50 in. Eiteljorg Museum of American Indians and Western Art. (p. 138)

Il Regalo, 1998. Oil on wood panel with lead ground, 36 x 72 x 1 in. Collection of the artist. (p. 136)

Il Sogno, II, 1998. Oil, gold leaf, and glass beads on wood panel, 24 x 48 in. Collection of the artist. (pp. 126, 137)

Danae in Arizona, Variation II, 2001. Oil and gold leaf on wood panel, 35.81 × 71.75 in. Munson-Williams-Proctor Arts Institute Museum of Art. 2002.20.a–b (p. 38–39)

Gioioso, Variation II, 2001. Oil and gold leaf on wood panel, 32 x 64 in. Eiteljorg Museum of American Indians and Western Art. (pp. 140–41)

ACEA V, 2003. Gouache and gold acrylic on paper, 19 x 38 in. Collection of the artist. (pp. 144, 146)

ACEA VI, Bacchantes, 2003. Gouache, conté crayon on paper, 19 x 38 in. Collection of the artist. (p. 146)

October 5, 1877, 2003. Charcoal, gouache, and encaustic on paper, 25 x 50 in. Collection of the artist. (p. 37)

Over Lolo Pass, 2003. Charcoal, gouache, and encaustic on paper, 25 x 50 in. Collection of the artist. (p. 37)

Wallowa Mountains, View of Home, 2003. Charcoal, gouache, and encaustic on paper, 25 x 50 in. Collection of the artist. (pp. 12–13)

Duccio's Devil, 2005. Oil and gold leaf on wood panel, 16 x 32 x 1 in. Collection of the artist. (p. 40)

Two Walls, 2006. Oil and gold leaf on wood panel, 24 x 48 x 1 in. Collection of the artist. (p. 158, 161)

Our Land, 2007. Oil on wood panel, 32 x 64 in. Collection of the artist. (p. 150)

Farewell to the Smokies, 2007. Oil on wood panel, 36 x 72 x 1 in. Denver Art Museum: William, Sr., and Dorothy Harmsen Collection. 2008.14 (title, p. 157)

Nez Perce Crossing, Variation, 2008. Oil stick on paper, 25 x 50 in. Collection of the artist. (p. 125)

Howitzer Hill Fusillade, 2008. Oil stick on paper, 25 x 50 in. Collection of the artist. (pp. 122–23)

The Sandias, 2008. Oil stick on paper, 25 x 50 in. Collection of the artist. (p. 150)

Volute/Volupte, 2009. Oil on wood panel, 36 x 72 x 1.25 in. Collection of the artist. (pp. 176–77)

Autumn's End, 2009. Oil and aluminum leaf on wood panel, 32 x 64 in. Collection of the artist. (p. 21)

July Low Water, 2010. Oil and palladium leaf on wood panel, 24 x 48 x 1 in. Collection of the artist. (pp. 42–43)

Going to the Sun Road, 2011. Oil and white gold leaf collage on wood panel, 24 x 48 in. Collection of the artist. (p. 154)

New Mexico Desert, 2011. Oil on wood panel, 40 x 80 x 2 in. National Museum of the American Indian, purchased through a special gift from the Louise Ann Williams Endowment, 2013. 26/9250 (cover, pp. 164–65)

St. Mary's Mountain, 2011. Oil on wood panel, 36 x 72 in. Collection of the artist. (pp. 148, 152–53)

Orilla Verde at the Rio Grande, 2012. Oil on wood panel, 40 x 80 in. Collection of the artist. (p. 168)

The Pecos, 2012. Oil on wood panel, 40 x 80 in. Collection of the artist. (p. 103)

SKETCHBOOKS

All works are paper, ink, watercolor, and pencil on paper, collection of the artist. Illustration of all fifteen sketchbooks, p. 36.

Rome, 1996; 12 x 8 x .6 in. (p. 208)

Italia, 1996; 6 x 10 x 1.38 in.

American Academy, 1998; 8 x 13.5 x 5.13 in.

Morocco, 1999 / Rome, 2000; 7.5 x 13.75 x 1.25 in. (p. 36)

Rome, 2000 / Home, 2001; 11 x 15.38 x 1 in.

Istanbul, Rome, Pompeii, US Southwest, 2001–03; 9.5 x 12.5 x 2 in.

Montana, 2003; 9.5 x 12.5 x 1.25 in. (p. 35, 200)

Rome, Sicilia, 2003; 8.5 x 10 x 1.25 in.

Ithaca, 2004 / Rome, 2005; 8.75 x 14.13 x 1 in.

California, 2005 / Santa Fe, Taos, 2006–07; 11.38 x 15.5 x 1.25 in.

North Carolina, Rome, and American Southwest, 2006–08; 8.5 x 11 x 1 in.

Colorado, Amsterdam, Montana, Rome, 2008–10; 7.75 x 14 x 1 in. (p. 199)

New Zealand, Ramapo River, 2008–09; 11.25 x 13.5 x 1.25 in. (p. 183)

Santa Fe, Point Reyes, New England, 2011–12; 8 x 13.5 x 1.25 in.

Sicily, 2012; 6 x 11 x .9 in.

156. Detail of sketchbook
(Montana), 2003. 9.5 x 12.5 x 1.25
in. Collection of the artist.

INDEX

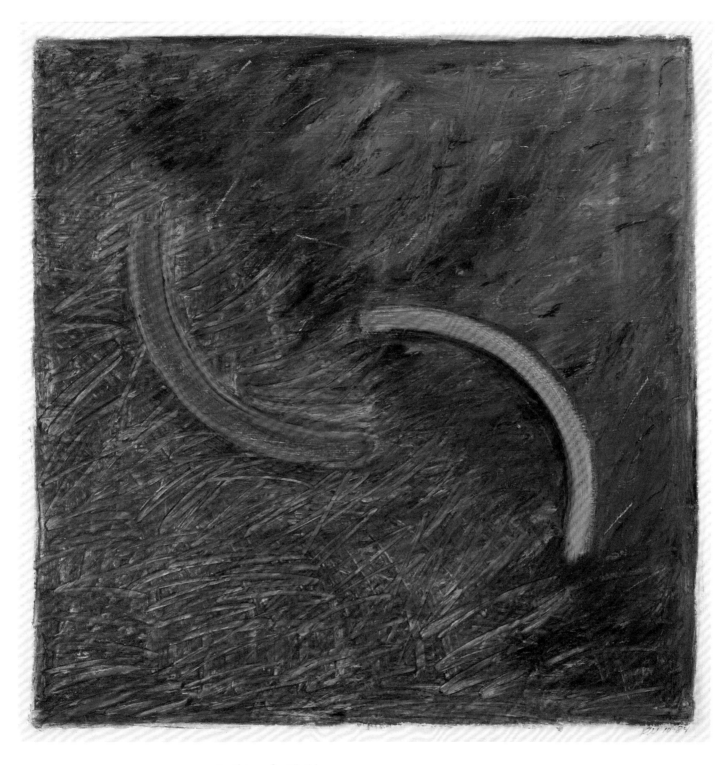

157. *Las Platas*, 1984. Oil stick on
paper, 24 x 24 in. Collection of the
artist.

CREDITS

Unless otherwise specified, all images of Kay WalkingStick and her artwork courtesy of the artist. All artwork © the artist.

Cover: Ernest Amoroso, National Museum of the American Indian, Smithsonian Institution

Title page: courtesy Denver Art Museum

Figures

Becket Logan: 4, 10, 31, 32, 35, 36, 84, 85, 88, 99, 100, 115, 117, 118, 119, 120, 124, 125, 130, 132, 136

Cascadilla Photo: 9, 37, 38, 71, 74, 101, 102, 103, 105, 106, 107, 109, 113, 123

Lee Stalsworth, Fine Art through Photography, LLC: 5, 20, 25, 27, 28, 29, 30, 34, 41, 43, 44, 45, 46, 47, 48, 49, 50, 51, 53, 55, 59, 60, 61, 62, 63, 65, 66, 67, 69, 72, 77, 80, 81, 86, 87, 89, 108, 110, 116, 121, 122, 126, 128, 131, 144, 153, 154, 155, 156, 157, 158

1, Alex Jamison, National Museum of African American History and Culture; 2, courtesy Heard Museum, Phoenix, Arizona; 3, Jack Mitchell for Atlantic Center for the Arts, New Smyrna Beach, Florida; 6, courtesy Montclair Art Museum; 7, © J Henry Fair/www.IndustrialScars.com, special thanks to flight partner SouthWings/www.SouthWings.org; 8, Subhankar Banerjee; 11, Julia Verderosa; 12, courtesy Kay WalkingStick; 13, courtesy Joy Walkingstick Couch; 14, courtesy Dartmouth College Library; 15, courtesy Syracuse University Library; 16, courtesy Joy Walkingstick Couch; 17, Charles Walkingstick, courtesy Joy Walkingstick Couch; 18, courtesy Joy Walkingstick Couch; 19, Reverend Donald Theobald, courtesy Kay Walking-Stick; 21, Michael Echols, courtesy Beverly Doering Connolly; 22, courtesy Kay WalkingStick; 23, Doug Mesney; 24, Michael Echols, courtesy Kay WalkingStick; 26, Michael Echols; 33, courtesy Munson-Williams-Proctor Arts Institute Museum of Art, Utica, New York; 39, R.A. Whiteside, National Museum of the American Indian, Smithsonian Institution; 40, Doug Mesney; 52, John Pickett; 54, courtesy The Phillips Collection, Washington, DC; 56, John Pitkin, Gilcrease Museum, Tulsa, Oklahoma; 57, David Sundberg, Esto Photographics, Inc., courtesy Kay WalkingStick; 58, R.A. Whiteside, National Museum of the American Indian, Smithsonian Institution; 64, John Pitkin; 68, Rhoda Sydney, courtesy Kay WalkingStick; 70, courtesy The Museum of Contemporary Art San Diego; 73, courtesy Kay WalkingStick; 75, James Dee; 76, John Reiss; 78, James Dee; 79, courtesy The Rockwell Museum; 82, Ken Thomas; 83, courtesy The Metropolitan Museum of Art, New York; 90–98, courtesy Heard Museum, Phoenix, Arizona; 104, courtesy The Frick Collection; 111, 112, courtesy Eiteljorg Museum of American Indians and Western Art, Indianapolis; 127, courtesy Denver Art Museum; 133, Ernest Amoroso, National Museum of the American Indian, Smithsonian Institution; 135, courtesy Alexander Gray Associates; 137, Julia Verderosa; 138–40, courtesy Kay WalkingStick; 141, Michael Echols; 142, Bob Yoskowitz; 143, courtesy Kay WalkingStick; 145, courtesy Kay WalkingStick; 146, Jack Mitchell for Atlantic Center for the Arts, New Smyrna Beach, Florida; 147, 148, courtesy Kay WalkingStick; 149, courtesy Eiteljorg Museum of American Indians and Western Art, Indianapolis; 150, Kay WalkingStick; 151, Howard Nathanson, courtesy of Kay WalkingStick; 152, Kathleen Ash-Milby

158. Detail from sketchbook
(Rome), 1996. 12 x 8 x .6 in.
Collection of the artist.